WWW.DYNAMITE.COM

NICK BARRUCCI CEO/Publisher
JUAN COLLADO President/COO

JOSEPH RYBANDT Executive Editor
MATT IDELSON Senior Editor
ANTHONY MARQUES Associate Editor
KEVIN KETNER Assistant Editor

JASON ULLMEYER Art Director
GEOFF HARKINS Senior Graphic Designer
CATHLEEN HEARD Graphic Designer
ALEXIS PERSSON Graphic Designer
CHRIS CANIANO Digital Associate
RACHEL KILBURY Digital Multimedia associate

BRANDON PRIMAVERA V.P. of IT and Operations
RICH YOUNG Director of Business Development

ALAN PAYNE V.P. of Sales and Marketing
PAT O'CONNELL Sales Manager

Dynamite addresses:
113 Gaither Dr., STE 205
Mt. Laurel, NJ 08054

Online at www.DYNAMITE.com
On Facebook /Dynamitecomics
On Instagram /Dynamitecomics
On Tumblr dynamitecomics.tumblr.com
On Twitter @dynamitecomics
On YouTube /Dynamitecomics

Standard Edition ISBN: 978-1-5241-0708-6
Halfbrick Exclusive Edition ISBN: 978-1-5241-0709-3
Printed in China

THE ART OF
HALFBRICK
FRUIT NINJA, JETPACK JOYRIDE, AND BEYOND

WRITTEN BY
SARAH RODRIGUEZ

FOREWORD BY
HARRY SLATER

BOOK DESIGN BY
RODOLFO MURAGUCHI

EDITED BY
HANNAH ELDER

DYNAMITE®

TABLE OF CONTENTS

FOREWORD

There was a time when mobile gaming was something of an afterthought. Your phone had a couple of distractions on it, little games that you might sink some time into, but that was about it. The smartphone era changed that. And, in a not insignificant way, Halfbrick changed the smartphone era. It did it with bright colors as much as it did with mesmerizing gameplay.

When *Fruit Ninja* first came out in 2010, the inexorable creep of grays and browns was well under way in the console and PC arena. Games were gritty, they were dark, and the only spark among their drab palettes was the occasional splash of deep red gore.

But *Fruit Ninja* dealt in primary colors. It was loud and cheerful, and it managed to be an action game where your main aim wasn't mindless slaughter. It was one of the first games that really got to grips with what touchscreen gaming was actually meant for. This wasn't about forcing a control scheme that didn't work onto a device that didn't want it, it was about expressing the freedom that swipes and taps can offer.

The splashes of color here were the gooey innards of defeated fruit; cheery faces smiled at you from every corner of the screen; animated bombs drifted into play with all the joyful menace of explosives from Saturday morning cartoons.

It was brilliant in all the ways that 'brilliant' can be defined. But it was simple too; the sort of experience that anyone can grasp within a few seconds of starting it up. "Oh, so you slash the fruit? Okay, got it."

Those three things— simplicity, brightness, and control— ushered in a lot of what we still see on the App Store and Google Play Store today. But *Fruit Ninja* was never meant to have its parts viewed in isolation; it was a polished and preened experience where the colors fed into the play, the controls helped the simplicity, and everything came together to create something special.

Take one of those facets away, and the game would be irreparably changed. One of the things you see a lot of in mobile gaming is cloning— games that take an idea that's worked and then shuffle things around to offer a slightly different take. Sometimes it's the clone that takes off while the game with the original idea languishes in obscurity. However, this was not the case with *Fruit Ninja*. It was an original in the true sense; but it got that original idea so right, so spot on, that anything imitating it was going to feel just like that— an imitation.

Fruit Ninja, of course, isn't the only game in the Halfbrick library, but it's the one that set the pattern for what was to come; games that were, first and foremost, fun. It's that fun that resonates through everything that the studio has made. As a critic who's played thousands of mobile games, Halfbrick is a developer I know I can rely on to put a smile on my face.

Whether it's the amazing sense of speed in *Jetpack Joyride*, or the tactics and explosions of *Colossatron*, everything that comes from the stable is a guaranteed grin-maker— and so much of that is down to the art style. It's more than bright colors and cheery grins; there's something inherent in a Halfbrick game that lets you know it's a Halfbrick game.

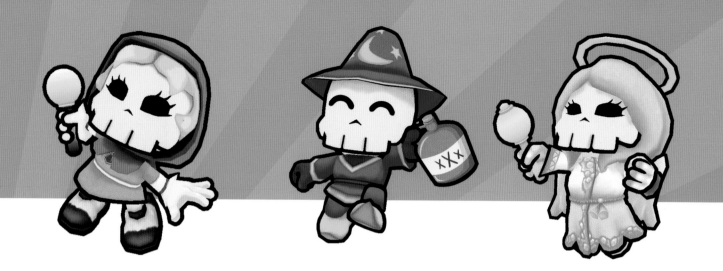

At the same time though, they manage to avoid the dashing mundanity of the generic. Each game is its own experience, offering its own take on the core philosophies that were set out with such aplomb in *Fruit Ninja*.

Where other studios might have rested on their laurels, churning out iterations of their big hit, Halfbrick went in the other direction. It experimented, it played around, it delved deeper into the mobile gaming world to see what else might work. The end results are always interesting, always charming, and always bear the hallmarks of a developer that clearly and succinctly understands the market and the devices that it's working for.

For me, anyway, it's that willingness to explore that makes Halfbrick stand out. And it's what made writing this foreword such a pleasure. Going back, playing the games again, remembering what it was that made them fizz and pop so much in the first place, has been an absolute joy.

And I think that's the word I most associate with Halfbrick: joy. While other games feel perfunctory, bashed out to fill a space in the developer's line up or to try and cater for a gap in the mobile market, Halfbrick's creations always play like they've been made with the single goal of filling the player with a special kind of glee.

It's fair to say that the art is a massive, immovable part of that. I've played countless endless runners, all perfectly mechanically competent, but ask me for an example of the genre and I'm going to say *Jetpack Joyride*. And that's because it sticks in the mind. It's got a swagger that reminds me of the imagination of my younger days, when everything was jetpacks and explosions and the world was my oyster.

That connection to a time when games weren't all about grit and grime and quick-scoping, to when it was okay to enjoy things in and of themselves without having to deal with griefers and joypads with thousands of buttons, is something that it sometimes feels like we're losing.

Which is why Halfbrick is so important. Here's a company where every frame of every animation, every cut scene, every game icon, even every menu, is designed to add some cheer to the player's life. Here's a company with a style that doesn't get bogged down in repetition, that builds its games with one eye on a bright blue sky from some not-so-dim and distant past.

In a hundred years, when a pop-culture historian in a jumpsuit on Mars is writing up a history of gaming in the early 21st century, I hope they look to Halfbrick with fondness. Not just as a purveyor of primary colors in a world of beige, but as a developer that understood that so much of the enjoyment of a game comes from the way that it's presented to the people playing it.

Who knows, they might even quote this foreword.

Harry Slater
Deputy Editor *pocketgamer.co.uk*
January 18th 2018

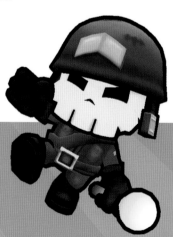

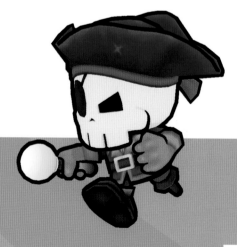

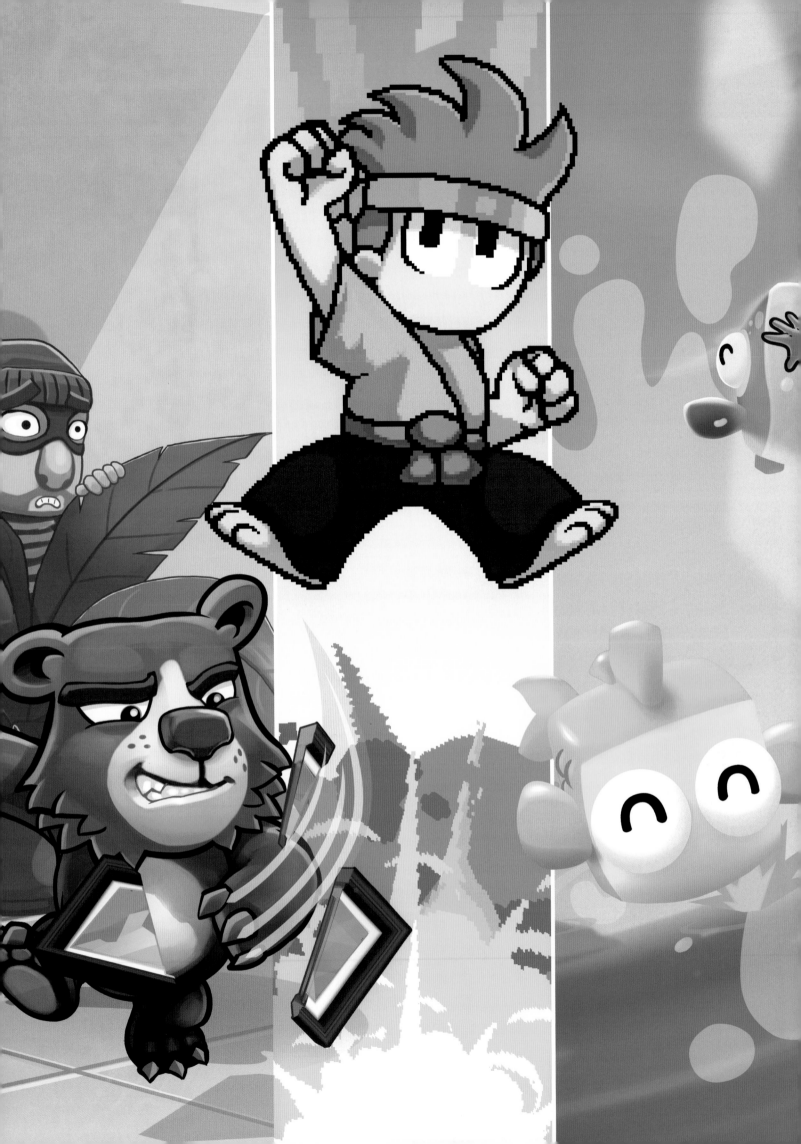

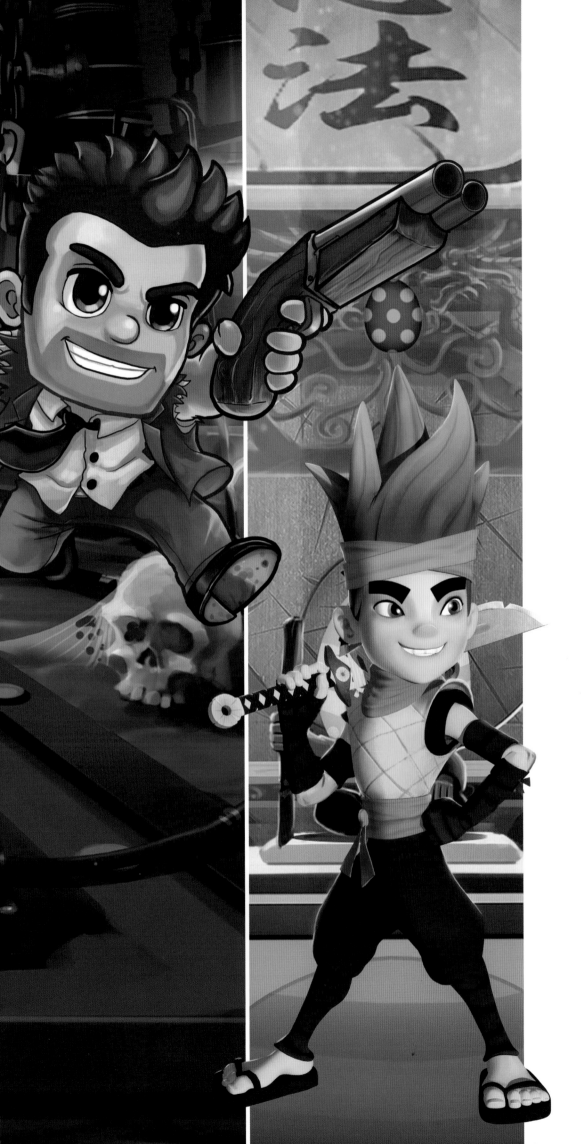

THE ART OF
HALFBRICK

WHO IS HALFBRICK?

Born in 2001, in Shainiel Deo's basement, Halfbrick was a group of six game developers working on licensed games. After almost ten years in the uncertain Australian game market, they decided to make the switch to creating their own, original games.

That's when they changed the mobile gaming world forever.

Fruit Ninja, the first of many successful games created by Halfbrick, was a smashing success. It had over a billion downloads and was one of the first multiplayer games for mobile devices. It became a cultural phenomenon, sparking everything from video parodies to an actual cartoon.

But Halfbrick was no one-trick pony. They went on to release games like *Jetpack Joyride*, *Monster Dash*, *Age of Zombies*, and their latest hit: *Dan the Man*. They expanded from Brisbane, Australia to Sydney and Adelaide. Outside of Australia, they opened offices in Spain, Bulgaria, and the U.S.

This book seeks to capture some of the magic of those moments, small and large, that make Halfbrick games so special. From lush to 16-bit style animation, the art of Halfbrick inspires feelings of nostalgia, excitement, and in the case of one game, an unquenchable desire for fresh fruit!

THE AUSTRALIAN GAMING DEV SCENE

TOP ROW:
James Barnes, Aaron Green, Paul McNab, Sean Druitt, Rinal Deo, Matt Ross, Stephen Last, Phil Larsen, Ben Vale, Michael Dobele, Richard McKinney, Jesse Higginson, Hugh Walters, Matthew Maguire, Anthony Hansen, Murry Lancashire, Dan Vogt, Tony Takoushi, Motze Asher, Clint Hobson

BOTTOM ROW: Dean Loades, Grant Peters, Brent Hobson, Jason Harwood, Ryan Langley, Jason Maundrell, Daniel Fisher, Sierra Asher, Scott West, Adam Wood, Alex Butterfield

Halfbrick was formed in 2001 when console developers dominated the games landscape in Australia. There were a few developers also working with licensed games for portable devices such as Gameboy Advance, PlayStation Portable, and Nintendo DS, but it was generally a console focused industry.

"In hindsight, our work in developing for portable devices prepared us well for developing for mobile," said Sam White, VP of Entertainment and Licensing. "The small screens, graphic restrictions, and limitations on controls proved to be great training for releasing on mobile."

Around 2009 and 2010, with the growth of the iPhone and Apple App Store, the Australian games industry changed rapidly. Many of the larger console game developers either shut down or pivoted to mobile games. At the same time, the accessibility of the app stores created the opportunity for any developer of any size to publish a game themselves for a global market.

In addition, the value of the Australian dollar also moved closer to, and for a while, higher than, the U.S. dollar, practically eliminating the country as a once "cheap" labor source for work-for-hire game development for the major publishers. If a video game company wanted to survive, it needed to be able to adapt.

"Where many of the indie developers were not able to survive this shift, Halfbrick was able to continue to reach players that loved the simple, joyful experience our games delivered. We have since had to adapt and evolve in an ever-more-sophisticated market," said White.

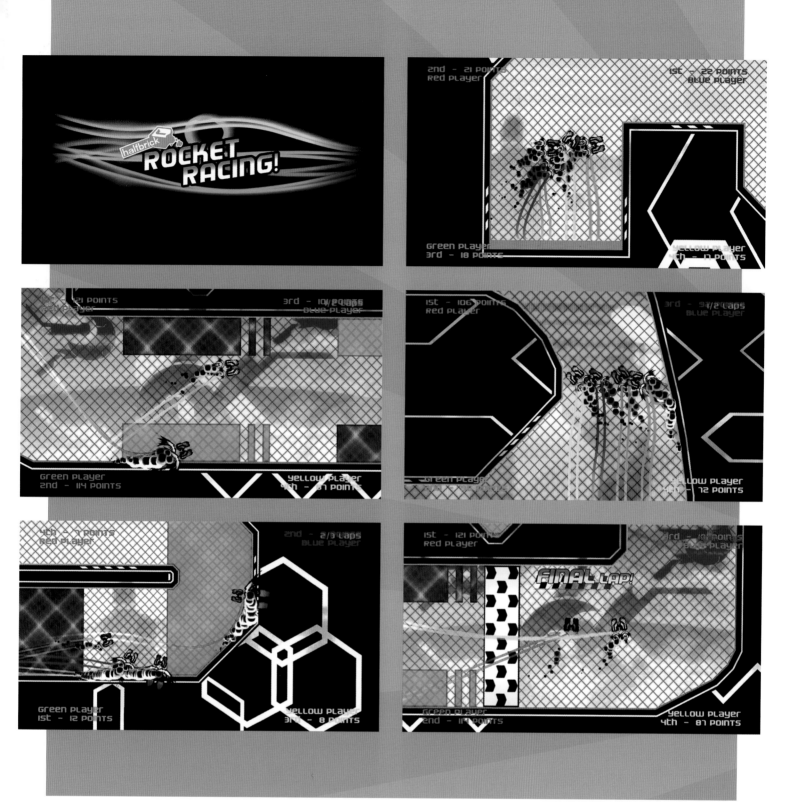

BABY STEPS

Halfbrick's first original IP was a PSP mini game called *Rocket Racing*. Although *Rocket Racing* was considered a commercial failure, game designer Luke Muscat used the lessons learned from making the game to eventually create *Fruit Ninja*.

"We learned things like don't make your game difficult to control, don't use an abstract theme, and don't make it tremendously difficult to play," said Muscat in a 2011 interview with *Kotaku*. "We learned a lot about branding and marketing in terms of having something that people can grasp onto, something bright and colorful, a concept that can be explained in three to four words."

Rocket Racing was abstract, complicated, challenging, and took six months to develop. *Fruit Ninja* couldn't be more different!

HALFBRICK FRIDAYS

It all started here. This small, unassuming bit of art was the very first piece created for the game that would become *Fruit Ninja*!

Luke Muscat created the image to pitch his idea for *Fruit Ninja* at Halfbrick Fridays. Something of a company-wide game jam, Halfbrick Fridays occur a few times a year and involve the entire company breaking into small groups to brainstorm new ideas. Team members can come from any department, from receptionist to accounting to everything in between. Once the team has a game concept or demo, they present or "pitch" it to the entire company.

Fruit Ninja isn't the only Halfbrick Fridays success story. *Age of Zombies* and *Monster Dash* also saw their beginnings in this creative setting.

Fruit Ninja came about at the time of a very precarious Halfbrick Friday. The company was in a tight spot. CEO Shainiel Deo estimated that the studio had perhaps nine months left if they did not create a successful game. The idea came from Luke Muscat, a designer who would go on to become the Chief Creative Officer of Halfbrick, before eventually founding his own company.

Inspired both by developing games for the DS, as well as by a late-night Chef knife commercial, Muscat wanted to create a simple and yet unique game, focused on the gory slicing of unsuspecting, juicy fruit!

"The original tagline was 'The Premiere Fruit Murder Simulator,'" Muscat said with a laugh.

Stephen Last, who would soon program the *Fruit Ninja* gameplay, was drawn to the idea because… well, fruit murder sounded kind of fun!

But unlike Last, most people at the studio thought it was a really bad idea. It just seemed too simple. Luckily for Muscat, the team eventually rallied behind the game after playing the first prototype. And it all began with a simple image of sliced fruit, pitched during Halfbrick Fridays.

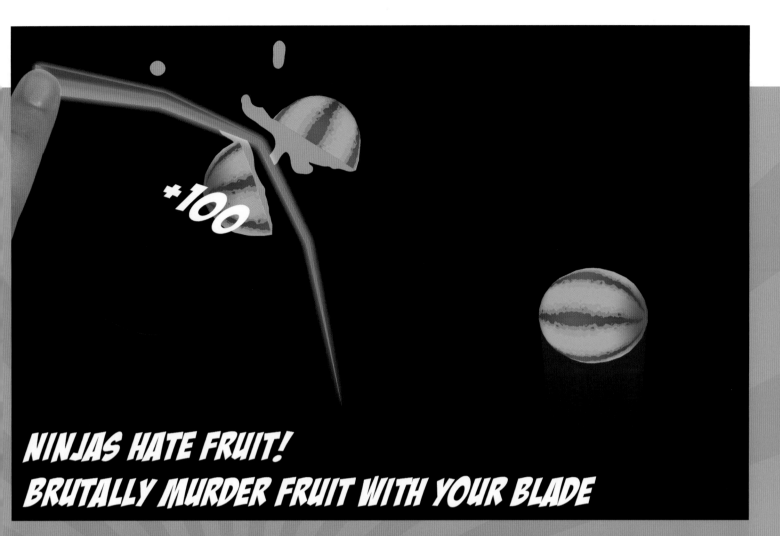

NINJAS HATE FRUIT!
BRUTALLY MURDER FRUIT WITH YOUR BLADE

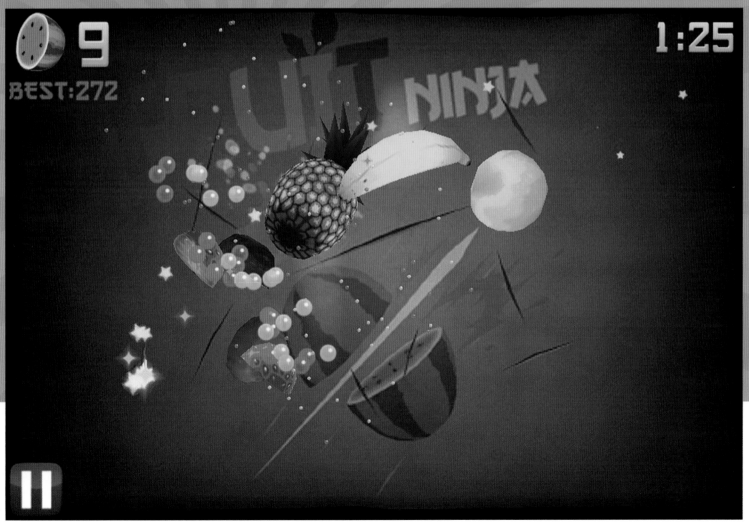

FRUIT NINJA

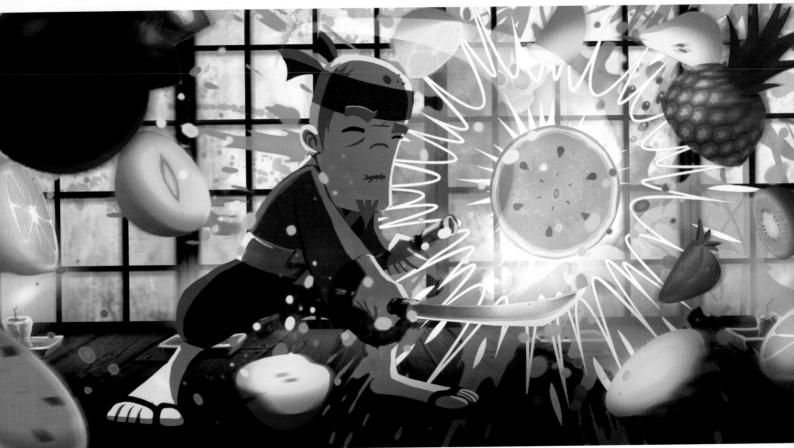

NINJAS HATE FRUIT?

In simplest terms, *Fruit Ninja* is a mobile game in which you use a slicing motion to chop fruit, while avoiding bombs. However, *Fruit Ninja* has become so much more than that. It became a Kinect game, a VR game, an iPad game, and an animated series. It has won awards and spawned videos with millions of views on YouTube. *Fruit Ninja* isn't just a touch-screen mobile game anymore: it is a cultural phenomenon.

Fruit Ninja came out at the perfect time in mobile games development. The simplicity of the gameplay meant that it was accessible to everyone, from grandmas to toddlers. Over time, Halfbrick continued to make changes and additions to the game, creating a thriving community and encouraging strategic gameplay with the release of special blades and dojos, scoreboards, online multiplayer, and much more.

Within three months, *Fruit Ninja* had a million downloads. By 2015, it had a billion downloads. This small mobile game about slicing colorful, delicious fruit is one of the most successful games ever made.

And it all started with one fun idea: what if ninjas hated fruit?

FRUIT MURDER SIMULATOR

By May of 2012, *Fruit Ninja* was on one-third of all U.S. iPhones. That was quite a big feat for a game that initially seemed to be too simple to be a success.

Fruit Ninja is the brainchild of Luke Muscat, and the seeds of the idea first formed in his head when he watched a late-night commercial for chef's knives. The chef was cutting shoes, cans, and even threw a pineapple into the air and sliced it before it landed. Years later, Muscat bought his own set of chef's knives and did what any adult would do in that situation.

He threw tomatoes in the air and sliced them, just as he'd seen the chef do all those years ago.

Fast forward to the Halfbrick Friday ideation session when Muscat and the team were thinking of ideas for iPhone games.

"I was like, okay what kind of verbs seem natural for this, and I was doing like press, and pinch, and swipe. What are other words to describe that kind of motion, and the thing that popped in my head was slice," said Muscat.

Like a lightbulb going off, the word "slice" reminded Muscat of the tomato incident.

"What if we could make a game that was really gory, but like G-rated gore?" he asked.

From that question, the idea of slicing messy, splatter-prone fruit was born. Despite being inspired by the humble tomato, he decided that tomatoes and vegetables were too boring for this game. The other thing the game needed was a difficulty edge. That's where the bombs came in. Why bombs?

"Because bombs are bad," Muscat explained.

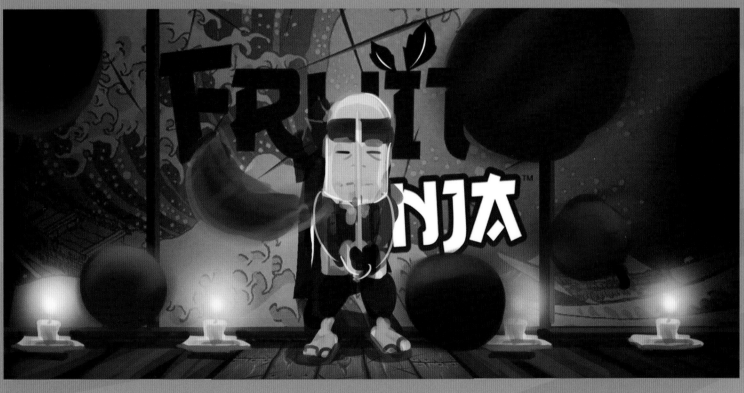

ABOVE: Concept art featuring
a newly-created Sensei.

However, despite Muscat's belief and enthusiasm for the game, most of Halfbrick was skeptical about the game's viability and the project died out.

Fortunately, the stars would align for Muscat's simple iPhone game when Shainiel Deo, the CEO of Halfbrick, began researching mobile games to create a hit.

"A lot of them were very simple, and they took advantage of the touchscreen," Deo said.

"So we were really looking for games that were single screen, touchscreen, and very easy to play because of the broad demographic."

Muscat's fruit slicing game fit each of these categories. It was pitched again, and this time he created a Flash prototype that helped sell the idea. Deo said that out of all the pitches, this was the game that really embodied the goal of that particular Halfbrick Friday.

"You played it and you could just feel straight away there was something about that game that was

fun, rewarding, and visceral. It just kept you coming back wanting to play more," said Deo.

Though *Fruit Ninja* may have looked like an overnight success, Halfbrick had been building the skills needed to create a successful mobile game through their work on console games and other portable platforms.

"We had been working on making games for memory limited devices, with small screens and touch input. We've been doing that for years, and so when the iPhone came along it really played to our strengths," said Jason Harwood, a producer at the time.

Combined with the innovation of a slice mechanic, *Fruit Ninja* both catered to and stood out from the rest of the mobile scene.

The first version of *Fruit Ninja* was developed by three people at the company. They had six weeks to get the game built and ready, then another six weeks to prepare for marketing and release. The game launched with classic mode, devoid of combos and no blades to unlock. The only character was Sensei. According to Shath Maguire, the artist of the original team, it only took one try to get Sensei right.

"That drawing of him was the first drawing I did of him. No sketches or anything," said Maguire.

One of the first challenges the team faced was getting players to understand the slicing motion. When people were handed the build to play, they immediately began tapping the screen, then handed the game back saying that it didn't work.

Muscat's solution was to detect when a player tapped the screen three times and to play a simple animation of a finger slicing through the fruit.

Once the kinks were worked out, it was time to release *Fruit Ninja* to the world. Halfbrick might have prepared themselves to create such a game, but they could not have prepared themselves for the overwhelming reaction it received.

"We never anticipated the success of this game. Not to this level," said Jason Harwood.

WARNING!

REAL FRUIT WAS HARMED IN THE MAKING OF THIS VIDEO...

BUT THE NINJA WAS FINE

FRUITNINJA.COM

NINJAS HATE FRUIT

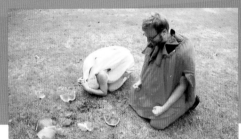

ABOVE: Images from the first *Fruit Ninja* trailer, released in April 2010.

THE FIRST TRAILER

The very first *Fruit Ninja* trailer was quite unique for the time. "It was right around the time when people started doing high budget trailers," said Luke Muscat. "And we were like, well, we'll do the opposite!"

The team bought twenty dollars' worth of fruit and went down to the park. The "actors" playing the fruits and the ninja were actually Halfbrick developers and artists. The idea paid off and the trailer stood out from the crowd for its irreverent humor. Though a lot has changed since that first trailer, and even the first version of the released game, it was a solid indicator of the kind of carefree, fun atmosphere that would mark future Halfbrick releases.

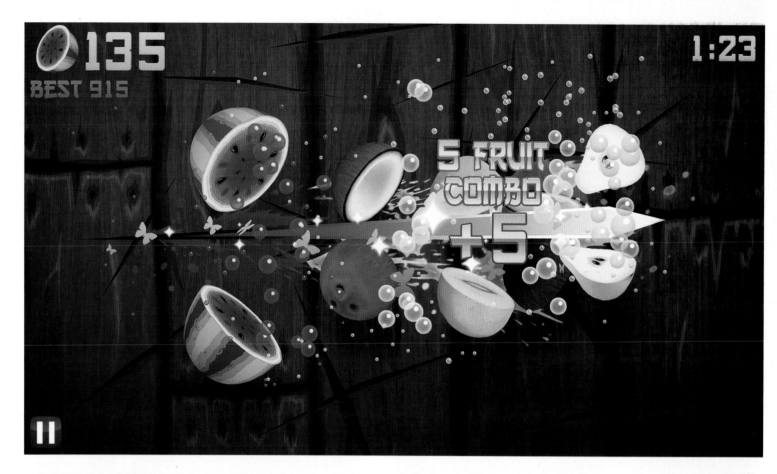

PERFECT FOR MOBILE

"If we released *Fruit Ninja* in the market today, I think we'd have a much tougher chance of getting noticed," said Shainiel Deo.

As Deo pointed out, the mobile scene was very different at the time *Fruit Ninja* was released. For example, *Fruit Ninja* was one of the first games to have multiplayer on a mobile phone. It launched without unlockable characters or advertising.

One of the biggest challenges the team faced was getting into the mobile mindset. Games on mobile phones had to be updated regularly. Players expected their feedback to be incorporated and to receive new content to keep the game exciting.

During the first year, the three-man team shipped about fourteen updates, which is an incredible number for such a small team. Perhaps their biggest update was the addition of Arcade Mode.

"We loved the three modes we had: classic, zen, and multiplayer. They were all really strong, but we wanted something to come along and just dominate and really change the whole thing," said Jason Harwood.

"Arcade Mode certainly did that. It changed everything in terms of just dialing it up to eleven," he explained.

Arcade Mode took the team three months to work on. There was a break in the middle of that time to release two multiplayer updates, so in total it took about six months to bring Arcade Mode to *Fruit Ninja*.

"For me, Arcade Mode is probably the most balanced thing I've ever designed. It seems simple, but the blitz system had so many intricacies," said Luke Muscat.

"I was really, really proud of that mode, because it was staggeringly complex, but it looks simple, and that's kind of the dream, right? You make something that's really quite complex and evolved, but it just looks really simple to people, and they just love it and have fun with it."

THE WAY OF THE NINJA

Beautiful yet minimalistic, the background art for *Fruit Ninja* serves as a player's canvas for the splattering of fruit, while being interesting without being distracting to the gameplay itself. These backgrounds are the dojos of the practitioners of Juice Jitsu, and many of them come with particular benefits.

Some dojos, such as Cherry Blossom and Cloudy Skies, amplify the power of particular blades. Others, such as Great Wave and I Heart Sensei, summon fruit waves. Gutsu and Truffles, the merchant buddies, have a dojo that adds bonus crates with goodies inside. Be sure to experiment with different blades in different dojos for maximum fruity combos.

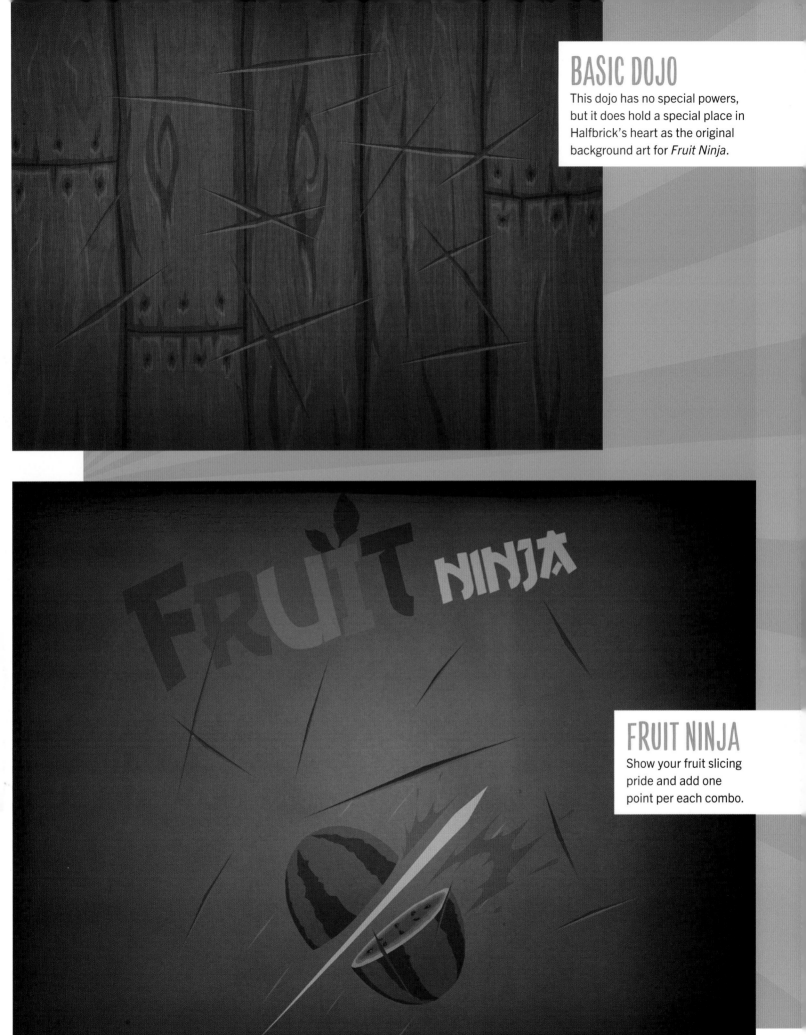

BASIC DOJO

This dojo has no special powers, but it does hold a special place in Halfbrick's heart as the original background art for *Fruit Ninja*.

FRUIT NINJA

Show your fruit slicing pride and add one point per each combo.

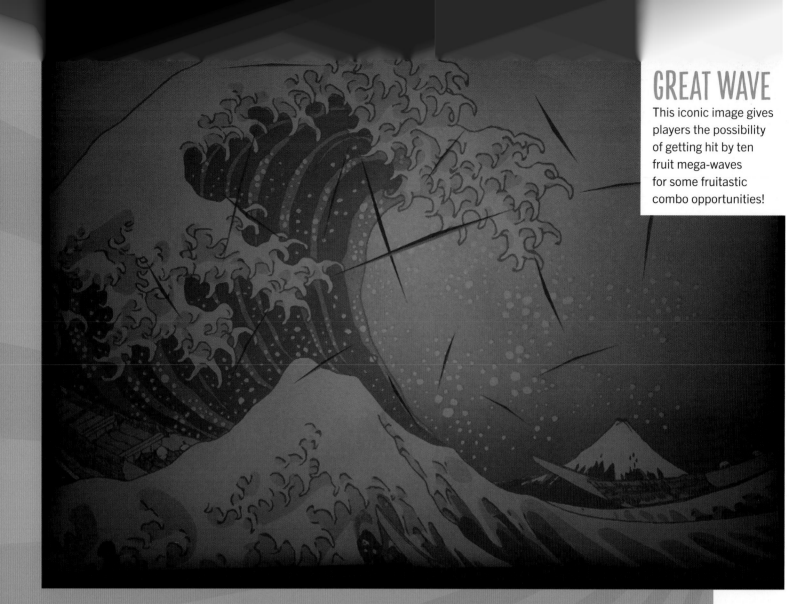

GREAT WAVE

This iconic image gives players the possibility of getting hit by ten fruit mega-waves for some fruitastic combo opportunities!

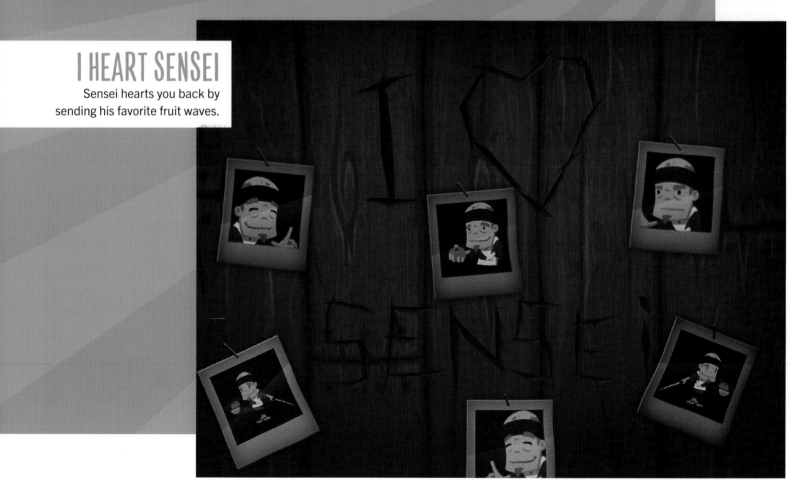

I HEART SENSEI

Sensei hearts you back by sending his favorite fruit waves.

YIN YANG

Finding balance leads to a feeling of inner peace, as well as ten extra seconds of play time. Those extra seconds are a great way to score more points!

PARCHMENT

If bombs have gotten you down, this dojo is a place for faster life regeneration.

先生のもの

GUTSU AND TRUFFLES

This travelling merchant and his pig buddy bring bonus crates filled with treats—awesome power-ups that can deflect bombs, add time, and give you extra points for certain fruits.

CHINESE ZODIAC

Spawns fortune jars with the help of a lucky zodiac sign.

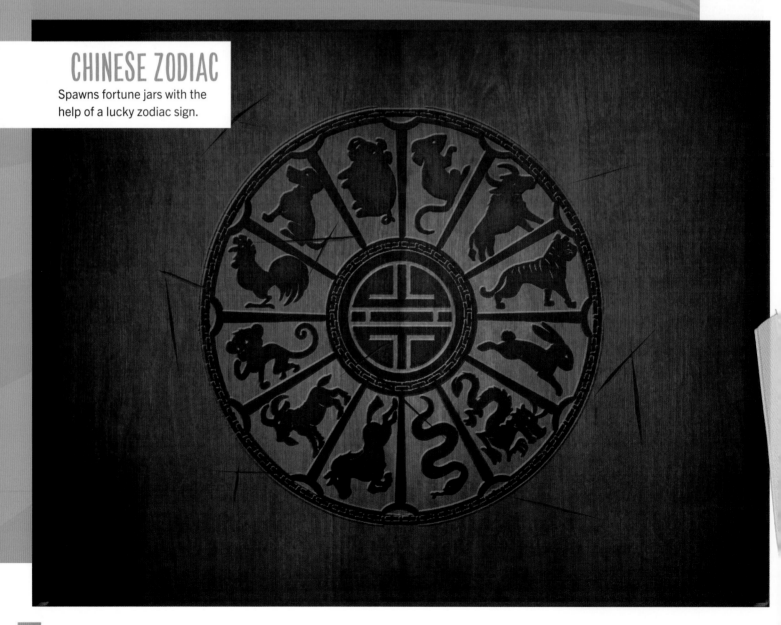

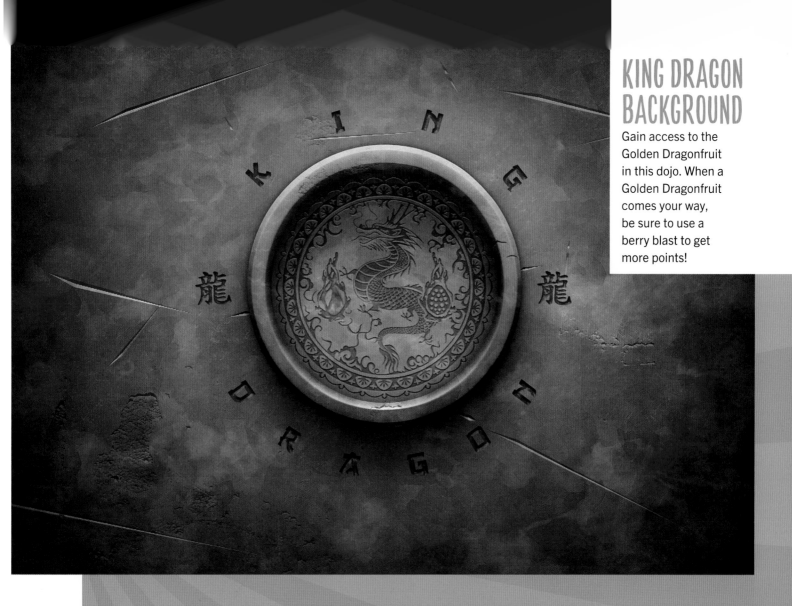

KING DRAGON BACKGROUND

Gain access to the Golden Dragonfruit in this dojo. When a Golden Dragonfruit comes your way, be sure to use a berry blast to get more points!

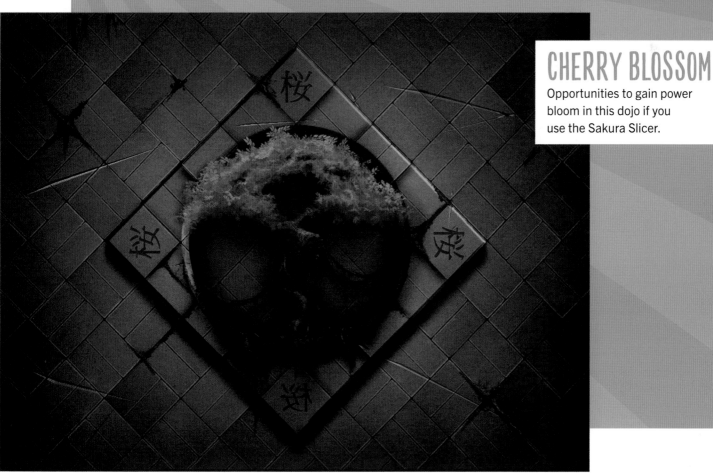

CHERRY BLOSSOM

Opportunities to gain power bloom in this dojo if you use the Sakura Slicer.

BATH HOUSE
This dojo is just like an ordinary bath house— only this bath house is covered in juicy fruit-splatter.

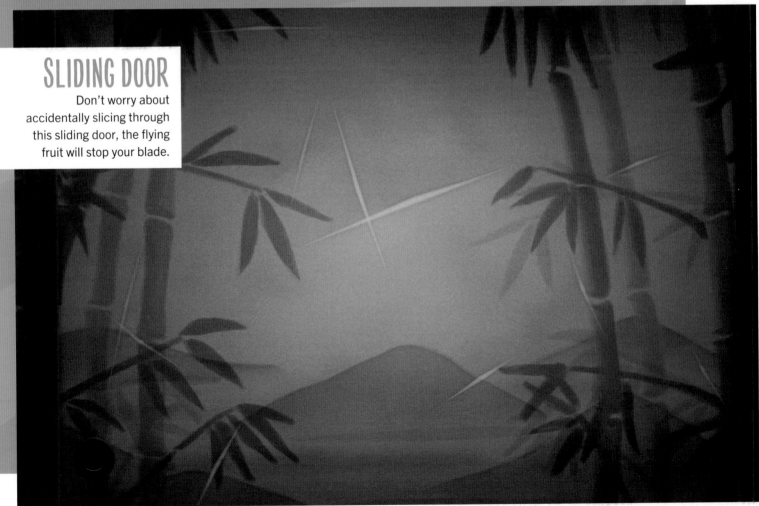

SLIDING DOOR
Don't worry about accidentally slicing through this sliding door, the flying fruit will stop your blade.

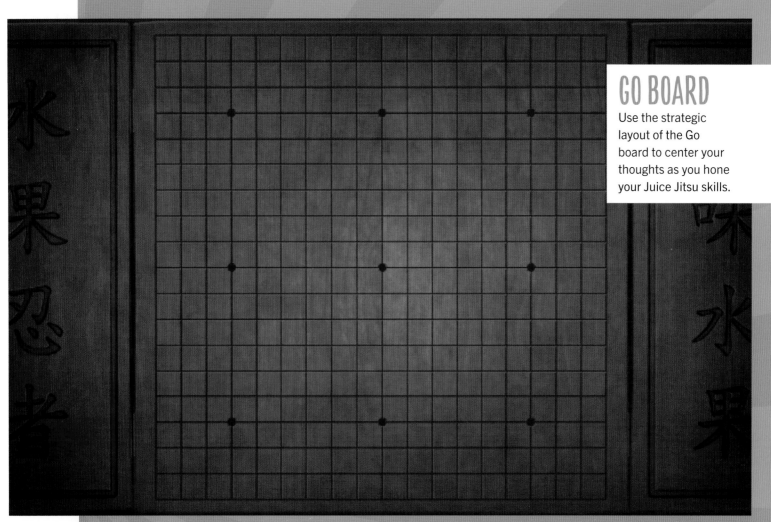

GO BOARD
Use the strategic layout of the Go board to center your thoughts as you hone your Juice Jitsu skills.

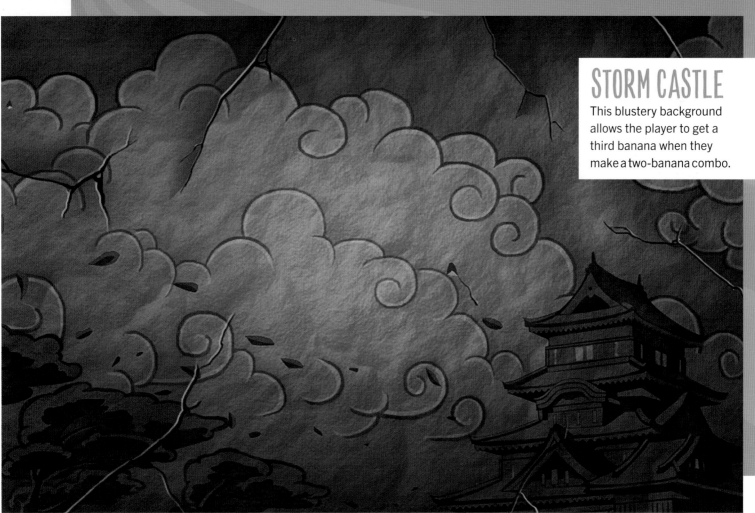

STORM CASTLE
This blustery background allows the player to get a third banana when they make a two-banana combo.

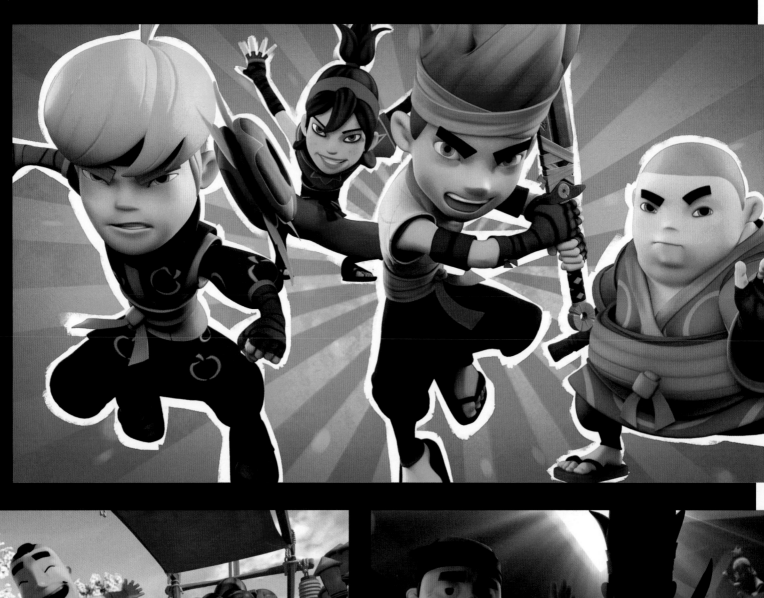

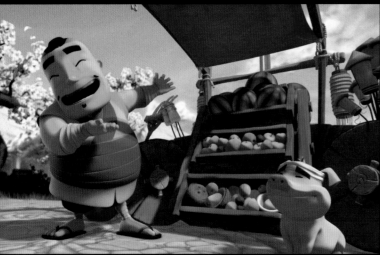

ABOVE: The spunky characters of the *Fruit Ninja: Origins* webisodes, released in September 2014 (top). Gutsu and Truffles showing off their wares (bottom left). Sensei training the youngsters (bottom right). OPPOSITE PAGE: Mari (top left) and Katsuro (top right). Nobu in the bamboo forest of Fruitasia (middle). Han (bottom left) and Truffles the pig (bottom right).

FRUIT NINJA: ORIGINS

Fruit Ninja: Origins is a five-episode series by Halfbrick. Released in the Fall of 2014 as part of a major *Fruit Ninja* overhaul, the short webisodes took players inside the dojo and introduced several characters, as well as the land of Fruitasia.

One thousand years ago in Fruitasia, there was a cliffside dojo high atop a mountain. There, the eccentric Sensei trained his students, Katsuro, Mari, Han, and Nobu, in the ancient art of Juice Jitsu. Merchant Gutsu and his best friend Truffles the pig also visit the dojo during the series, selling a few fireworks to the wise master. The series ends with the arrival of a mysterious villain, whose face is not revealed.

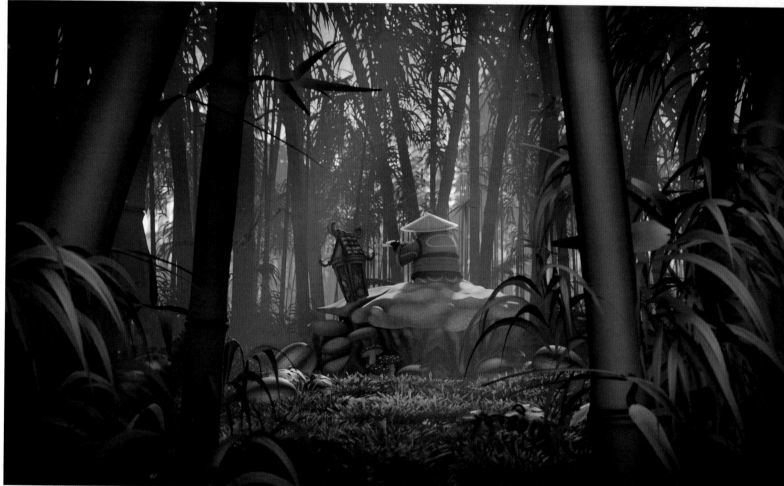

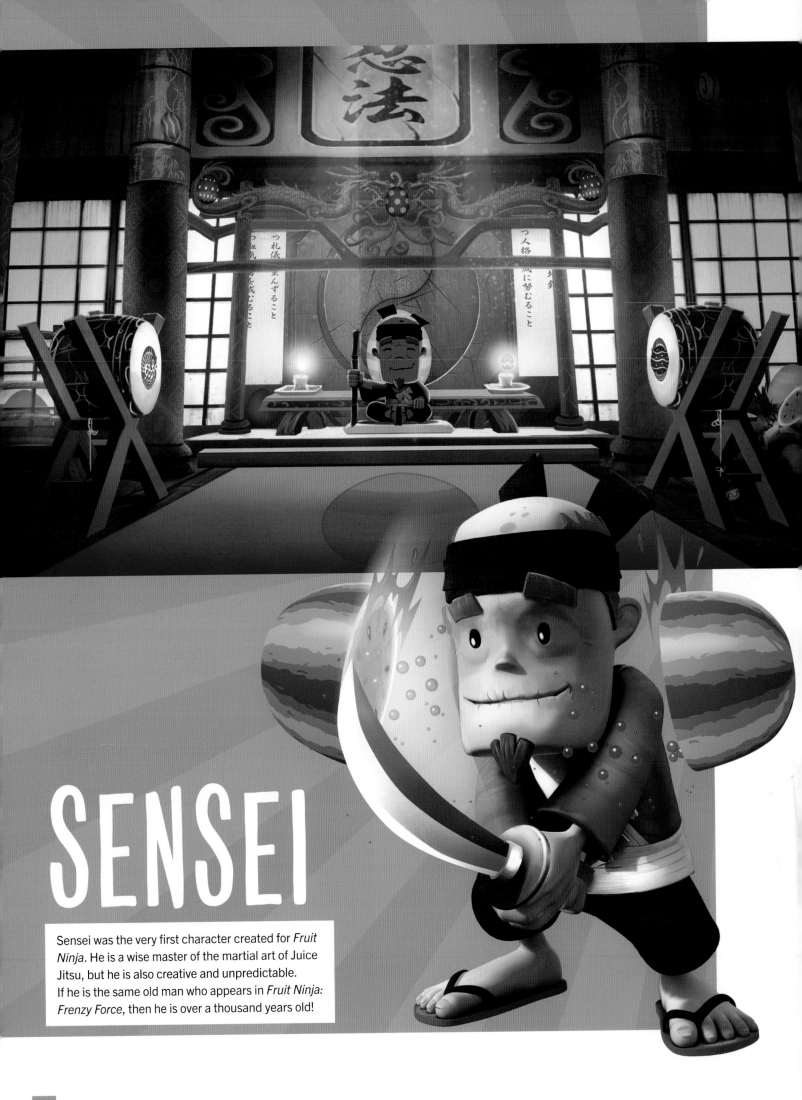

SENSEI

Sensei was the very first character created for *Fruit Ninja*. He is a wise master of the martial art of Juice Jitsu, but he is also creative and unpredictable. If he is the same old man who appears in *Fruit Ninja: Frenzy Force*, then he is over a thousand years old!

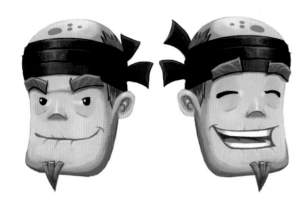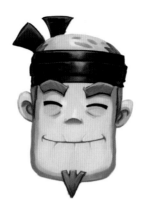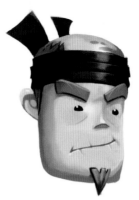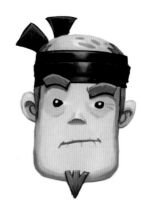

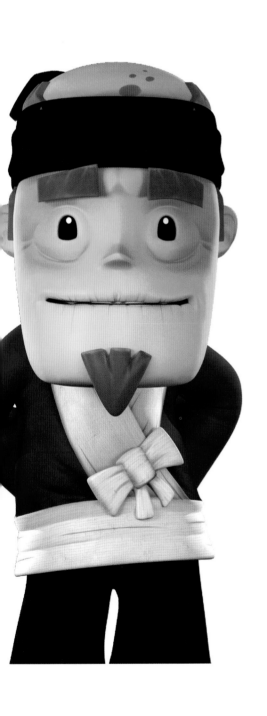

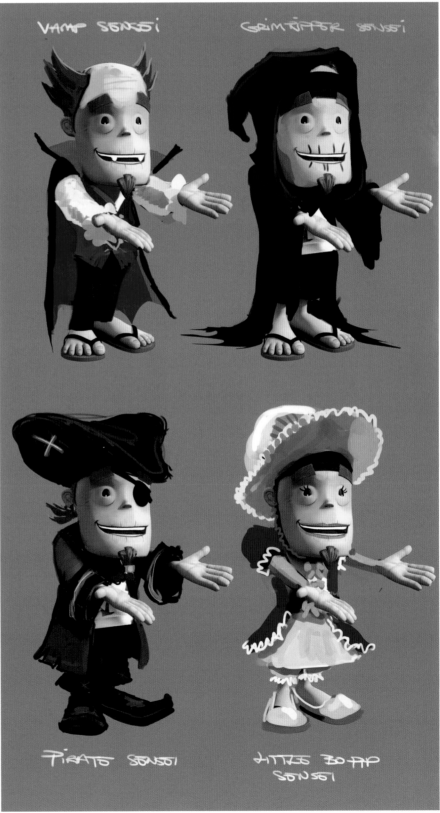

VAMP SENSEI

GRIM RIPPER SENSEI

PIRATE SENSEI

LITTLE BO PIP SENSEI

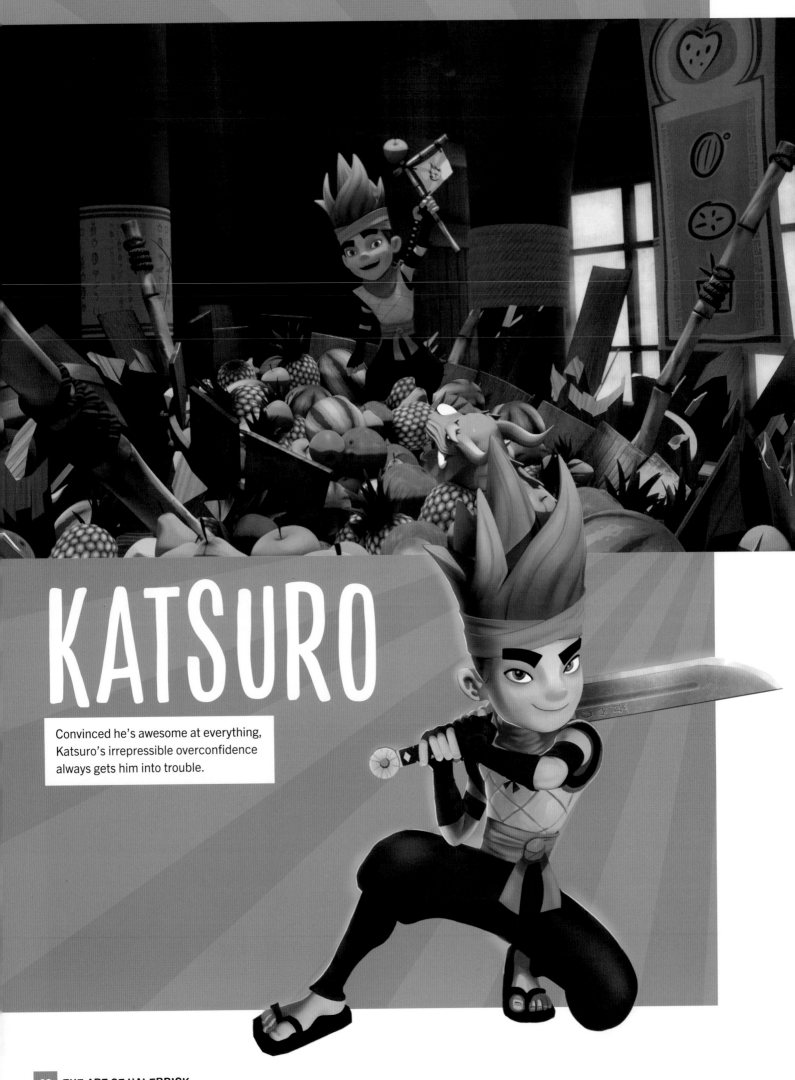

KATSURO

Convinced he's awesome at everything, Katsuro's irrepressible overconfidence always gets him into trouble.

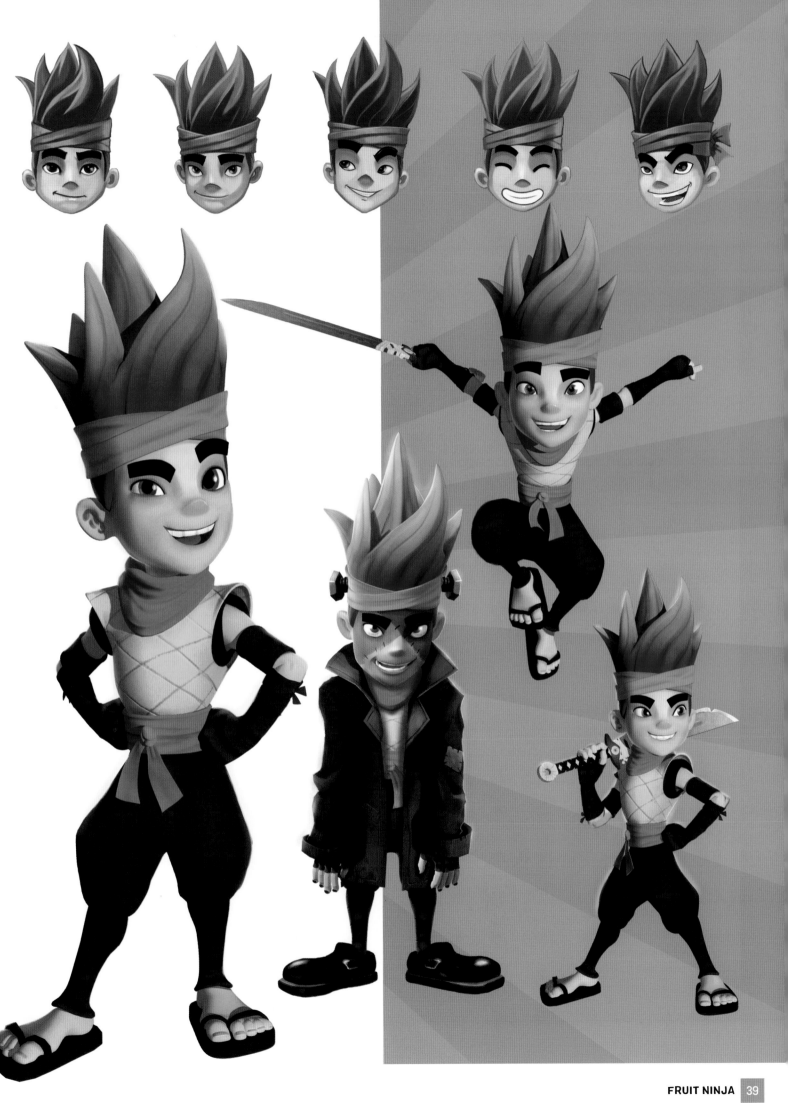

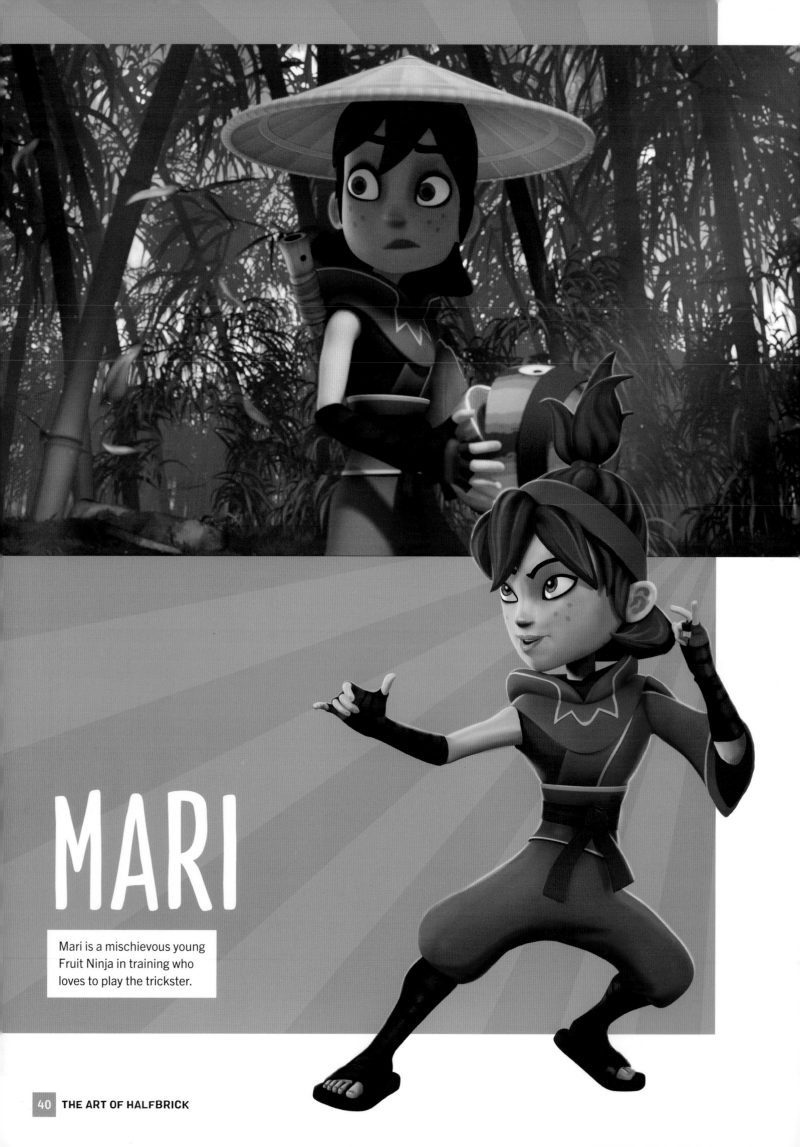

MARI

Mari is a mischievous young Fruit Ninja in training who loves to play the trickster.

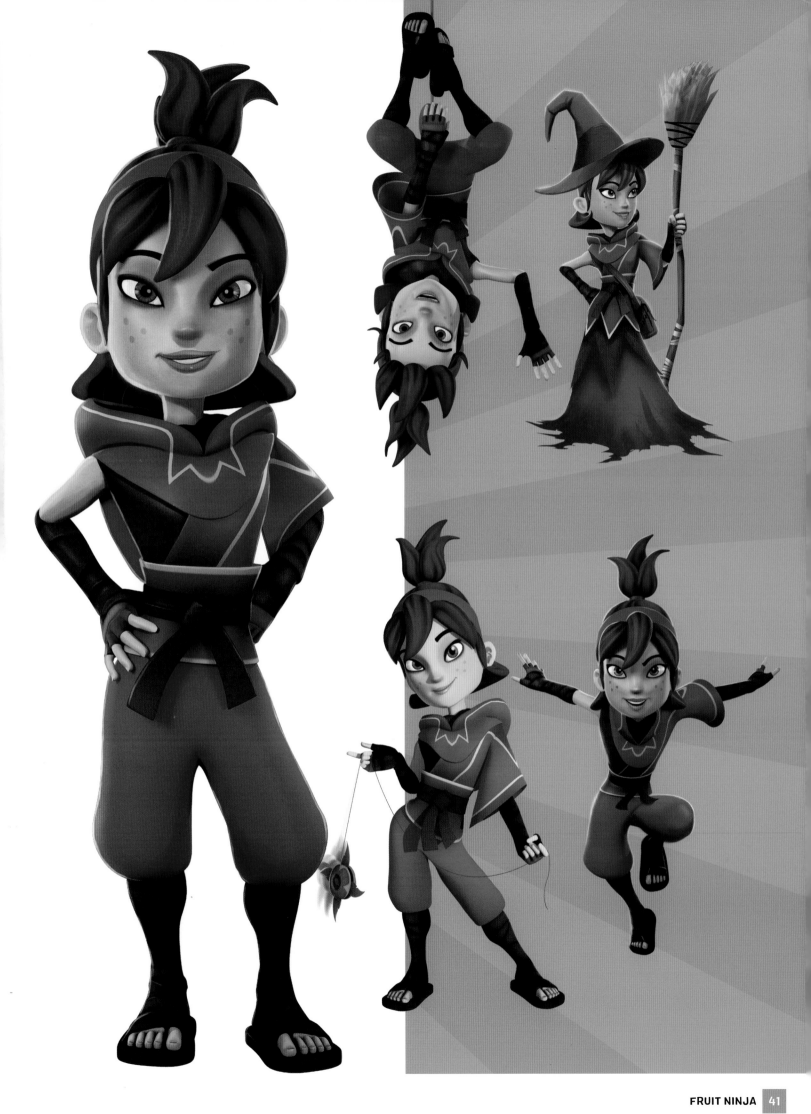

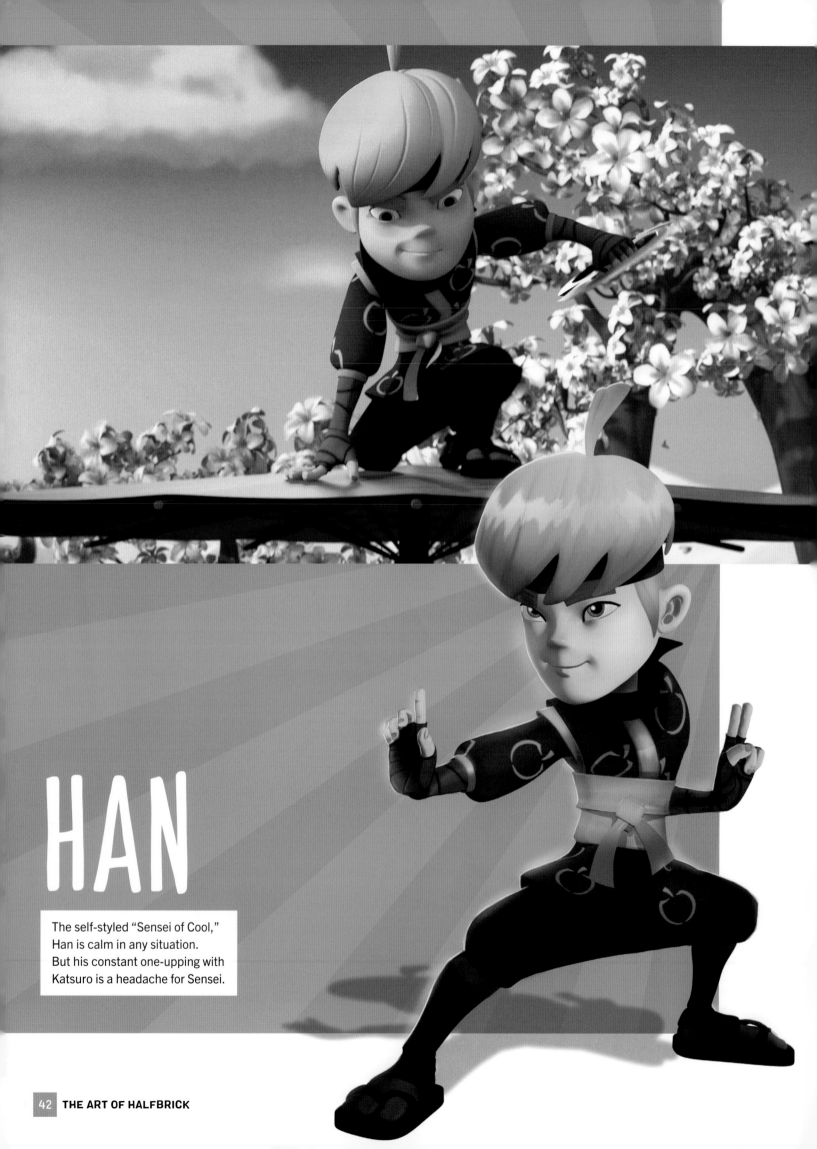

HAN

The self-styled "Sensei of Cool," Han is calm in any situation. But his constant one-upping with Katsuro is a headache for Sensei.

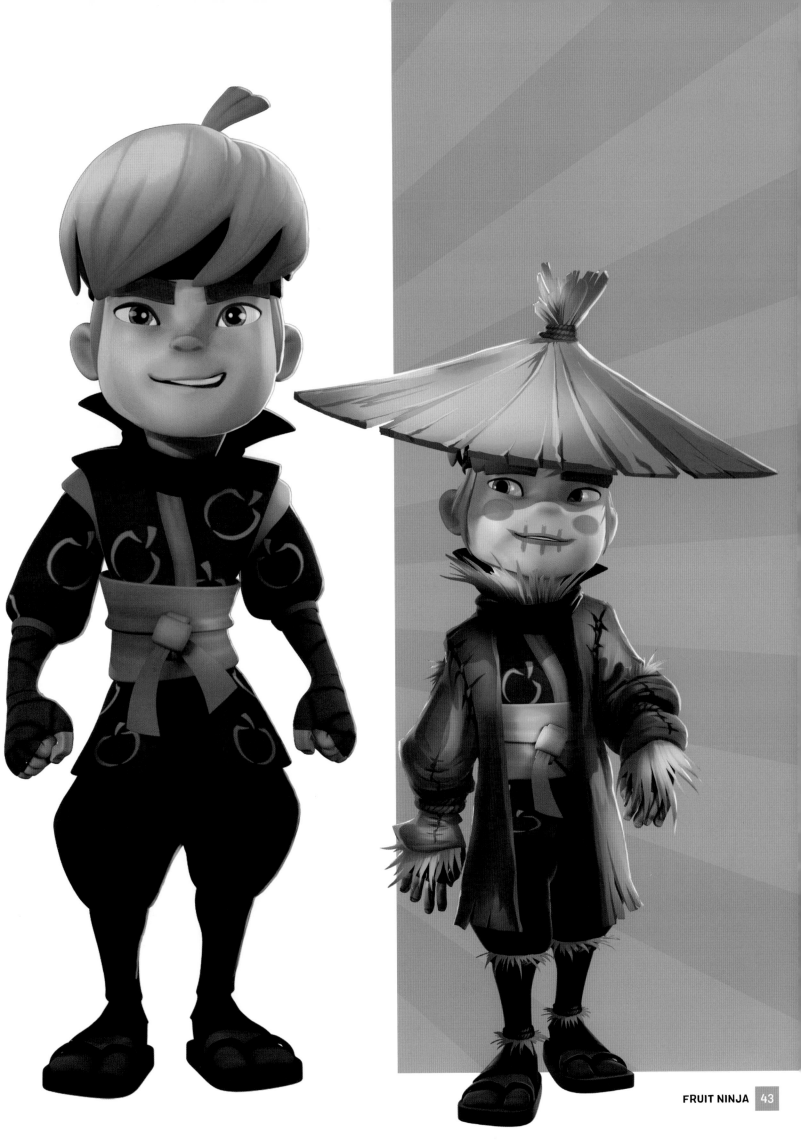

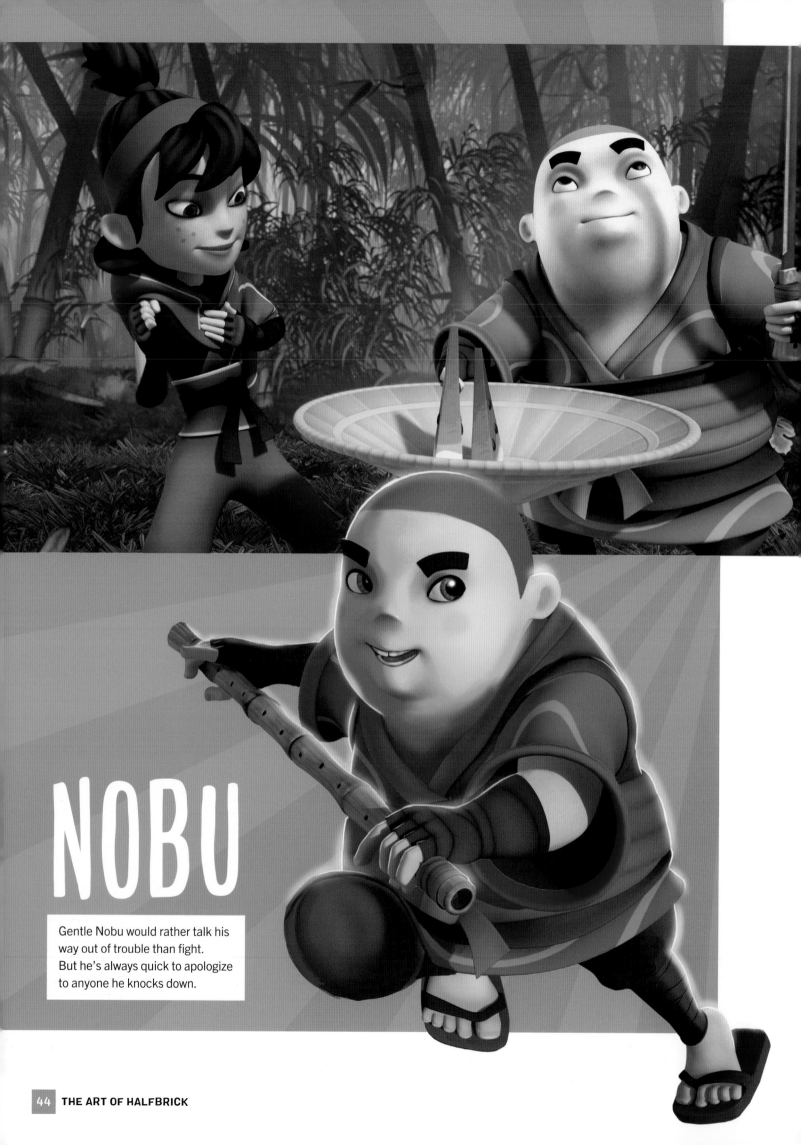

NOBU

Gentle Nobu would rather talk his way out of trouble than fight. But he's always quick to apologize to anyone he knocks down.

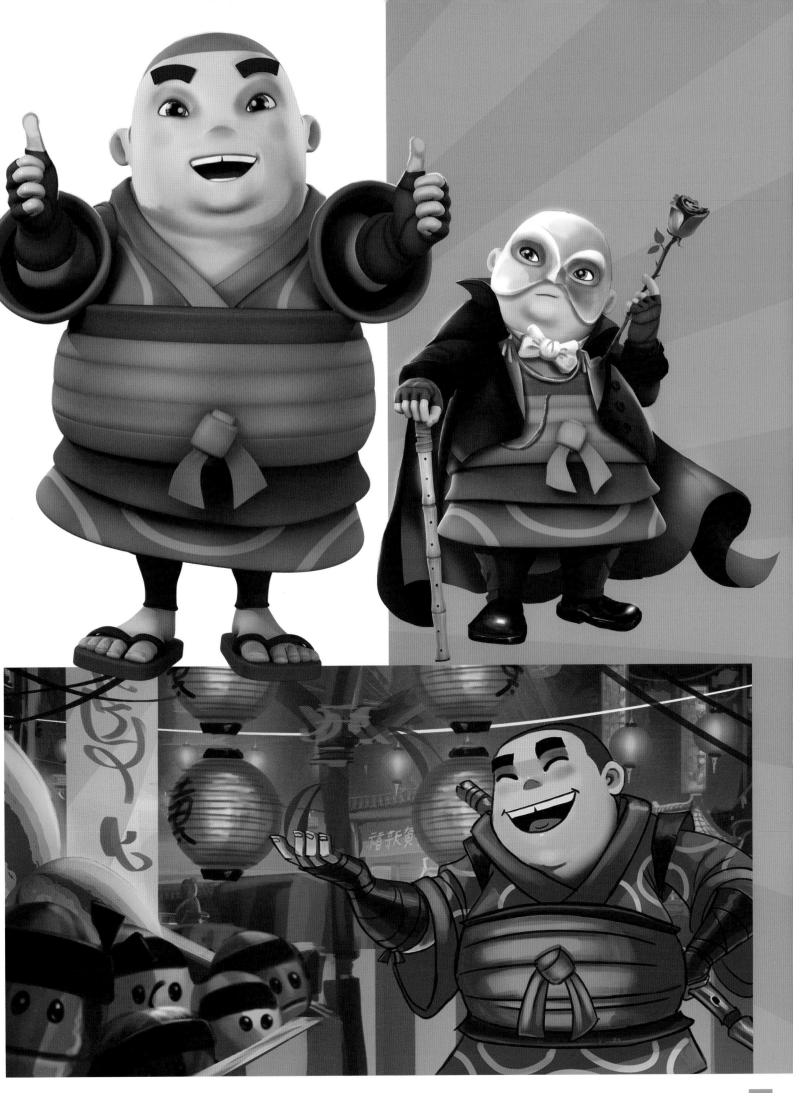

TRUFFLES

Truffles is a very smart pig and Gutsu's best friend. He joins Gutsu in his travels from village to village in Fruitasia.

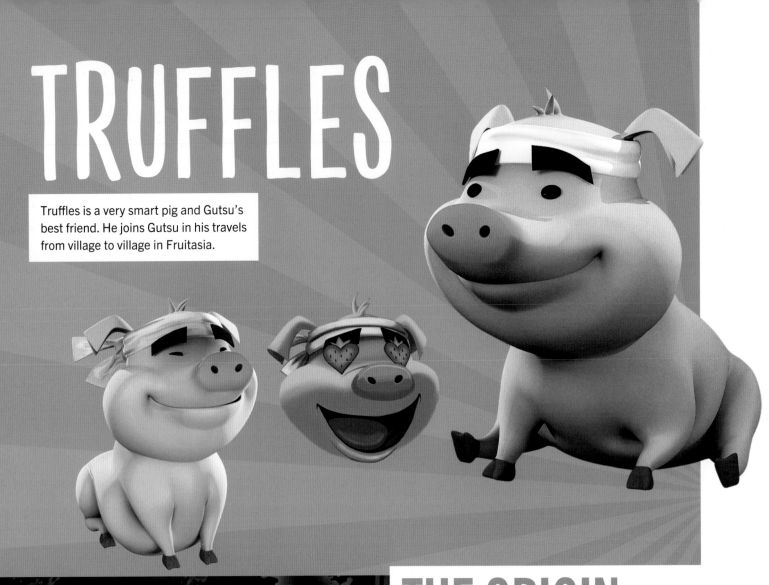

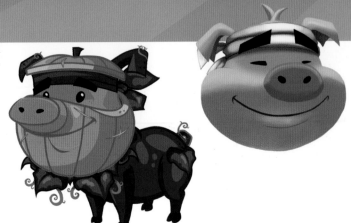

THE ORIGIN OF TRUFFLES

Rod Wong is the creator of Truffles, Gutsu's trusty side-pig.

"Gutsu was originally designed as a shop-front merchant type character for the game. I was tasked with coming up with a sidekick for Gutsu when I first started at Halfbrick, and my aim was to design something cute and adorable for the fans of the game.

"I'm not sure what led me down the path of drawing a pig, but Truffles' design came together pretty quickly and was given the greenlight to be put into the game and the Origins series. The idea was to have a small pig pulling a giant cart for comedic value, but his character has grown since then, from his love of strawberries to wanting to be a Fruit Ninja. In a way, he's a mascot for the game as he's such a cute and loveable character.

"The hardest part was coming up with a name for him. He initially was called Char Sui, which in Chinese means 'BBQ pork.'"

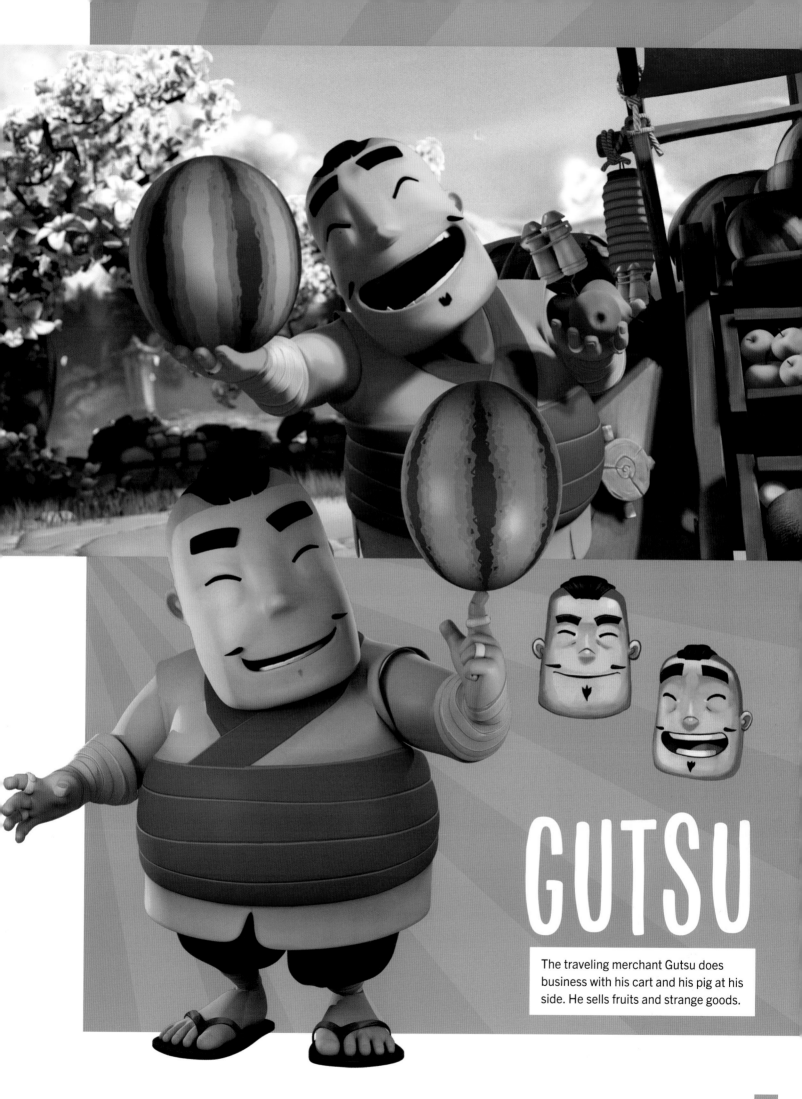

GUTSU

The traveling merchant Gutsu does business with his cart and his pig at his side. He sells fruits and strange goods.

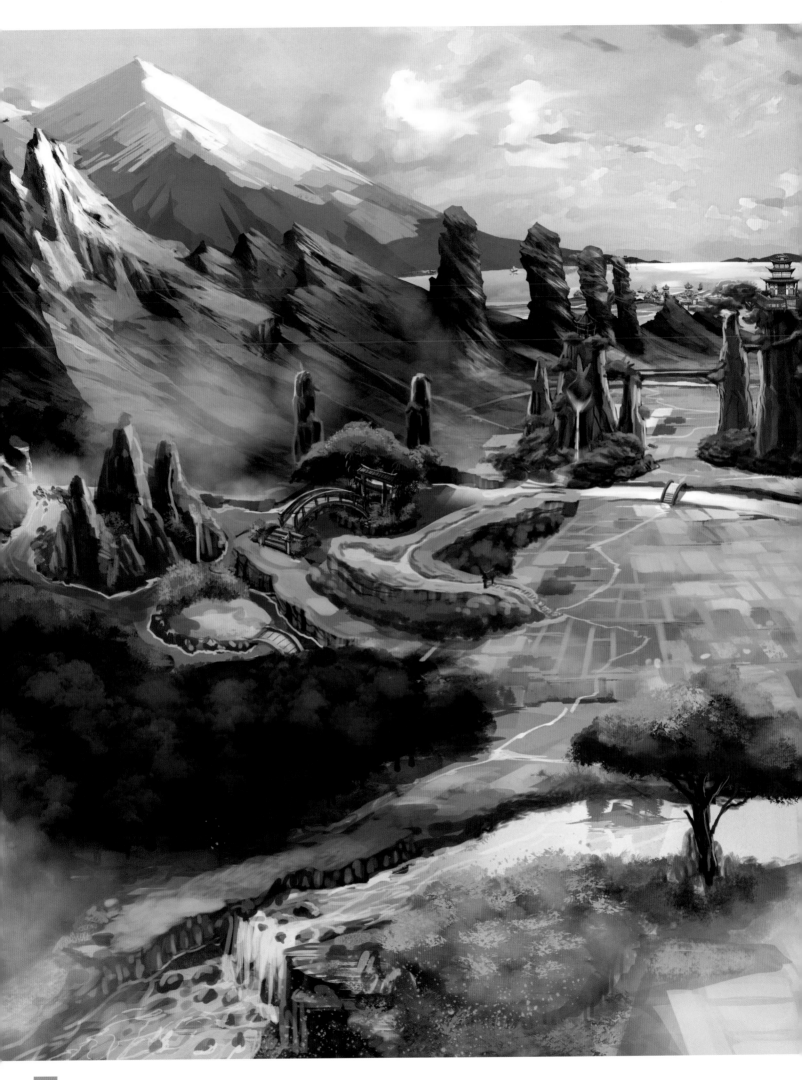

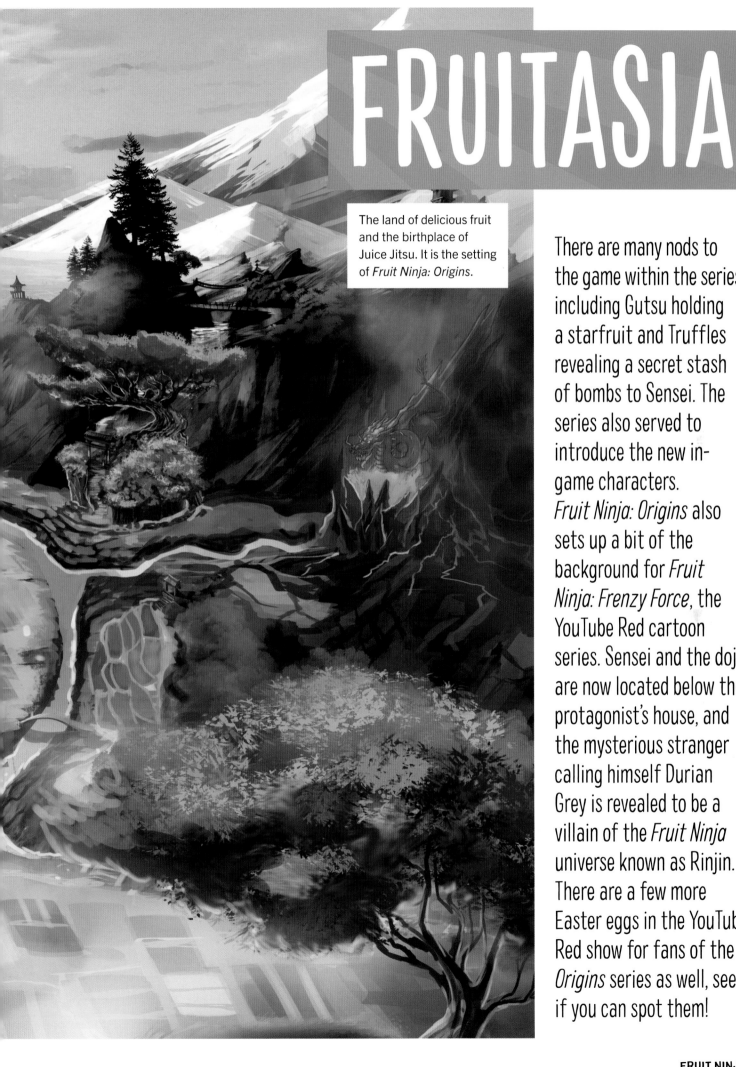

FRUITASIA

The land of delicious fruit and the birthplace of Juice Jitsu. It is the setting of *Fruit Ninja: Origins*.

There are many nods to the game within the series, including Gutsu holding a starfruit and Truffles revealing a secret stash of bombs to Sensei. The series also served to introduce the new in-game characters. *Fruit Ninja: Origins* also sets up a bit of the background for *Fruit Ninja: Frenzy Force*, the YouTube Red cartoon series. Sensei and the dojo are now located below the protagonist's house, and the mysterious stranger calling himself Durian Grey is revealed to be a villain of the *Fruit Ninja* universe known as Rinjin. There are a few more Easter eggs in the YouTube Red show for fans of the *Origins* series as well, see if you can spot them!

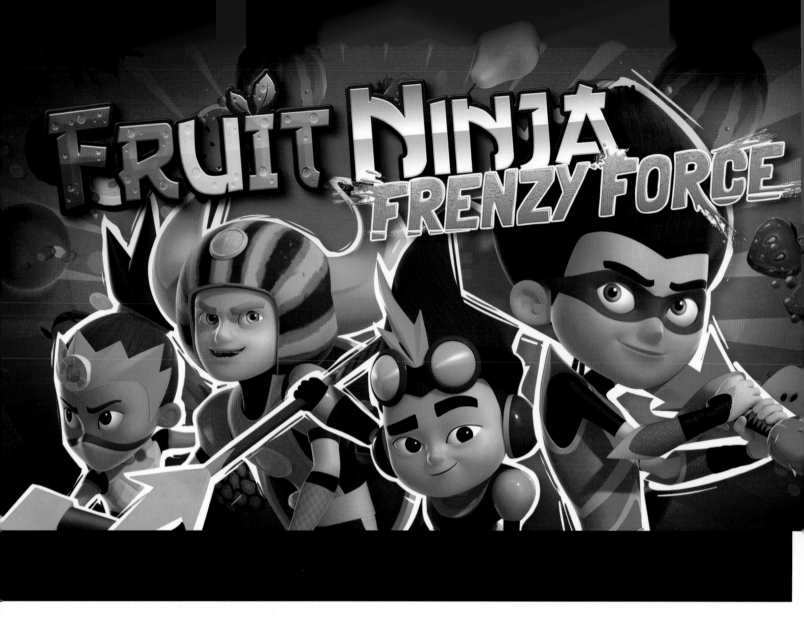

FRUIT NINJA FRENZY FORCE

FRUIT NINJA: FRENZY FORCE

ABOVE: The fruit-fighting crew of the *Fruit Ninja: Frenzy Force* animated series from May 2017.

Released in May of 2017, *Fruit Ninja: Frenzy Force* is an exclusive YouTube Red CGI animated series that follows the adventures of Seb, Niya, Peng, and Ralph as they train to master the ancient art of Juice Jitsu. Along the way, they meet a ton of interesting characters: an old master whose guidance isn't quite what the team is ever looking for, fearsome monsters, and even an ancient time traveler.

Set one thousand years after *Fruit Ninja: Origins*, the story begins when Seb and the gang cut into a watermelon and discover a secret message: a riddle that contains an invitation for those of exceptional fortitude, honor, and bravery. They decide to accept the invitation and set off exploring, finding fruity clues, and eventually uncovering a subterranean tunnel that leads to the remains of the ancient dojo. Luckily, they realize their new dojo is located directly beneath Seb's house. With the arrival of an ancient enemy, Durian Grey, who entered through a mystic time portal, the team puts their newly learned Juice Jitsu skills to the test against him and a variety of colorful foes.

As their journey progresses, it quickly becomes apparent that *Fruit Ninja: Frenzy Force* is no ordinary team-up action show—in this show, several tropes are turned on their heads. For example, instead of providing help, the old Sensei often just leaves the team more confused than they originally were. There are also instances of violence in the show, but instead of gory combat the audience is treated to the slicing and dicing of juicy fruit.

The driving theme of *Fruit Ninja: Frenzy Force* is that sometimes the things that make you unique, no matter how weird they are, are the things that make you strong. Seb's optimism, encouragement, and problem-solving throughout the show echoes this philosophy as he leads the team along the path of the Fruit Ninja.

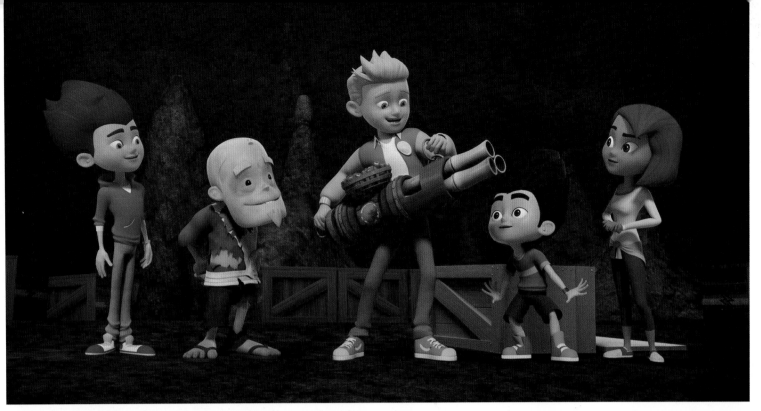

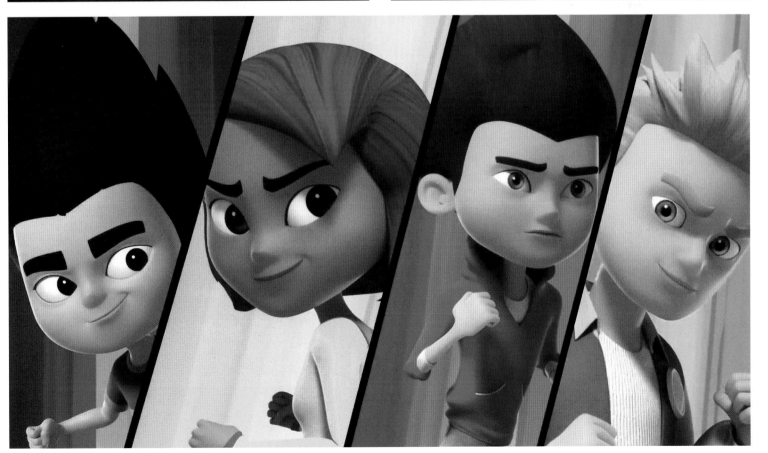

MEET THE TEAM

SEB

Seb is a brave, funny, and principled young man. Born a natural leader, he heads the new Fruit Ninja squad, guiding them from adventure to adventure.

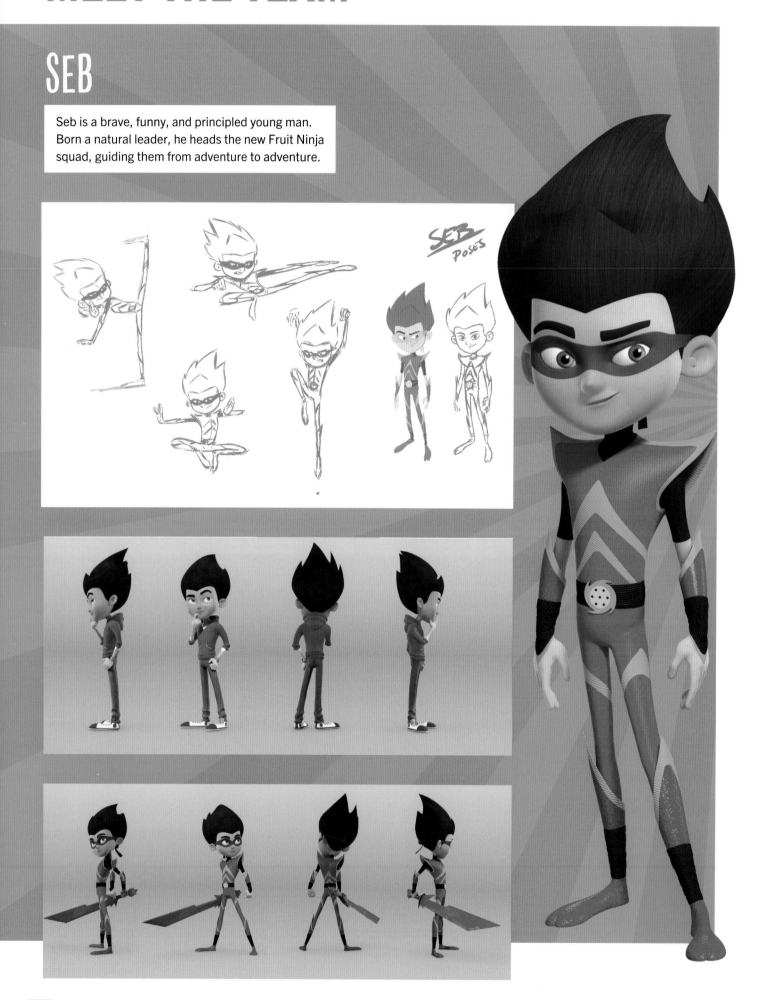

RALPH

Though he's not the smartest, Ralph is definitely the strongest and acts as the team's heavy hitter. He might not have the greatest decision-making skills, but he always tries to do what's best for the team.

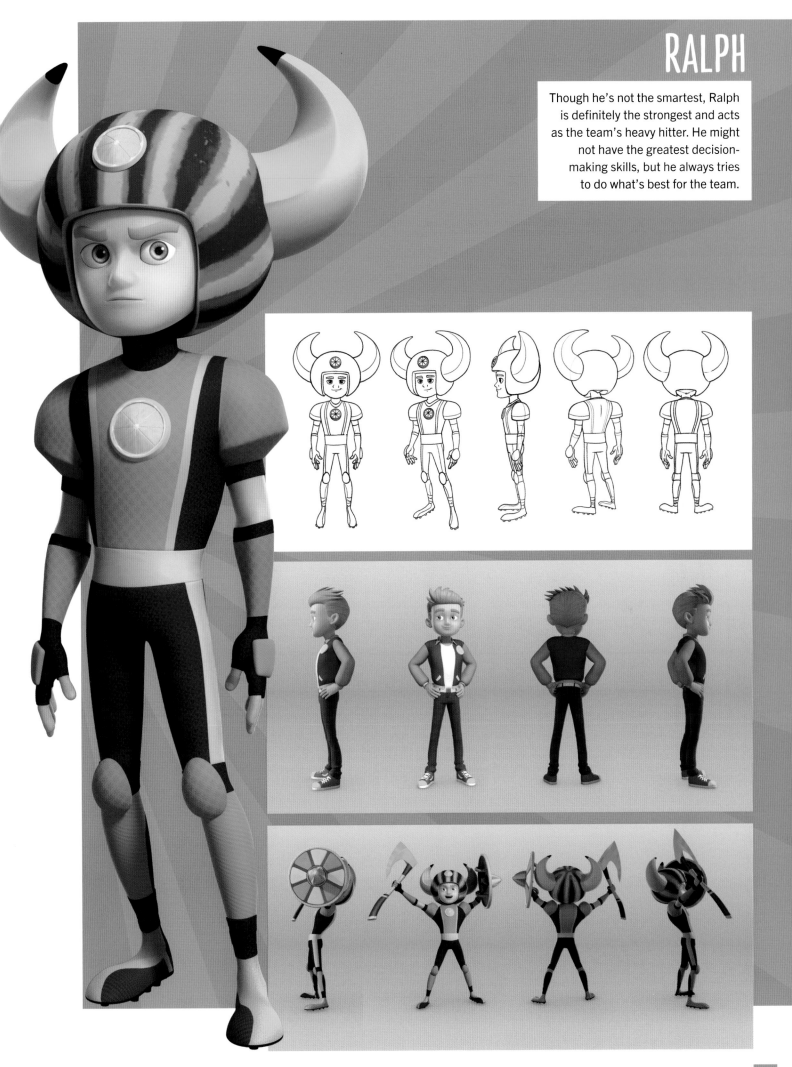

NIYA

Determined and maybe a little pushy, Niya is dedicated to becoming a master Fruit Ninja. She can be a bit of a hot-head, but her friends keep her balanced as she strives to be the best she can be!

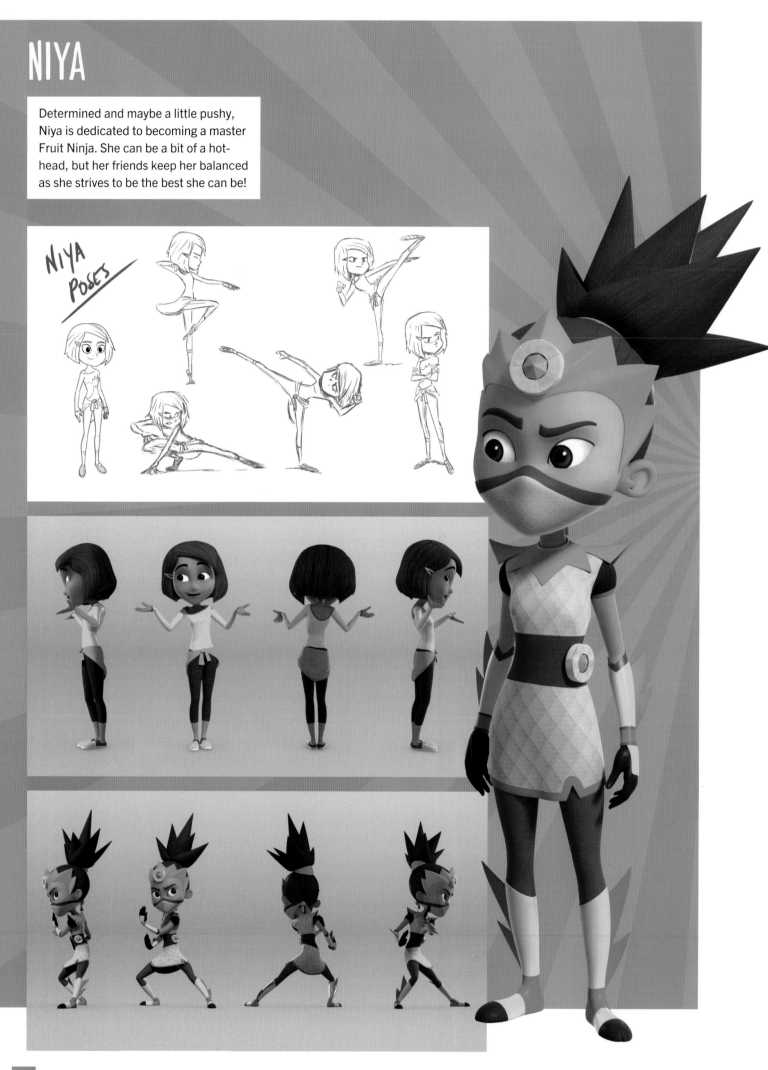

NIYA POSES

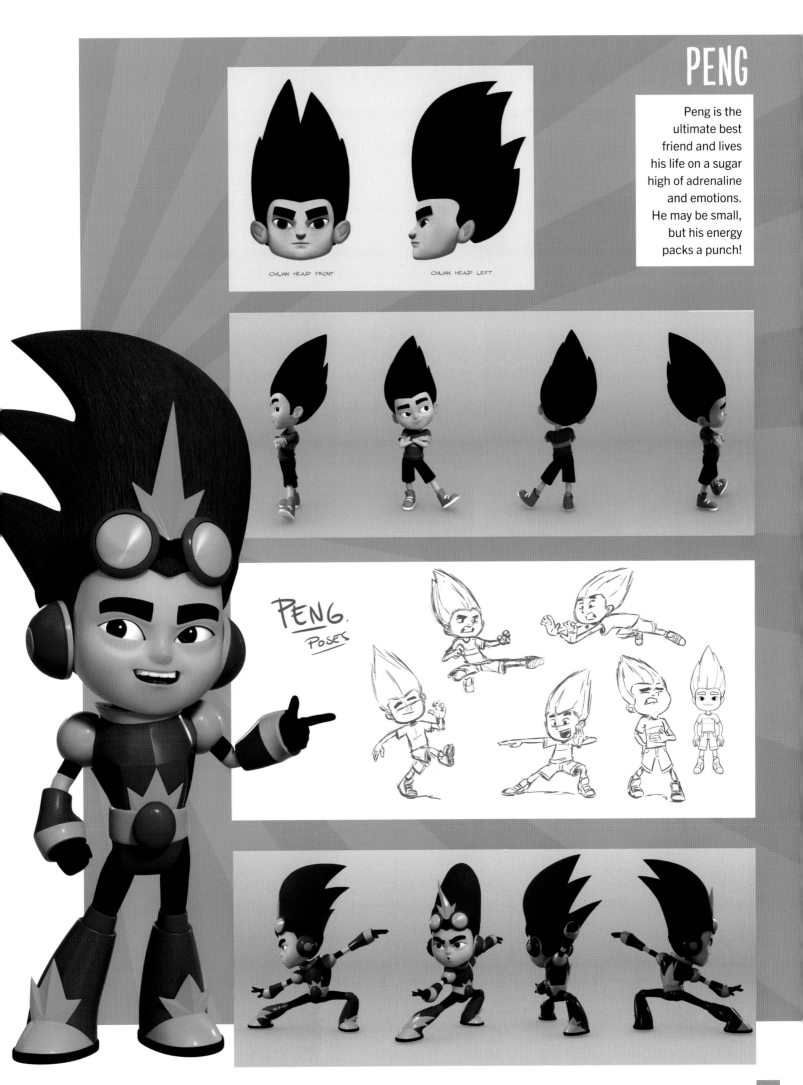

PENG

Peng is the ultimate best friend and lives his life on a sugar high of adrenaline and emotions. He may be small, but his energy packs a punch!

CIVILIAN HEAD FRONT

CIVILIAN HEAD LEFT

PENG.
POSES

THE MASTER OF JUICE JITSU

SENSEI

Not your typical ancient teacher, Sensei lives life by his own rules. He's a master of disguise who never ceases to astound his students.

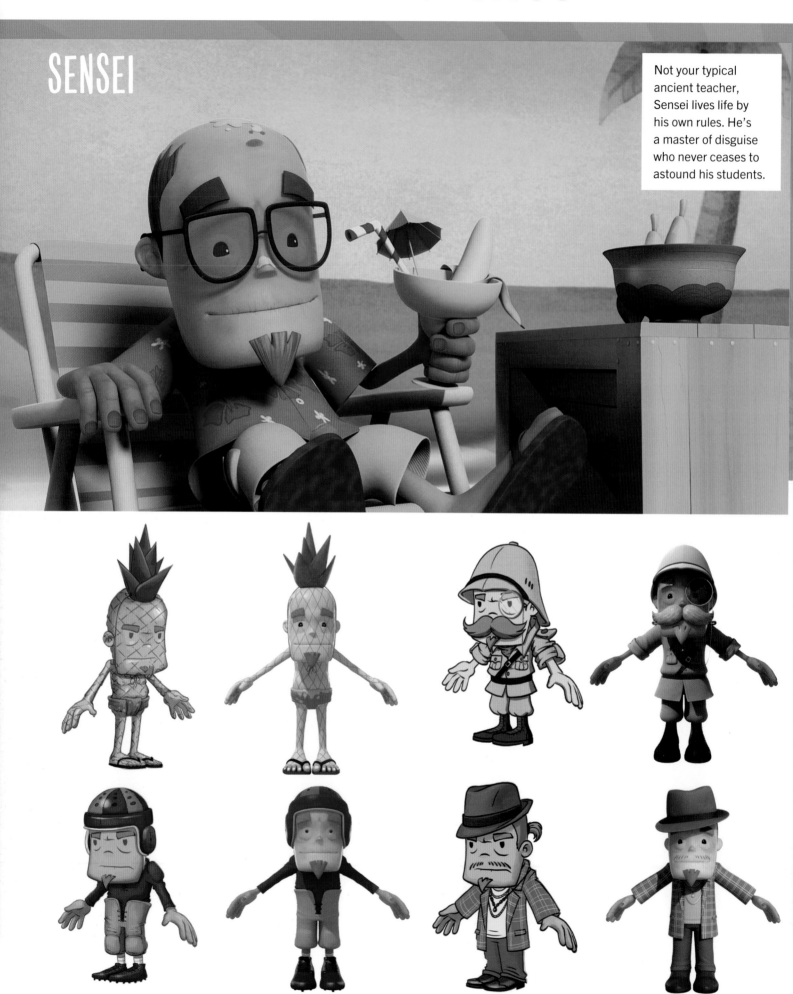

ENEMIES OF THE FRUIT NINJA

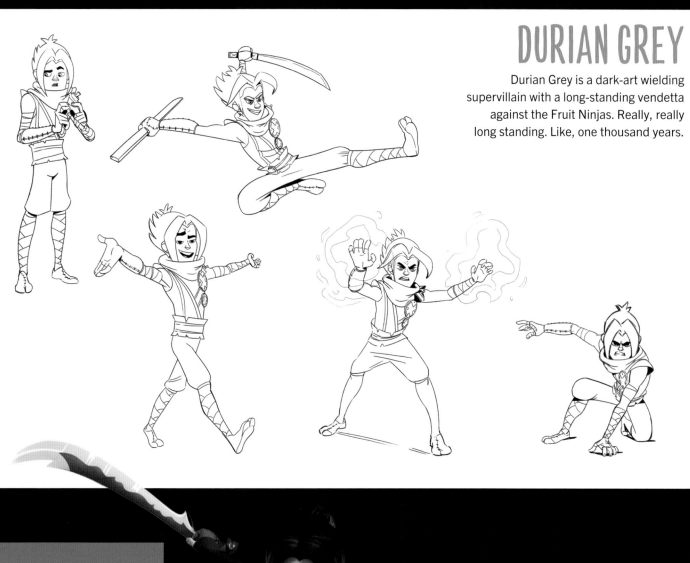

DURIAN GREY

Durian Grey is a dark-art wielding supervillain with a long-standing vendetta against the Fruit Ninjas. Really, really long standing. Like, one thousand years.

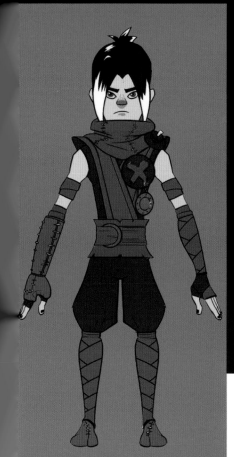

FRUIT NINJA

KRACKLEFLINT

Krackleflint is an insect-like alien ruler who plans to conquer Earth with his electrifying burps and massive ego. When he's not watching table tennis, he's wreaking havoc on the human race.

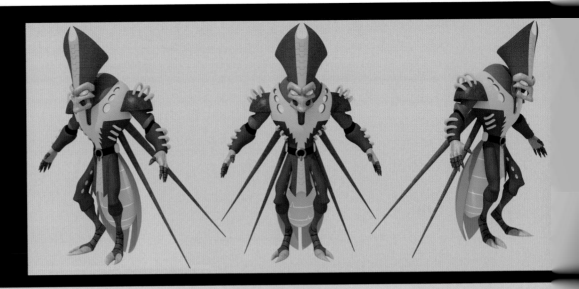

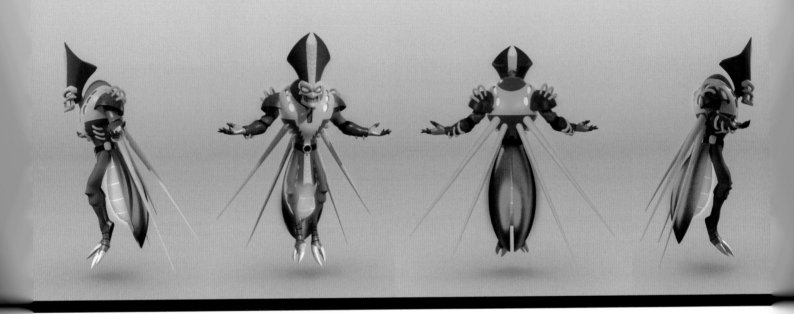

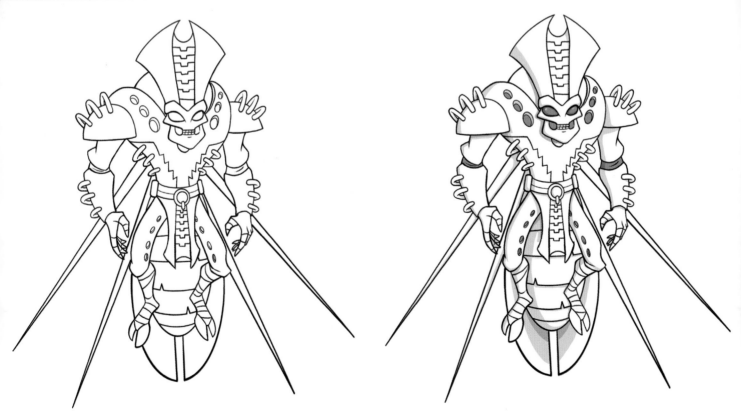

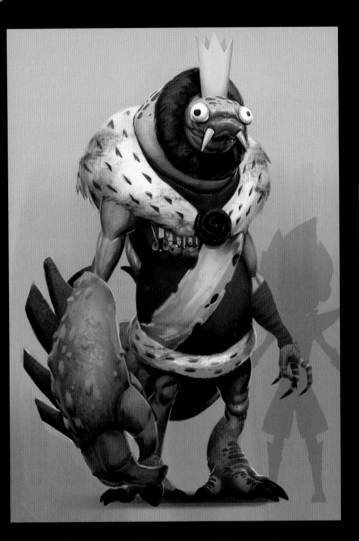

KING SCUMWORM

King Scumworm is the vile, giant ruler of the Scumworms— little mind control bugs that hide in rotten fruit. He's got super strength and he's super gross!

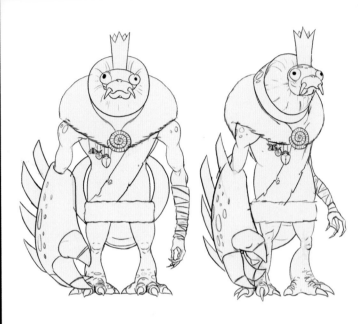

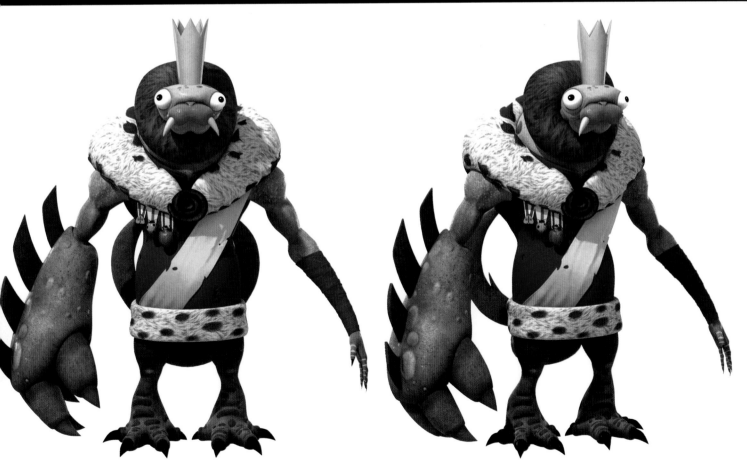

MARK SAMURAI

Mark Samurai is a bumbling burger joint manager who is unaware that he is a descendent of the Deep Fried Samurai.

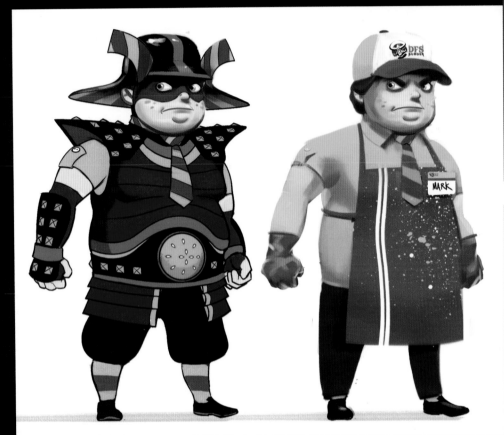

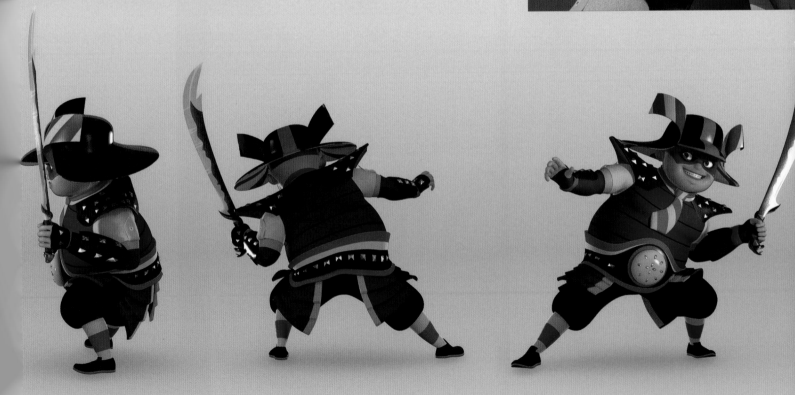

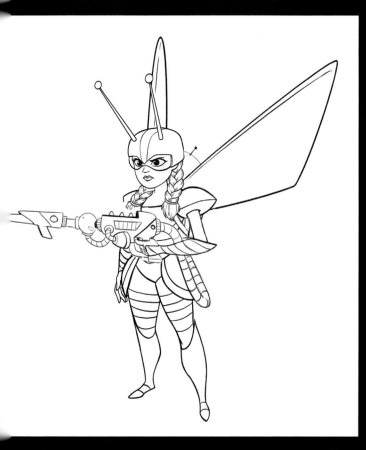

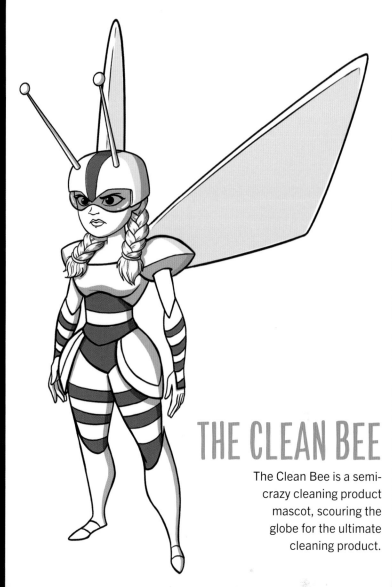

THE CLEAN BEE

The Clean Bee is a semi-crazy cleaning product mascot, scouring the globe for the ultimate cleaning product.

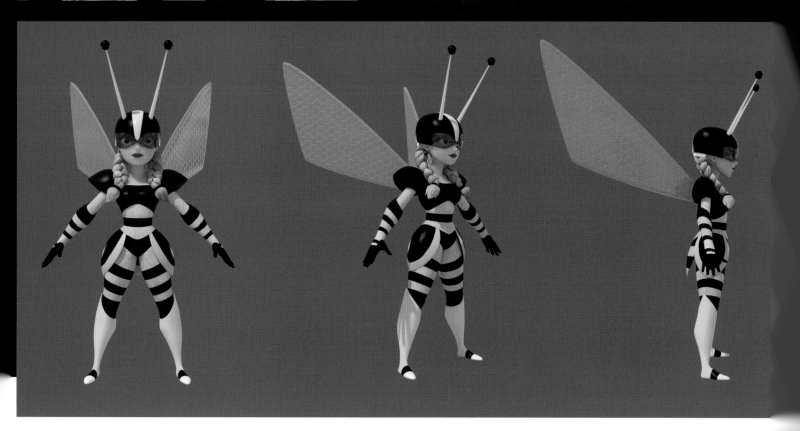

VERY IMPORTANT PLACES

PEELVILLE

Peelville is a place where anything goes. It's a mixed urban neighborhood in Anytown, USA, part small city and part suburbs, where surprises exist around every corner.

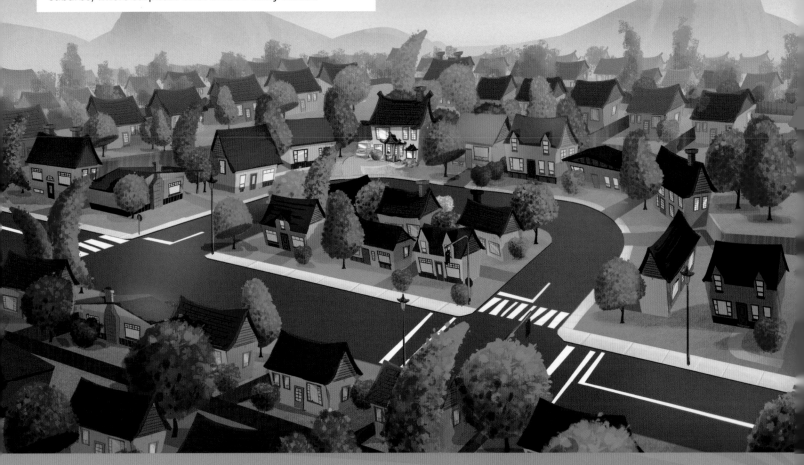

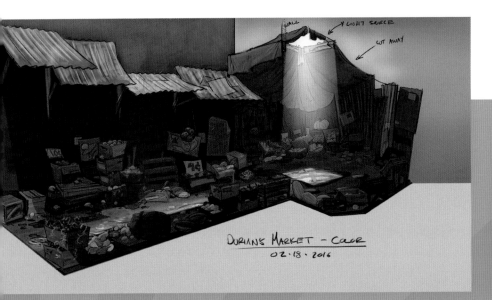

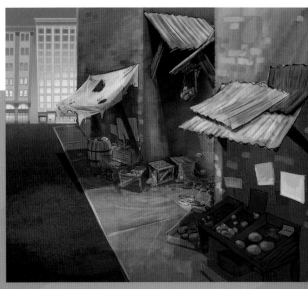

DURIAN'S MARKET - COLOR
02·18·2016

DFS BURGER- KITCHEN
- 4 DOOR ADDED
04·07·16

FREEZERS

FRUIT FRENZY JUICE STAND

The "Fruit Frenzy" juice stand is the pivotal location of the show. It's the team's "home base" and also rests directly over the passageway to the dojo. Despite not being the best small-business owners, the stand appears fairly popular.

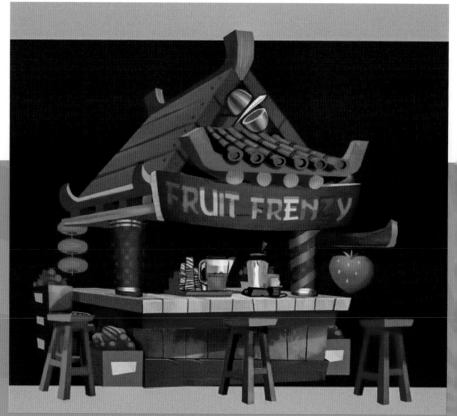

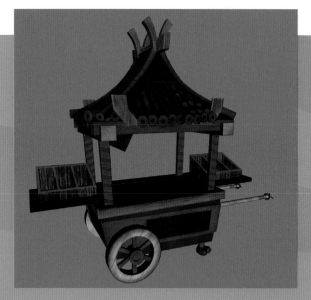

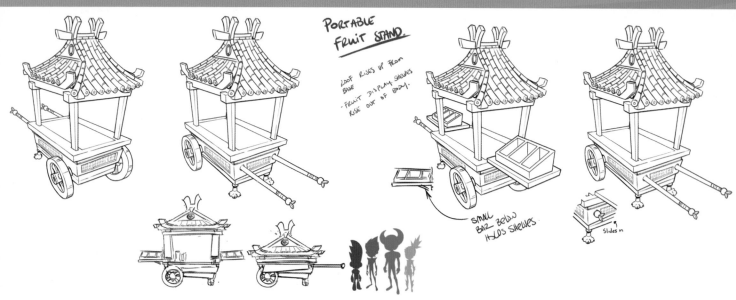

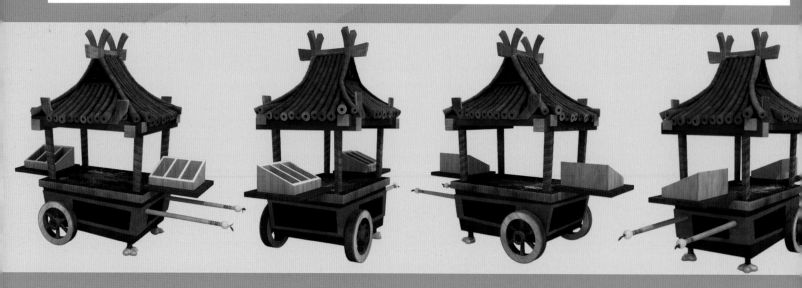

THE DOJO

The original dojo from the *Fruit Ninja* game is now hidden beneath Seb's home and acts as a sanctuary, fruit weapon dispensary, and training ground all at once.

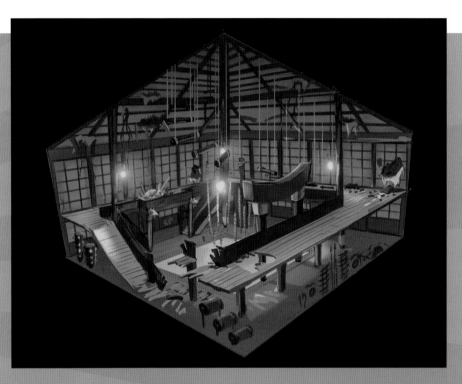

BY THE BLADE

A Fruit Ninja is only as good as their trusty weapon: the blade! Many different blades are unlockable in the game, and each one has its own unique properties.

ORIGINAL BLADE

The starting blade for any practitioner of Juice Jitsu.

BAMBOO SHOOT

Bamboo is one of the fastest growing plants in the world, which might explain this blade's mystical properties. The blade is said to be made in the forest where Sensei spent his childhood.

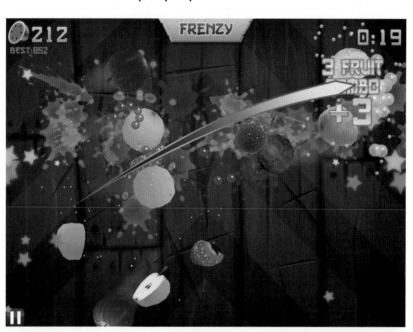

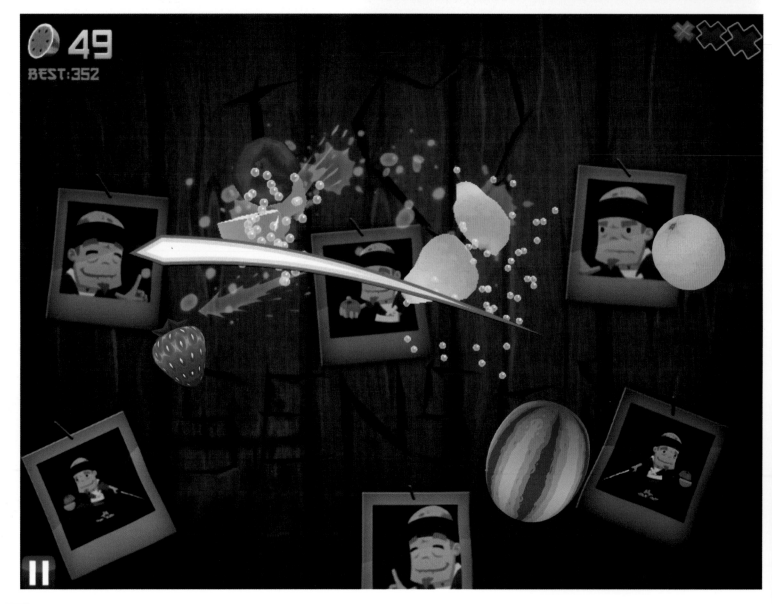

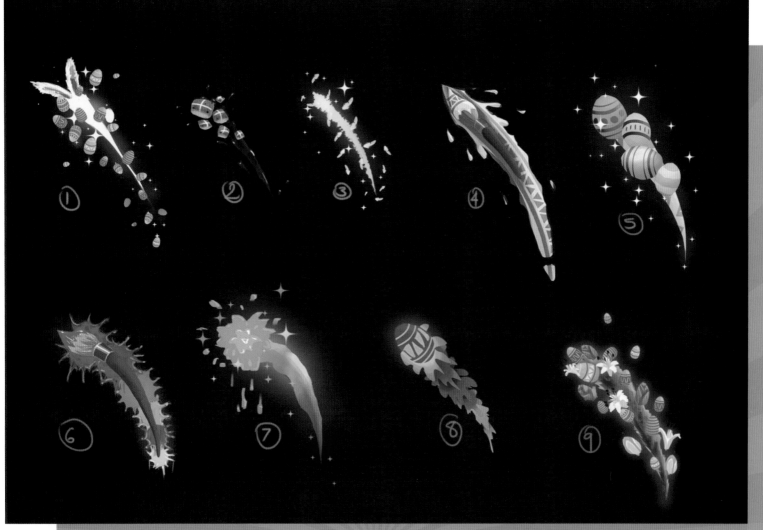

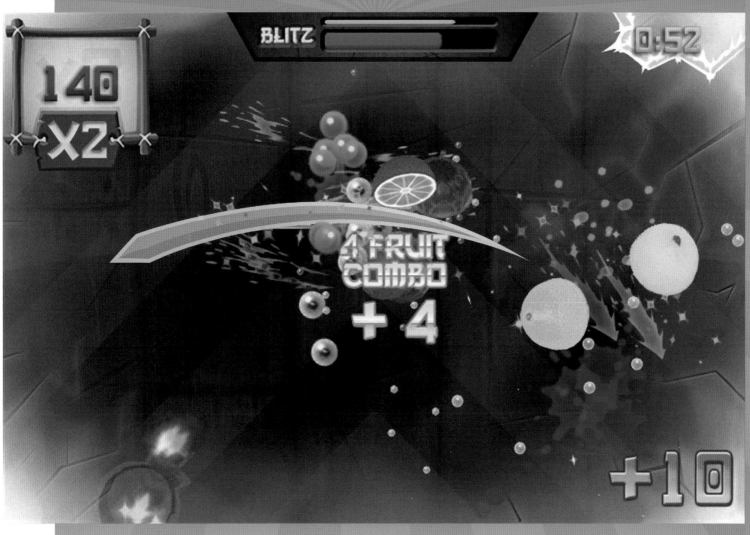

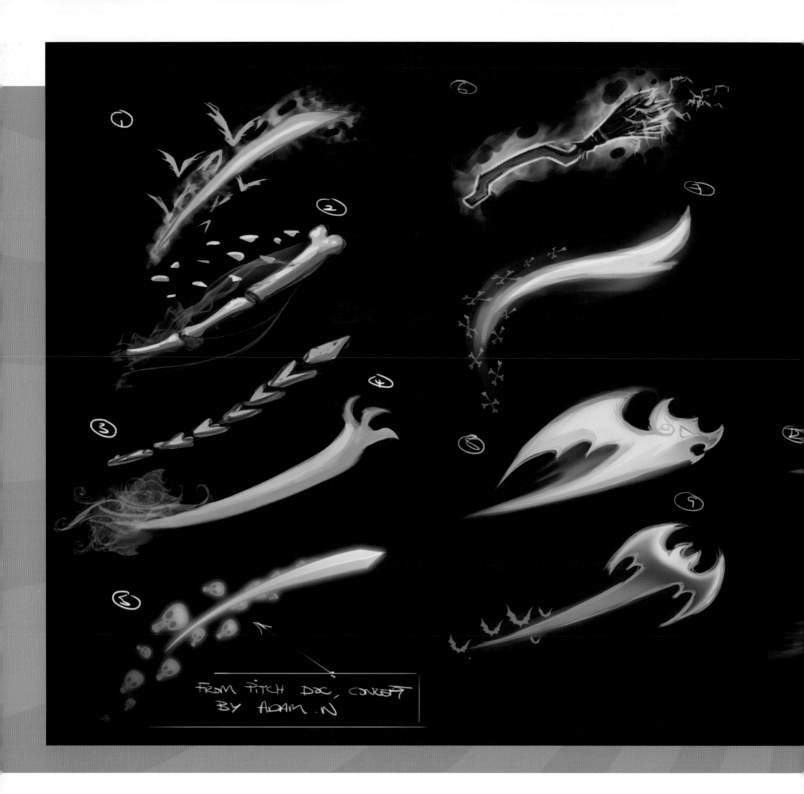

FROM PITCH DOC, CONCEPT BY ADAM .N

BUTTERFLY KNIFE

Much prettier than a normal knife, but uglier than your average butterfly.

DISCO BLADE

The funkiest blade in town.

FAIRY PRINCESS/ PRINCESS BLADE

Any fairy or princess—or fairy princess—would be proud to slice with this pink blade.

FLAME BLADE

If you don't mind attracting a few more bombs, this blade is perfect for the fiery tempered.

ICE BLADE

A very cool weapon that's always nICE to see.

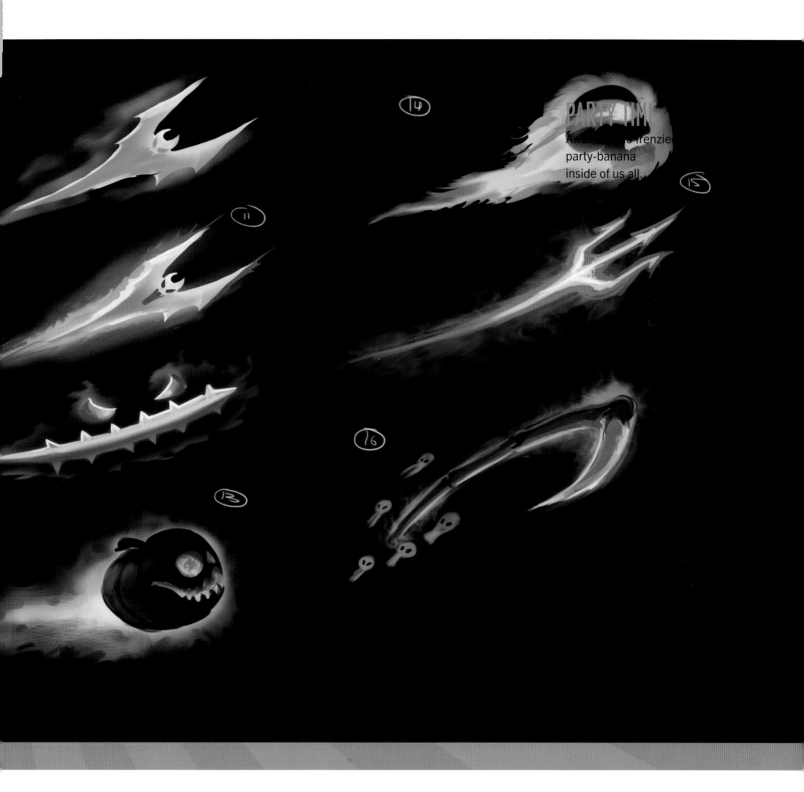

MR. SPARKLE

As the name suggests, this blade is very shiny.

PARTY TIME

Awakens the frenzied party-banana inside of us all.

PIANO BLADE

A perfect blade for musical-minded Juice Jitsu practitioners.

PIXEL LOVE

Pilgrims probably hate this blade but will battle with it to save their girlfriends.

ROCK BLADE/ ROCK SOLID

Rock out with this blade for the brave and the boulder.

SHINY RED

This blade is exactly what it claims to be: shiny and red.

SAKURA SLICER

Sakura is the Japanese word for cherry blossoms, which explains why cherries seem attracted to this blade.

THE FIRECRACKER

This one goes off with a bang. It also slices fruit.

THE SHADOW

Forged in darkness, devoid of all that is good. This blade is steeped in mystery.

OLD GLORY

Declare your independence from speed with this blade that slows down special fruit.

FRUITY GOODNESS

What other game makes you crave mother nature's tastiest treats like *Fruit Ninja*? Behold: the true stars of the fruit show.

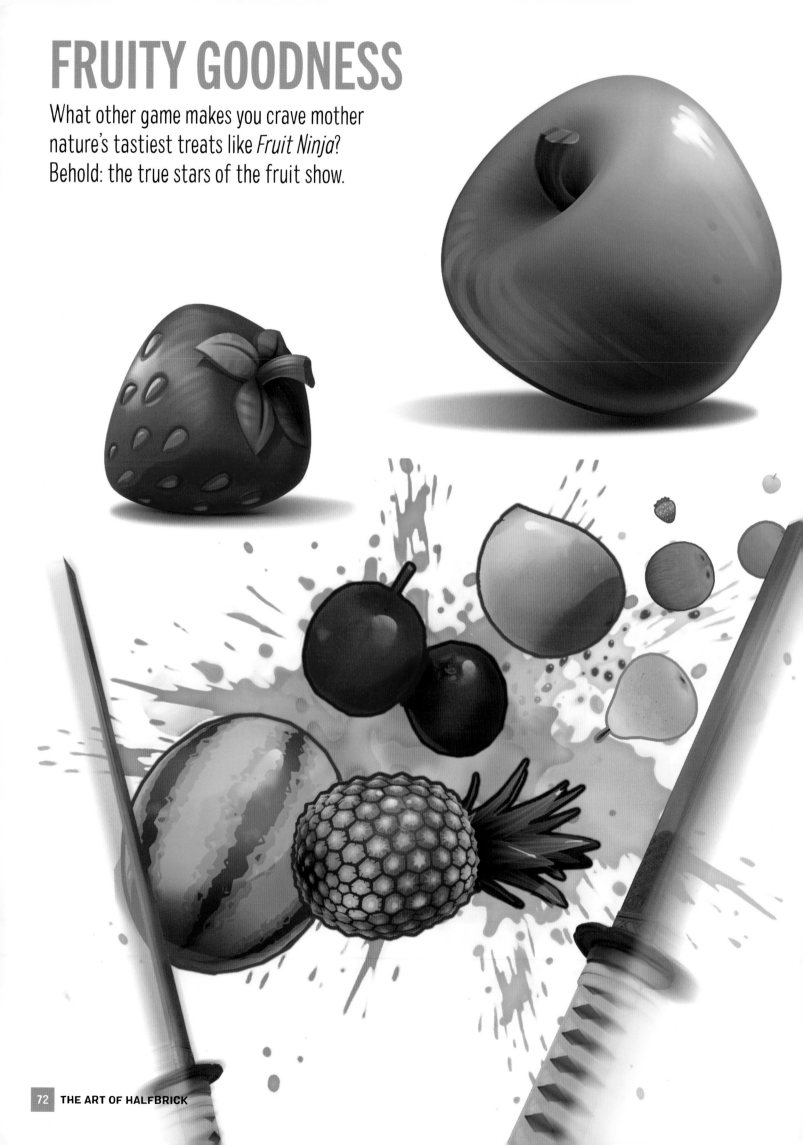

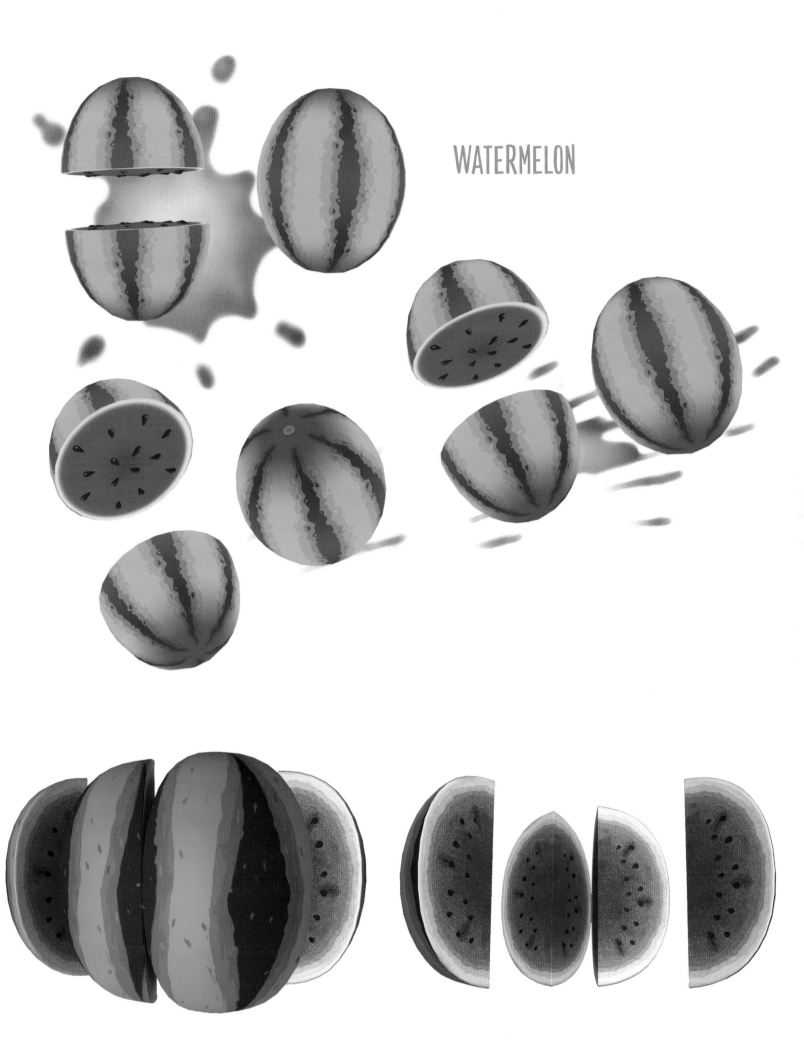

WATERMELON

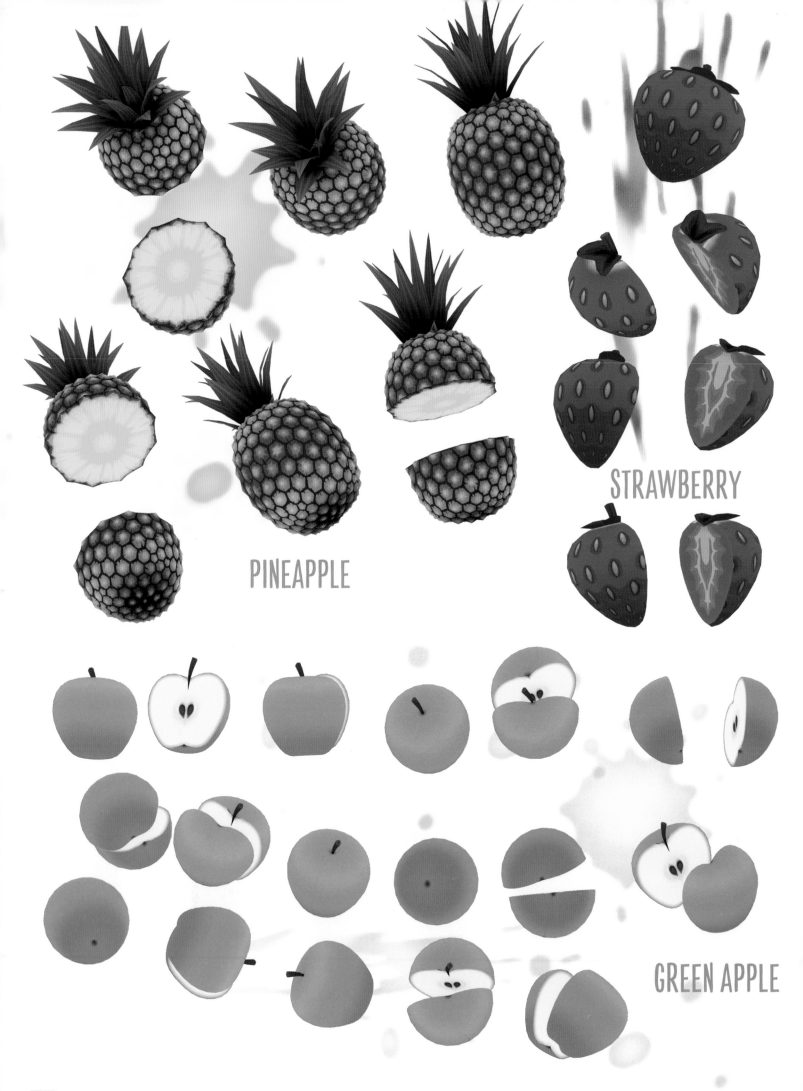

PINEAPPLE

STRAWBERRY

GREEN APPLE

PASSIONFRUIT

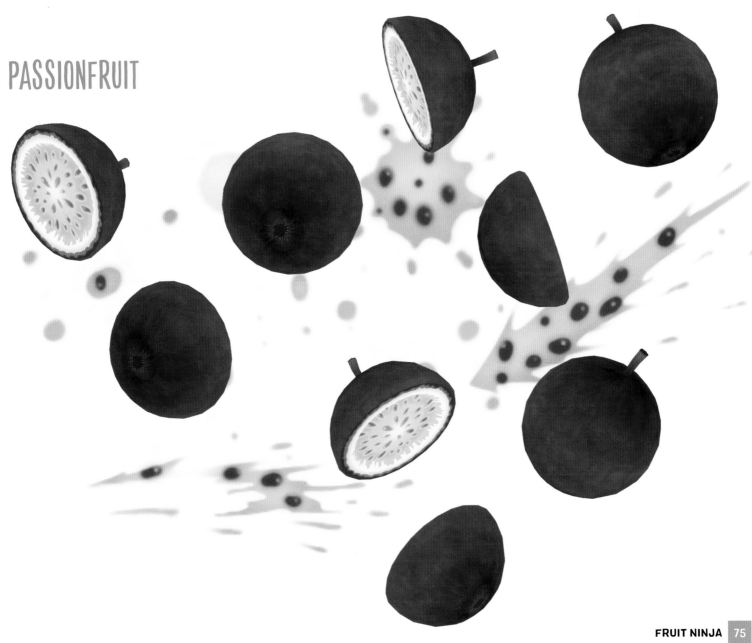

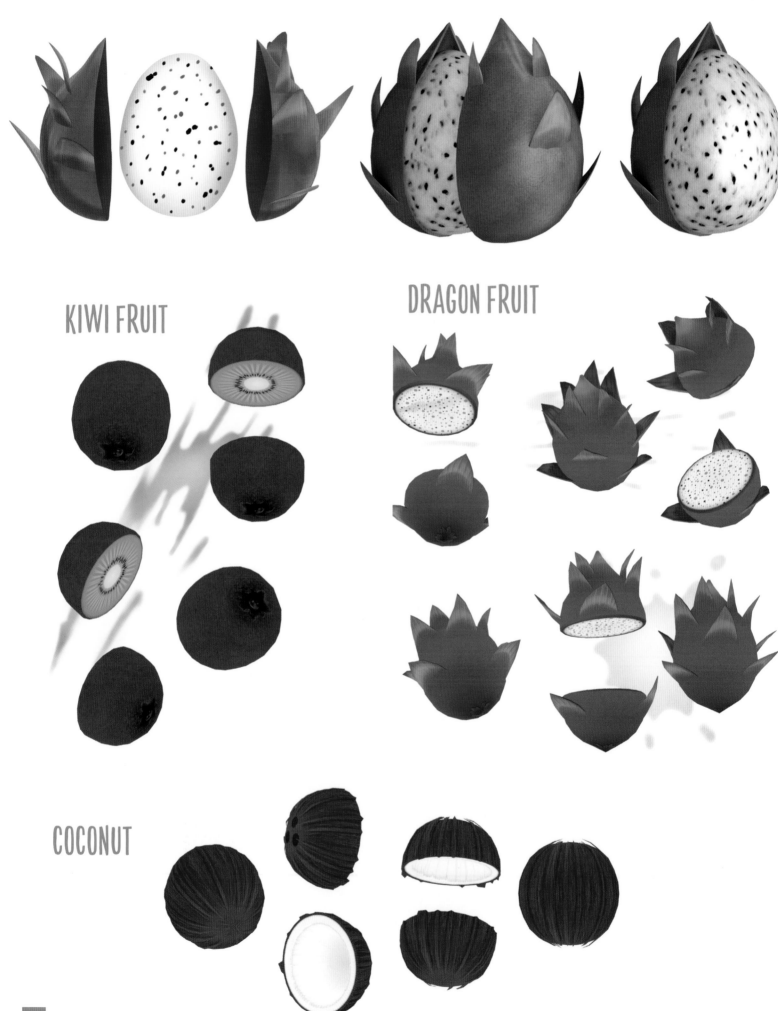

KIWI FRUIT

DRAGON FRUIT

COCONUT

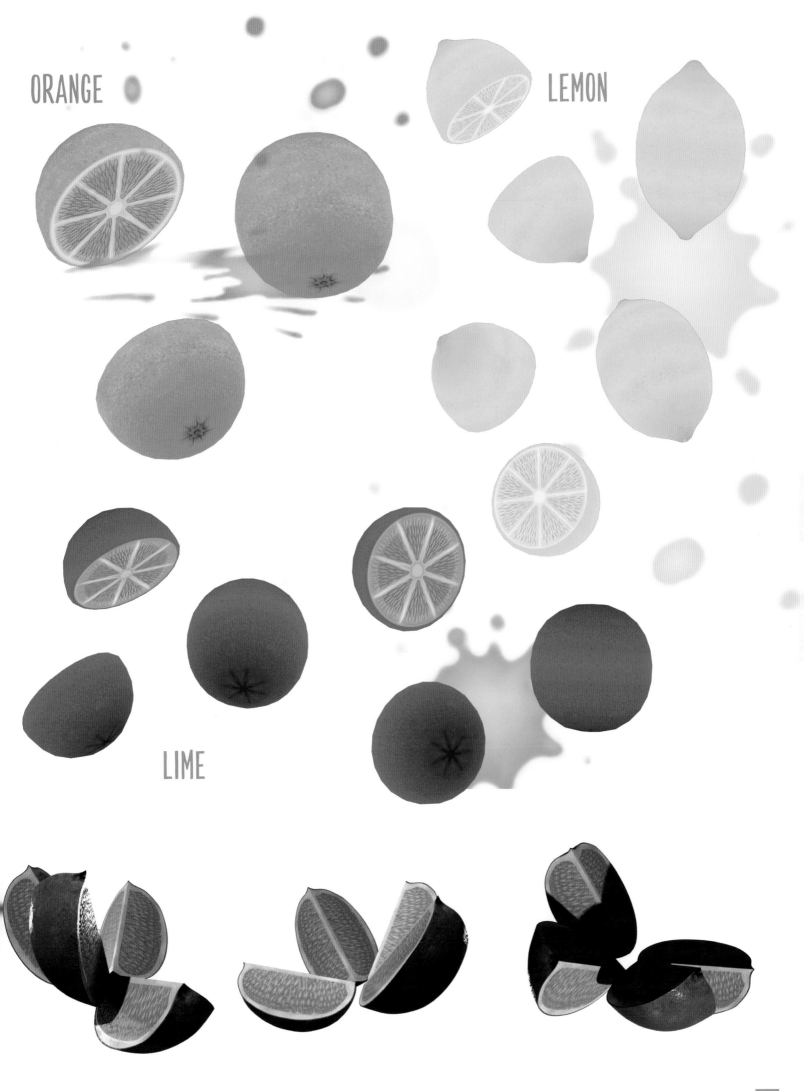

ORANGE

LEMON

LIME

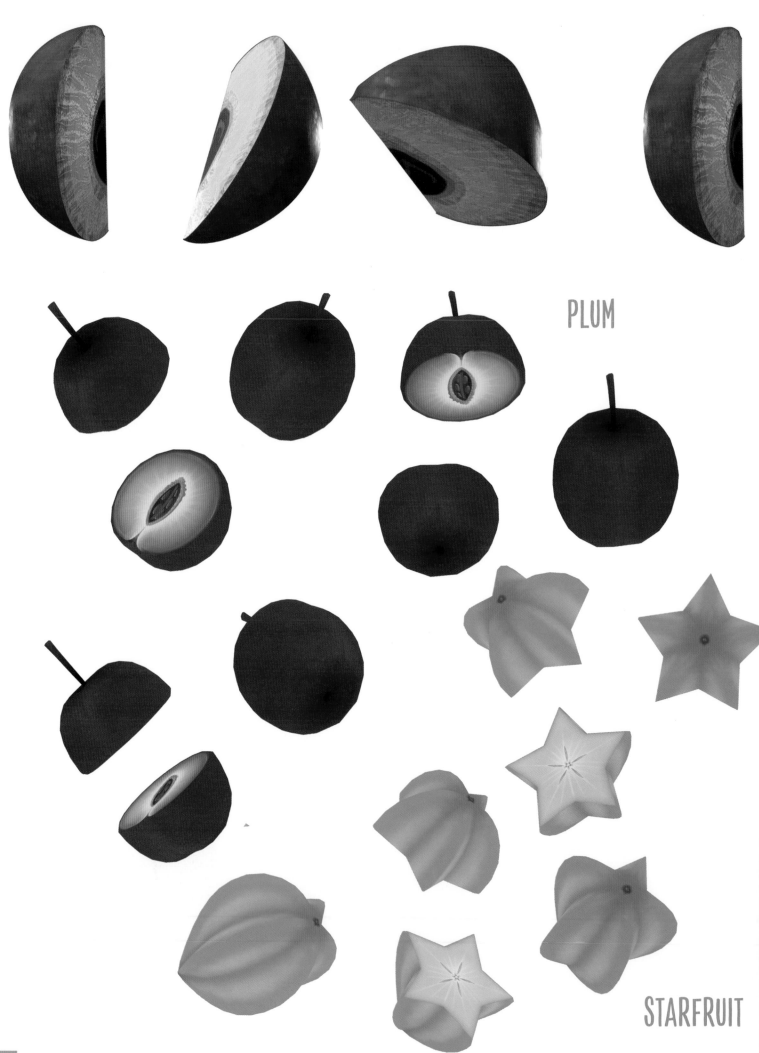

PLUM

STARFRUIT

PEAR

MANGO

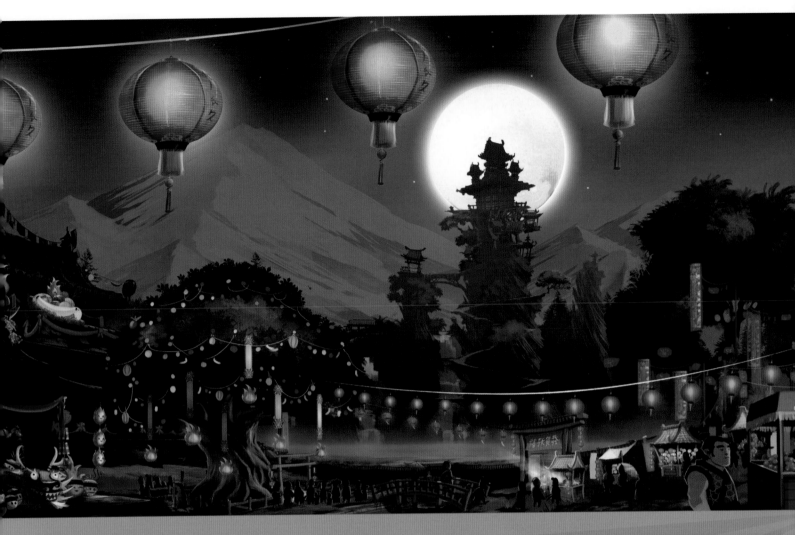

EVERYONE LOVES FRUIT

Fruit Ninja was originally released for the iPod Touch and iPhone in April of 2010. It debuted on the iPad in the summer, Android OS in the Fall, and on the Windows Phone in the Winter.

From its initial release on mobile phones, *Fruit Ninja* has since expanded to multiple gaming platforms with the release of *Fruit Ninja FX*, *Fruit Ninja VR*, and *Fruit Ninja Kinect*.

Fruit Ninja FX is made for arcades and features a giant touchscreen, so players can easily compete with their friends.

Fruit Ninja VR is available for the PlayStation VR, the HTC Vive, and Oculus Rift. The virtual reality version of *Fruit Ninja* immerses players in the game, allowing them to take full control of their blade.

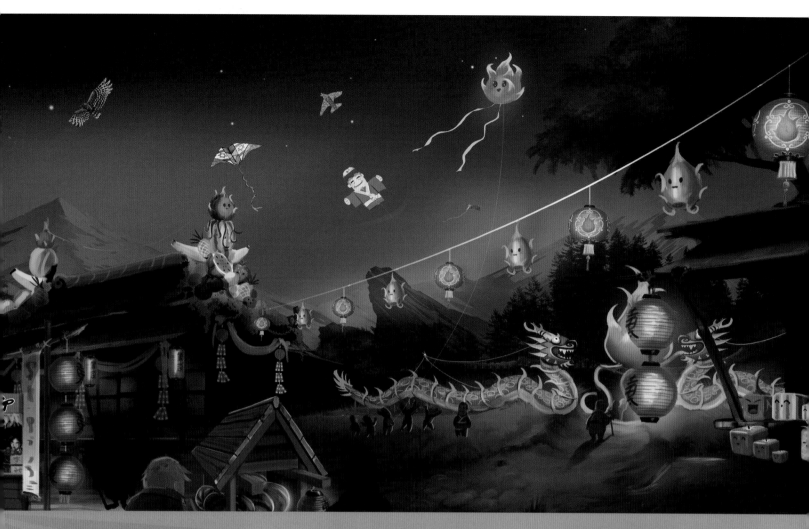

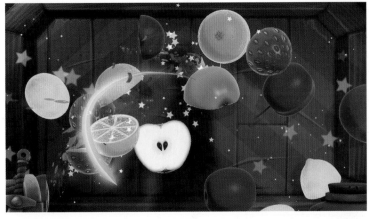

In *Fruit Ninja Kinect* and *Fruit Ninja Kinect 2*, arms become weapons as players get physical to battle the world's tastiest produce. *Fruit Ninja Kinect* was the first Xbox LIVE Arcade game to make use of the motion-sensing Kinect controller and ranks as one of the most popular Kinect games of all time. The Kinect version also introduced Party Mode, which allows multiple players to take each other on in a fruit-tastic tournament.

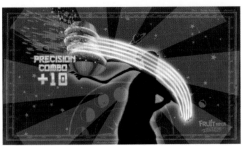

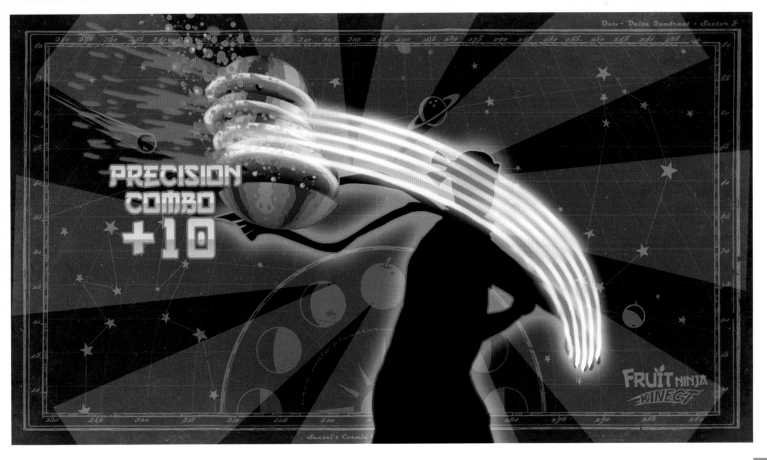

Fruit Ninja also came to Microsoft Windows in 2012, giving players yet another option to feed their fruit slicing needs.

In addition to the various versions of the game, the Halfbrick team maintained constant updates, including holiday and event-themed add-ons that continued to expand the game.

No matter which platform players choose to slice on, the core game remains the same: have a blast slicing fruit!

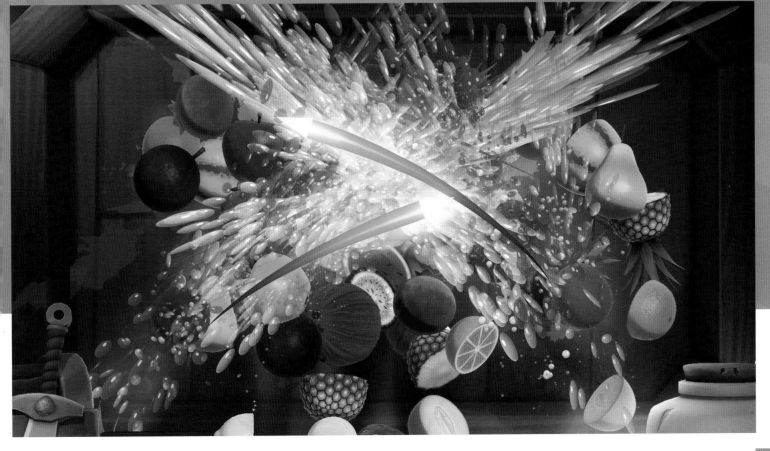

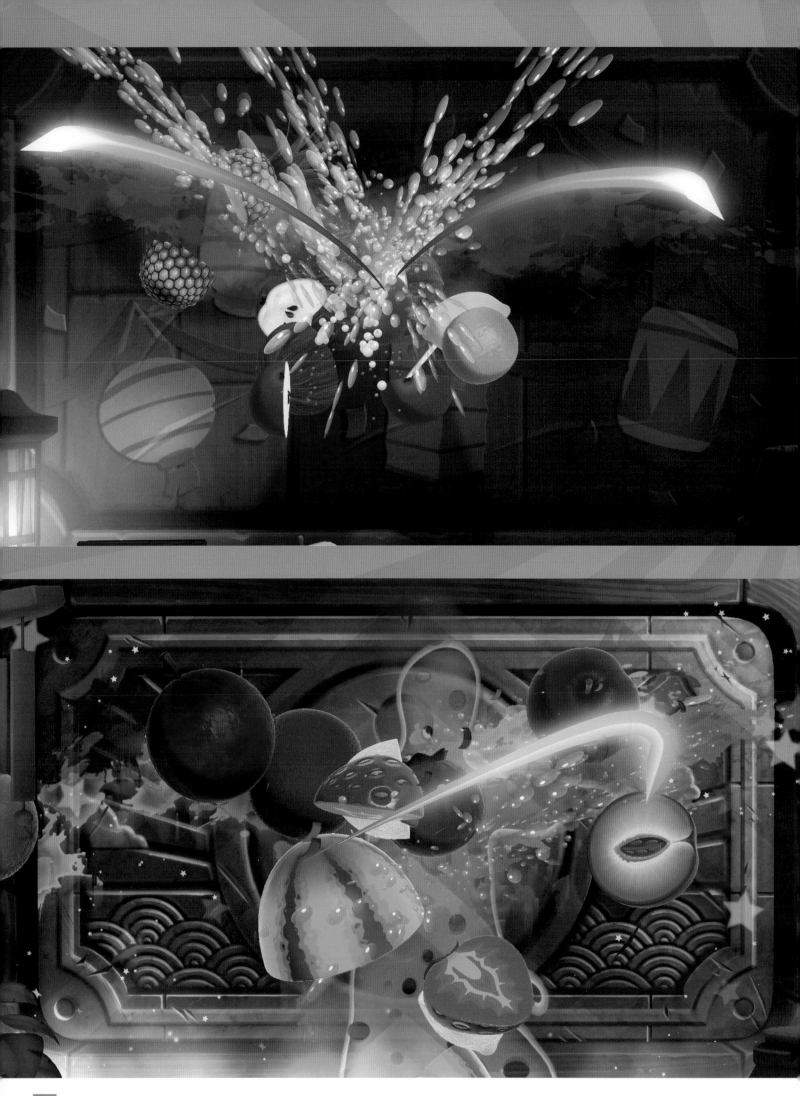

VIRTUAL REALITY

Virtual Reality, as it pertains to gaming, has been around for a while, but has enjoyed a resurgence in popularity within the last ten years due to changes in technology. When VR representatives approached Halfbrick about developing a VR game, Halfbrick saw potential, but at the time they were unable to spare anyone for its development.

Then, at a Halfbrick Fridays event, a programmer named Adam Wood put forward the idea of making *Fruit Ninja VR*.

"As soon as everyone played the game, we knew it had to be built properly and released," said Chris Schnitzerling, a gameplay programmer at Halfbrick.

VR development was not without its challenges. Frame rate drops were a big concern, as any drop in the frame rate can cause motion sickness for the player. Menu navigation was another issue, and the audio control had to be designed from the ground up.

"Even though *Fruit Ninja VR* is a simple game, we still pushed the limit of what VR can visually do, especially on PS VR," said Schnitzerling.

"When developing *Fruit Ninja VR*, we focused all of our attention on making the gameplay as enjoyable as possible."

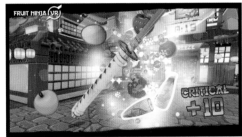

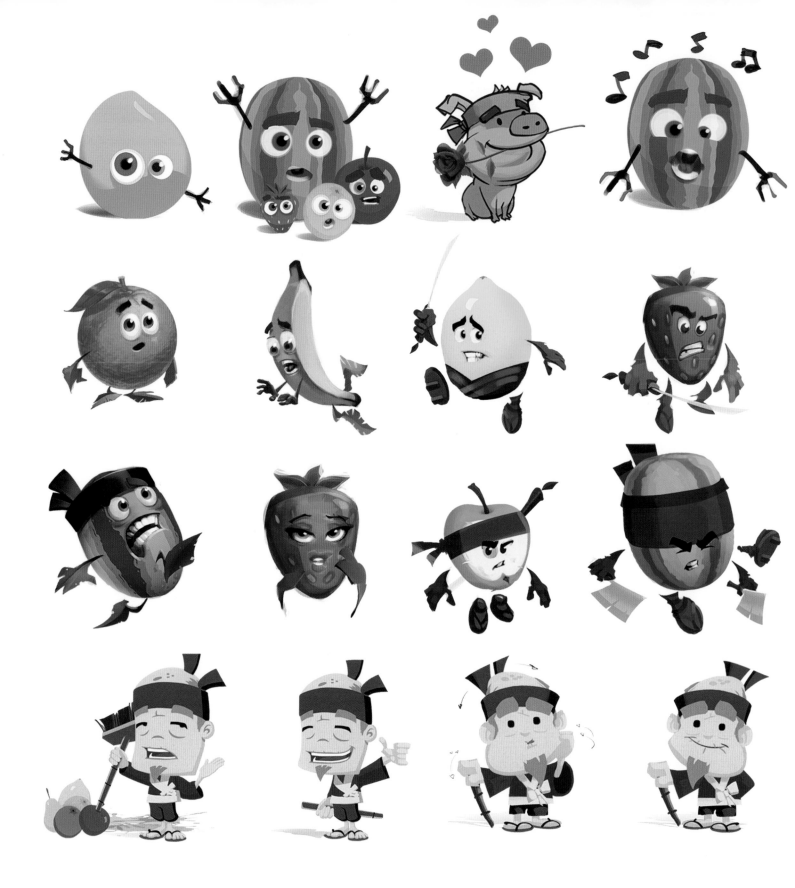

LEGACY OF THE FRUIT NINJA

*F**ruit Ninja** is a phenomenon that has continued to grow. Physical Therapists have used the game to develop fine motor skills in patients. It inspired a real-life fruit slicing YouTube video with more than three million views. It even made an appearance on a popular show to test the physics of using Juice Jitsu. There is fanfiction, fanart, and an entire community of hardcore gamers and casual gamers who have made *Fruit Ninja* a part of their lives.

And, for Halfbrick, it was the game that allowed the small studio to grow into one of the most successful businesses in Australia.

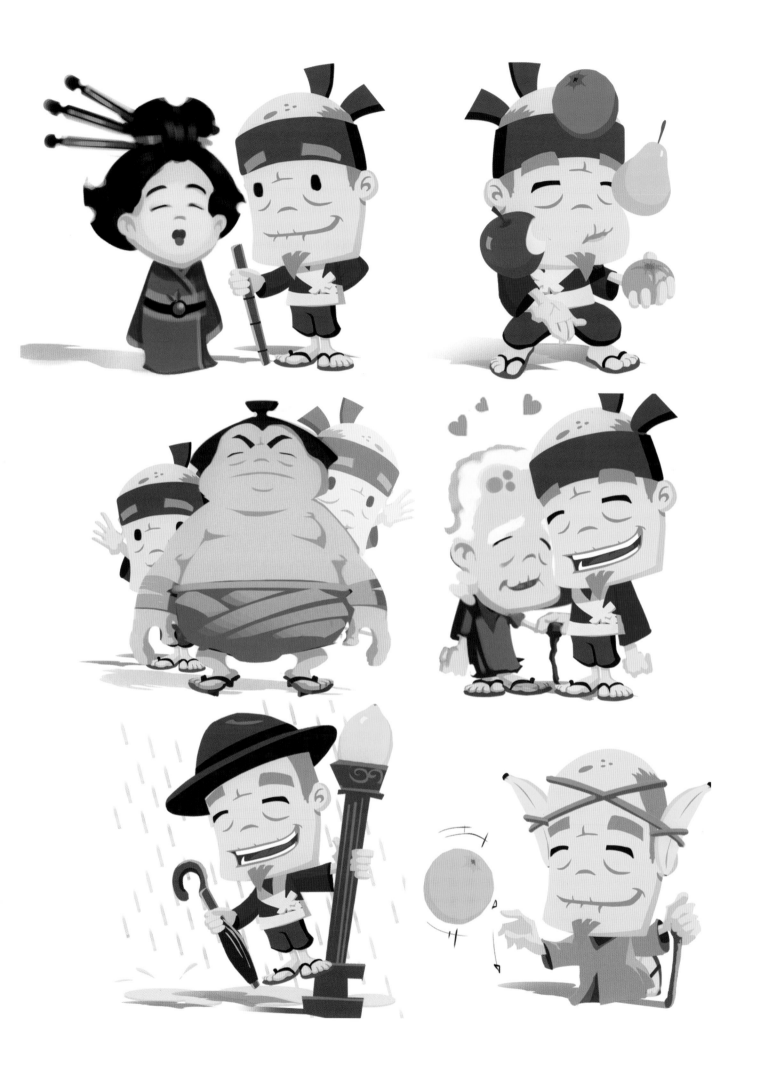

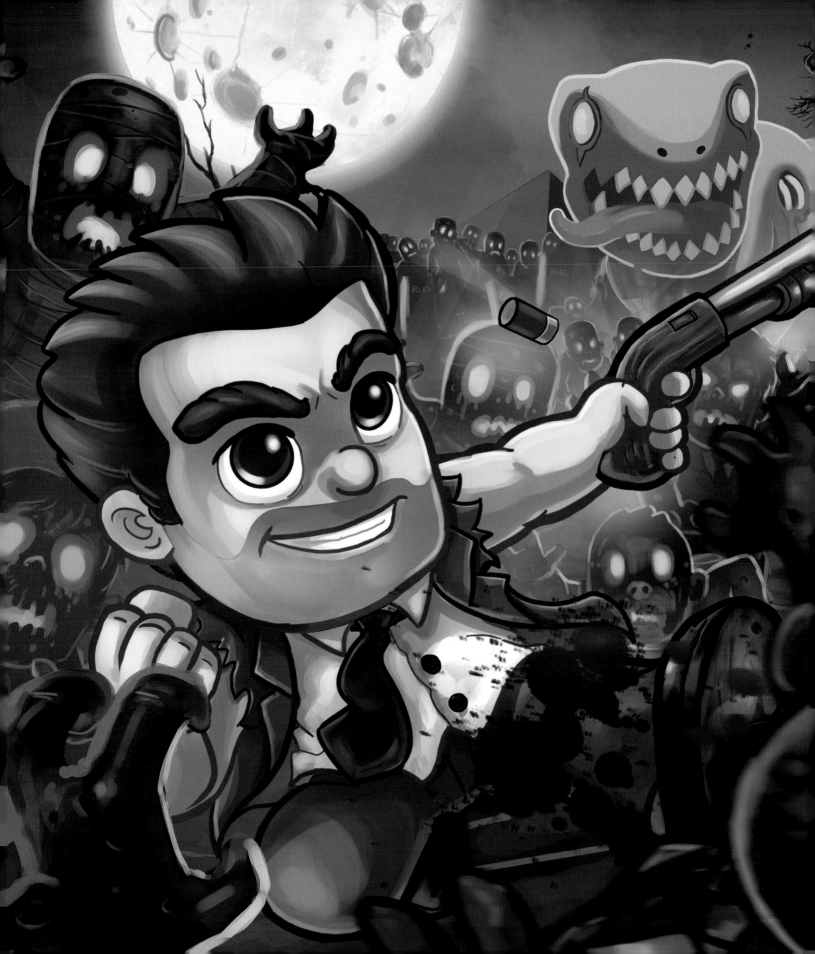

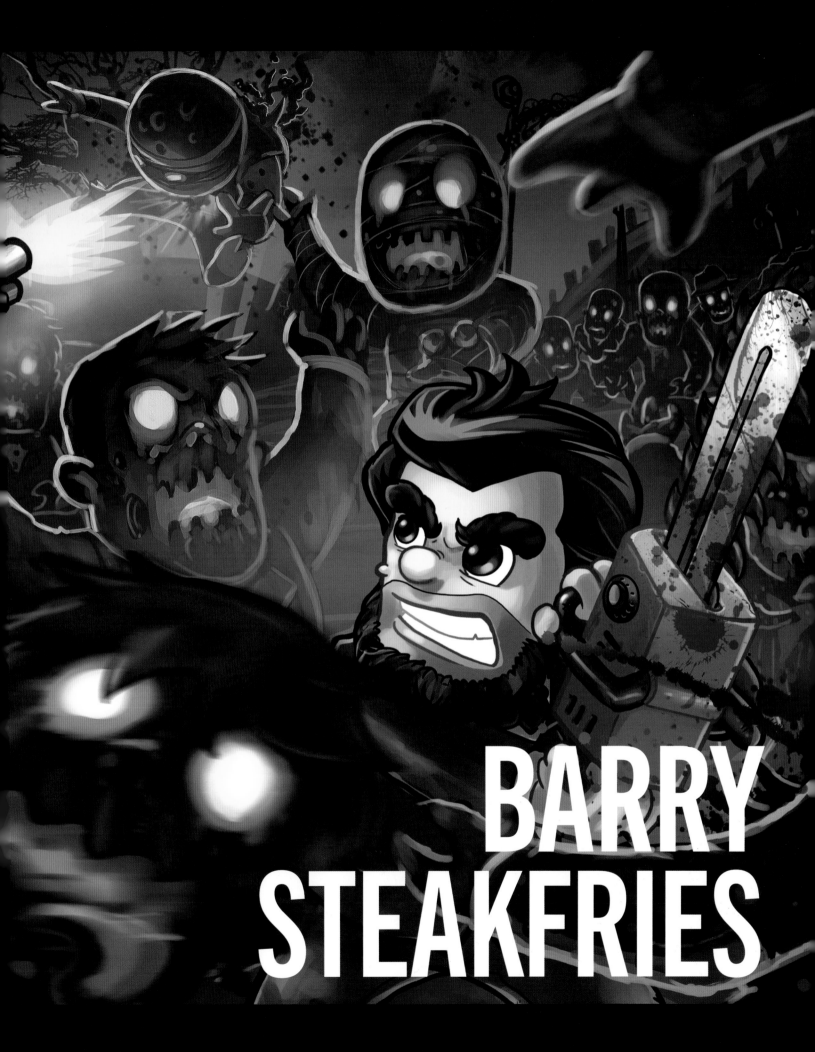

BARRY
STEAKFRIES

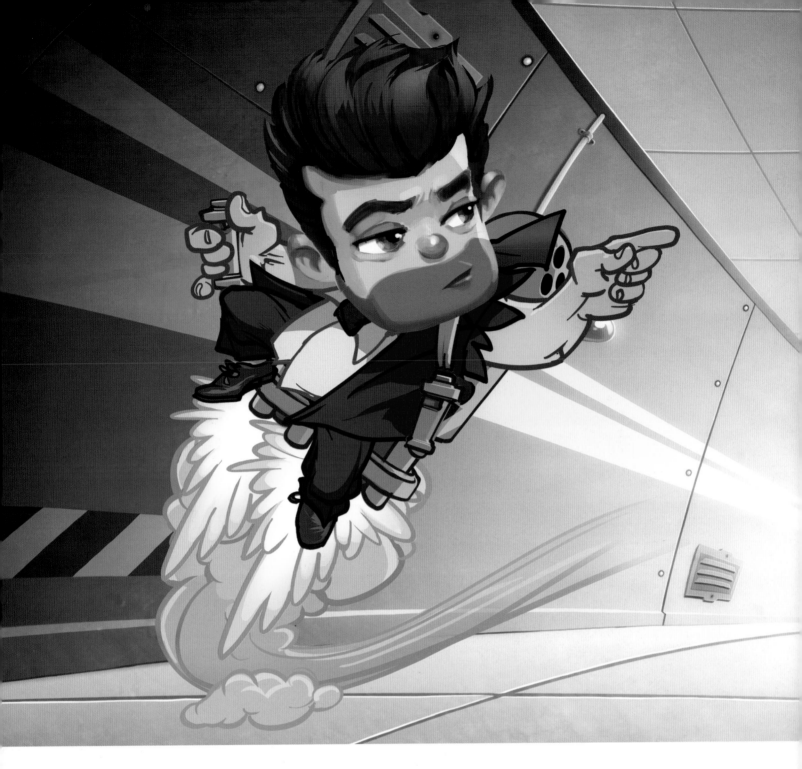

BARRY HATES SLEEVES

arry Steakfries didn't just become an overnight celebrity. He has appeared (canonically) in four Halfbrick games: getting his feet wet in *Raskulls*, crushing his enemies in *Monster Dash* and *Age of Zombies*, and then truly coming into his own in *Jetpack Joyride*. And you can even play as Barry Steakfries in *Dan the Man*!

Who is Barry? What does he want in life? Why do we like him even though he is arguably terrible? Why does he hate shirt sleeves so very much?

Barry is a simple man. He does his nine-to-five job, but what he really craves is adventure. Like most of us, Barry wants to be the hero of his own story. He might be a bit lazy and he might not always do what he knows he should, but Barry is, at heart, an optimist who believes in himself and who wants to take life by the horns and have fun. Whether it's by riding a mechanical dragon named Mr. Cuddles, or shooting zombies with a shotgun while riding a motorcycle in a leather jacket and cool shades, Barry plans to live his life to the fullest.

Barry also has a shirt-ripping disease: whenever he gets excited, he tears off his shirt sleeves.

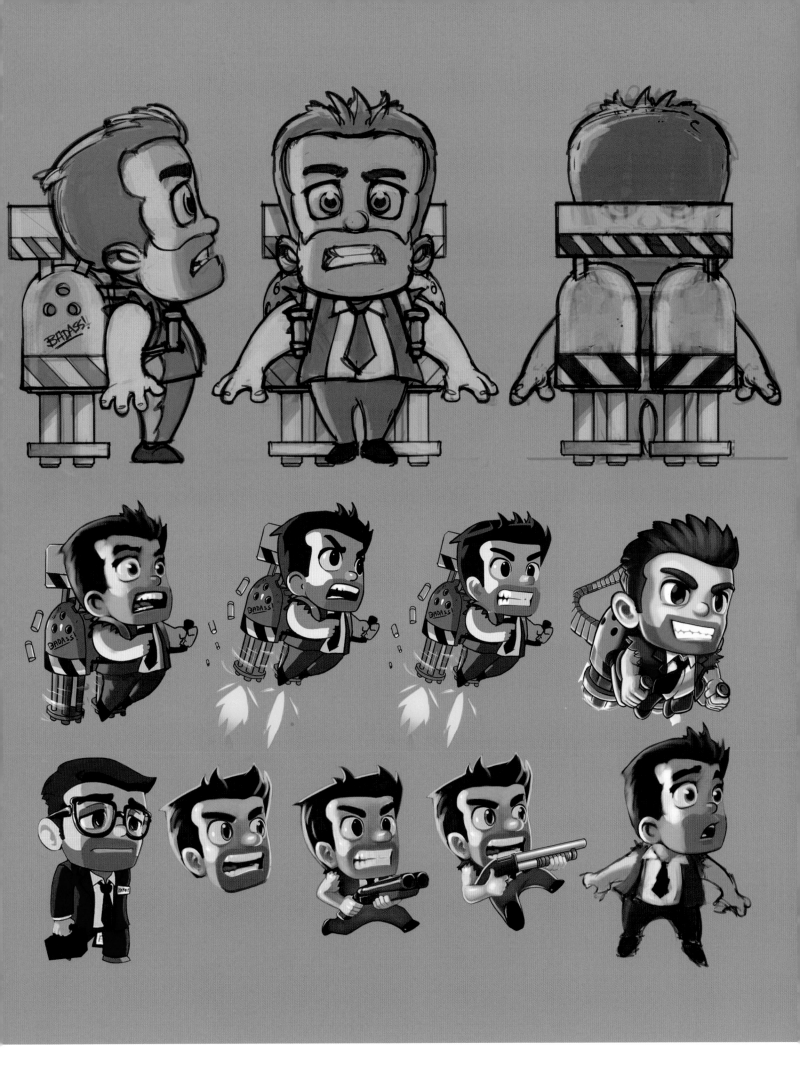

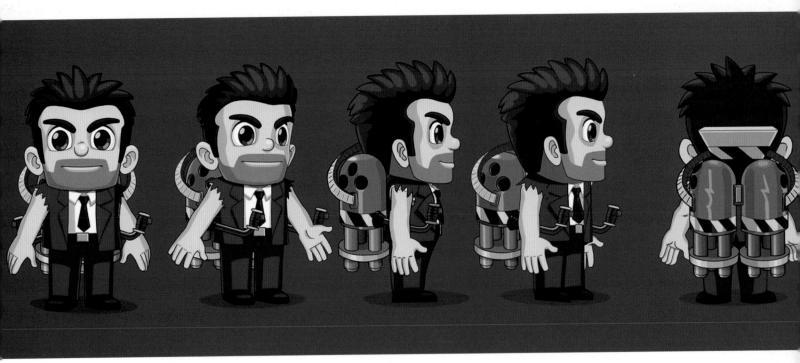

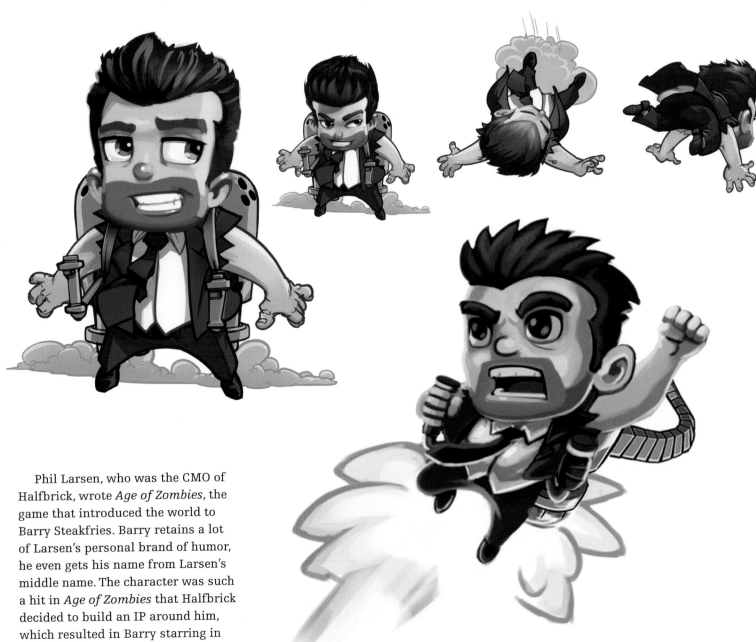

Phil Larsen, who was the CMO of Halfbrick, wrote *Age of Zombies*, the game that introduced the world to Barry Steakfries. Barry retains a lot of Larsen's personal brand of humor, he even gets his name from Larsen's middle name. The character was such a hit in *Age of Zombies* that Halfbrick decided to build an IP around him, which resulted in Barry starring in *Monster Dash* and *Jetpack Joyride*.

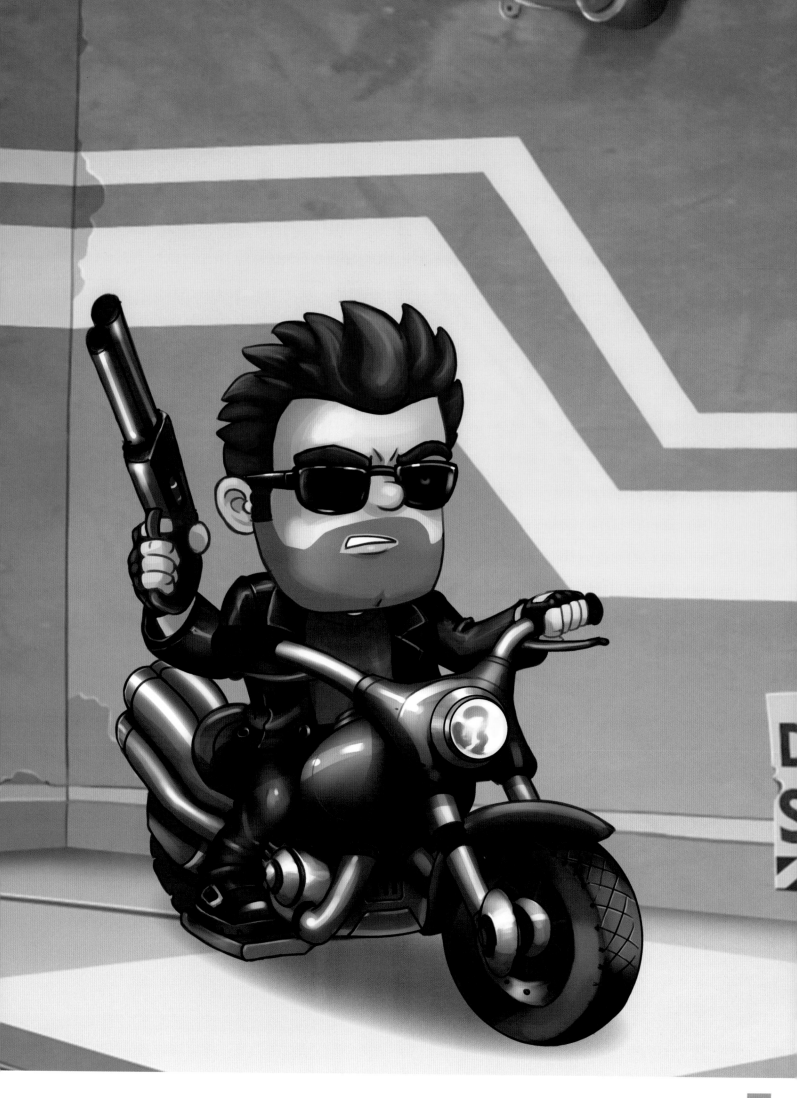

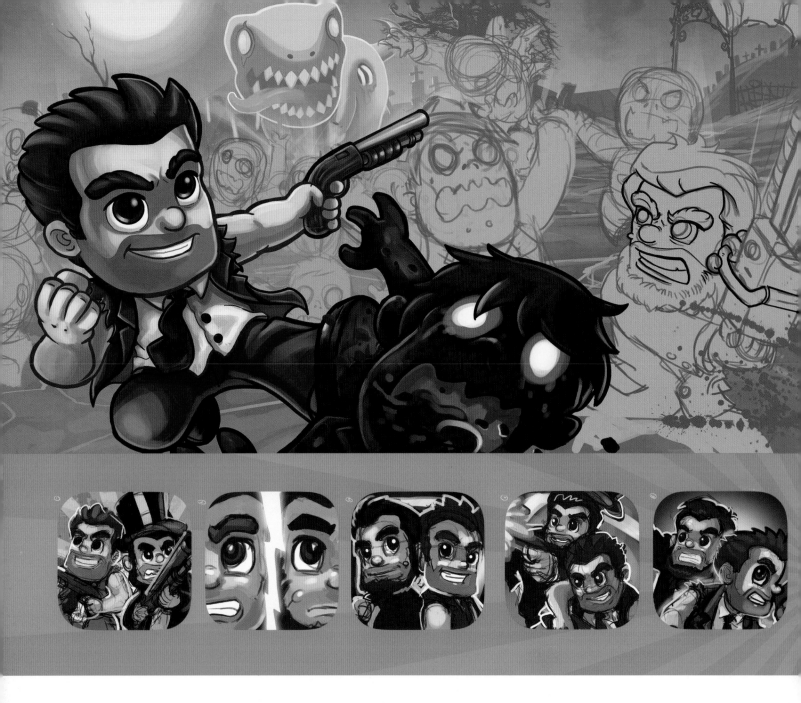

ABOVE: Concept art of Barry and Abraham Lincoln from *Age of Zombies—President Evil*, released in June 2014.

AGE OF ZOMBIES

The evil Professor Brains has sent hordes of the undead to the furthest reaches of time to destroy mankind. Players control Barry Steakfries, a commando eager to blast zombies and chew bubblegum. And he can do both at the same time.

Age of Zombies is a comedic action game in which players must fight off seemingly unending waves of zombies and incredibly massive bosses, with the aid of epic weapons and explosives. Shoot, blow up, and even bite, hordes of ninja zombies, cavemen zombies, cyber zombies, and more in gorgeously designed settings. Gameplay is fast-paced and frantic, as the hordes can quickly overpower Barry if he stays in one place too long. On the other hand, the tides can turn for those ravenous baddies if Barry happens to snag an overpowered weapon.

The idea for *Age of Zombies* came from a game pitched by producer Jason Maundrell during a Halfbrick Fridays session. The original game was called *Zombie TV*, it was a four-player horde mode game intended for consoles. It was pitched as a multiplayer tower defense game, but instead of towers, players had to defend a hero. The prototype was created in four days by a team of three.

Eventually, the tower idea was scrapped, as the team realized they were having more fun just trying to defend themselves from mass hordes of zombies as a team. Additional changes came when the game moved to portable devices: all the original art done by producer Jason Maundrell was replaced, touchscreen eliminated the need for the dual-stick shooter controls, and a story featuring our hero, Barry Steakfries, was created.

INTERVIEW WITH JESSE HIGGINSON

Jesse Higginson is an audio engineer who has been with Halfbrick for eleven years.

How did you design the music for *Age of Zombies*?
I don't know if Phil Larsen had any ideas at the time for what kind of music he wanted, but right from the start I had a strong feeling for what kind of soundtrack I thought it needed.

With zombies and comic violence: it had to be metal.

I wrote a piece for the Egypt level first, I think, and showed it to Phil. I'm not totally sure he was one hundred percent on board, but I think he let me run with it just because he saw how confident I was with that direction.

How would you describe your musical style?
Blunt force. I specialize in power and emotion and suck at subtlety.

What type of zombie is your favorite?
Fast, strong, mindless zombies.

Favorite thing about working on *Age of Zombies*?
Creating the music for the "Western" update. We were all massively into westerns at the time, and so jumping into that world and style was a lot of fun.

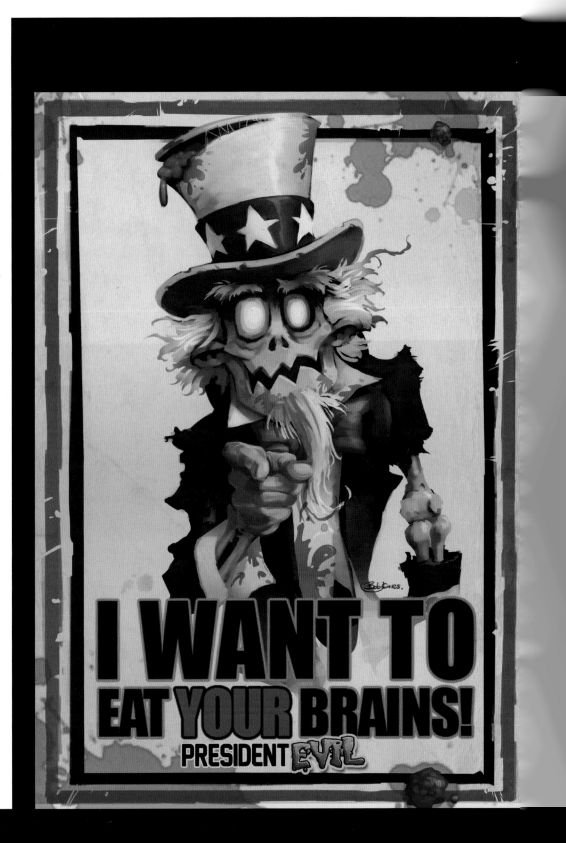

BARRY STEAKFRIES

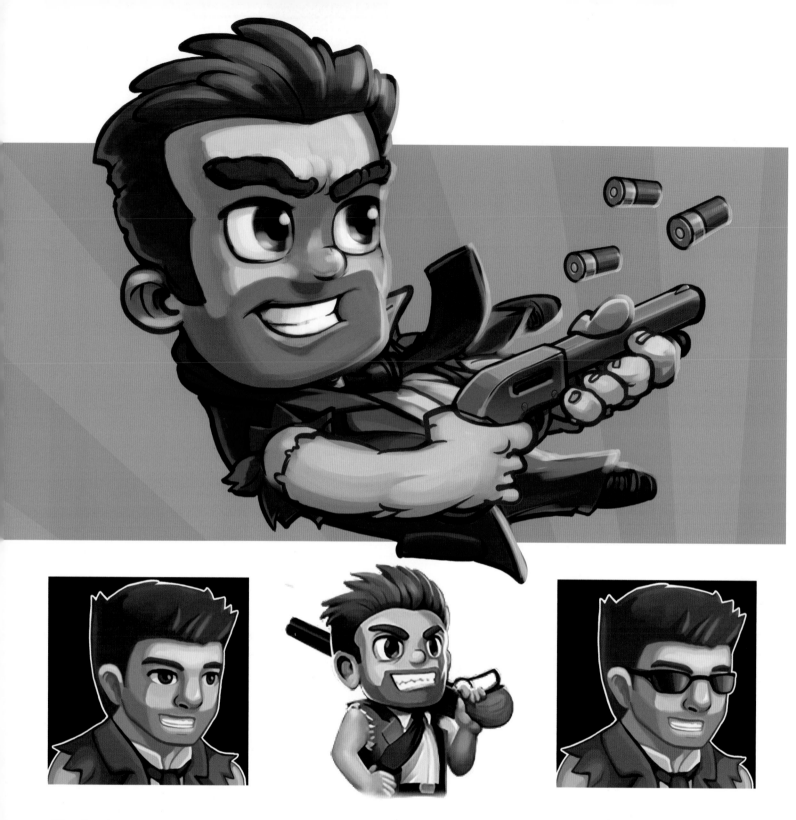

BARRY, SLAYER OF ZOMBIES

In *Age of Zombies*, Barry is a commando who gets by with his gun and his wit. Sometimes with his giant zombie dinosaur friend.

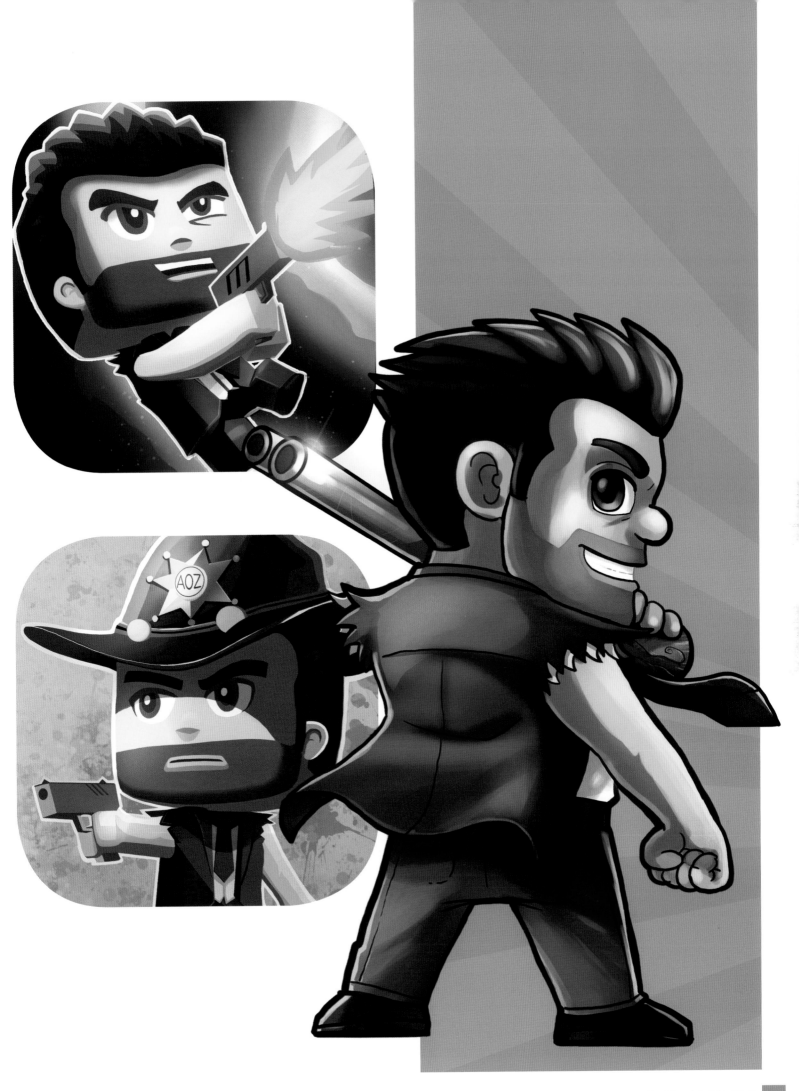

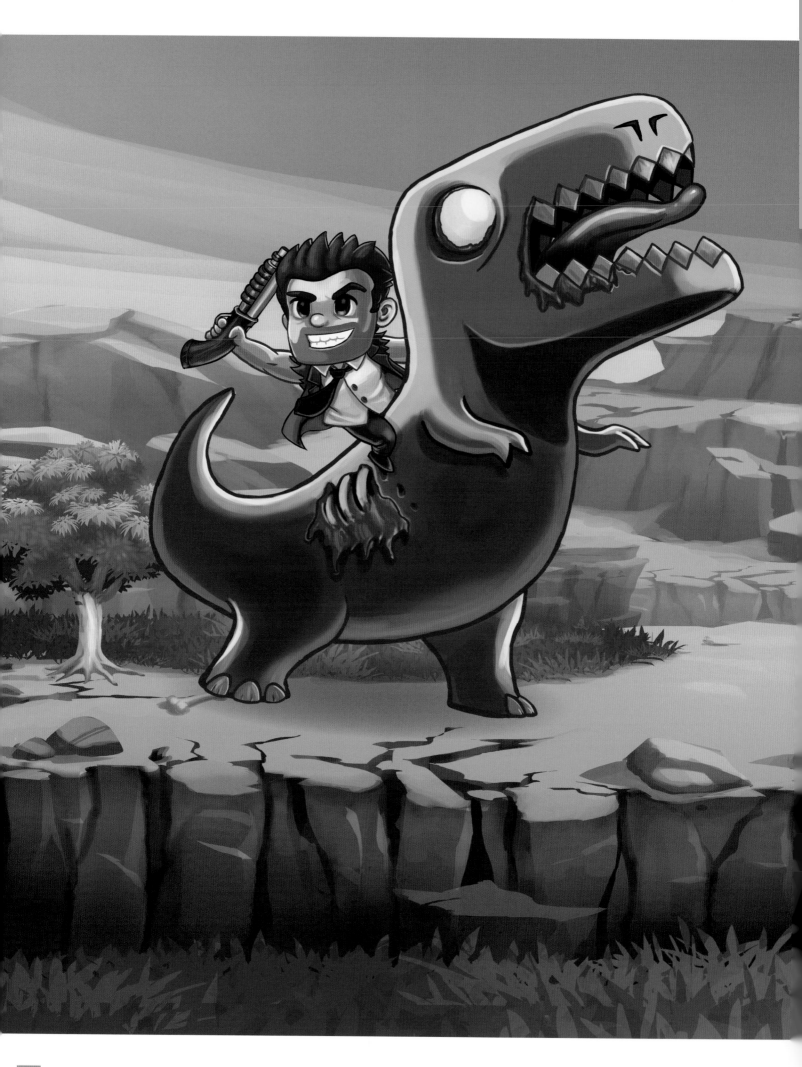

BRAINS

What do they want? Brains! When do they want them? Brains!

Barry has to take out zombies from prehistoric times, Ancient Egypt, Ancient Japan, the 1930's, and even the future. These undead come in many different forms.

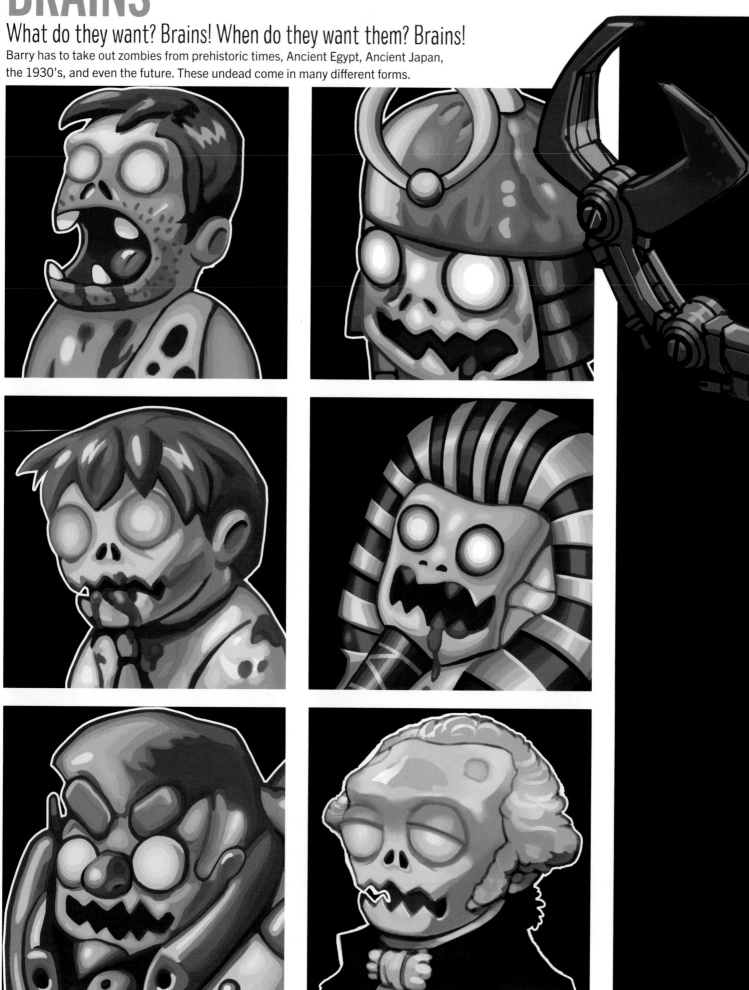

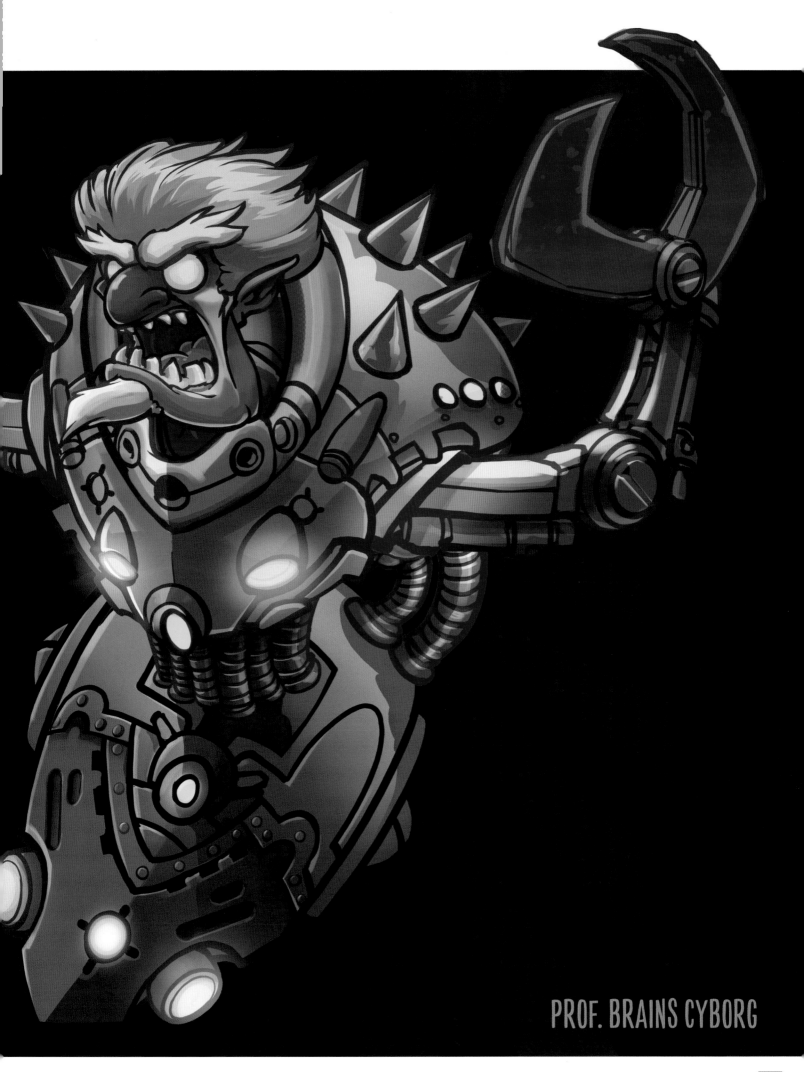

PROF. BRAINS CYBORG

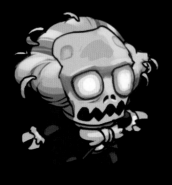
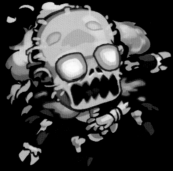
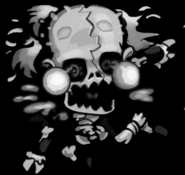
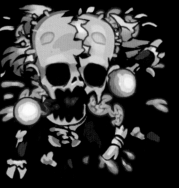

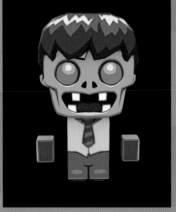
COMMON ZOMBIE

CAVEMAN ZOMBIE

GANGSTER ZOMBIE

MUMMY

PHARAOH MUMMY

NINJA ZOMBIE

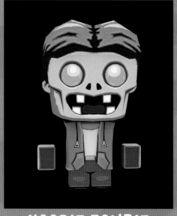
HOODIE ZOMBIE

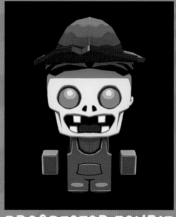
PROSPECTOR ZOMBIE

LADY ZOMBIE

GIRL ZOMBIE

JAPAN ZOMBIE

RED ZOMBIE

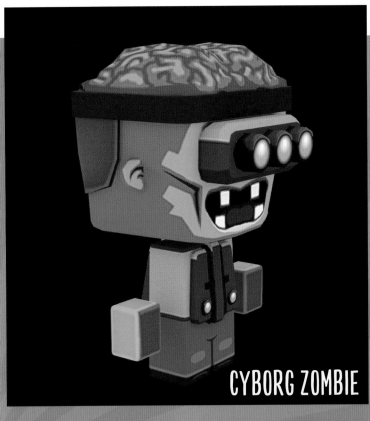

CYBORG ZOMBIE

GEORGE WASHINGTON ZOMBIE

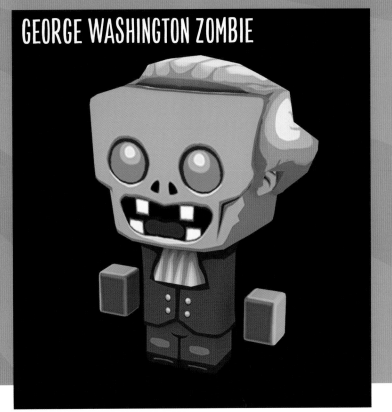

TINY ARMS, BIG DEAD BRAIN!

There is nothing better than a Zombie T-Rex. Okay, there is one thing better: a Zombie T-Rex you can ride.

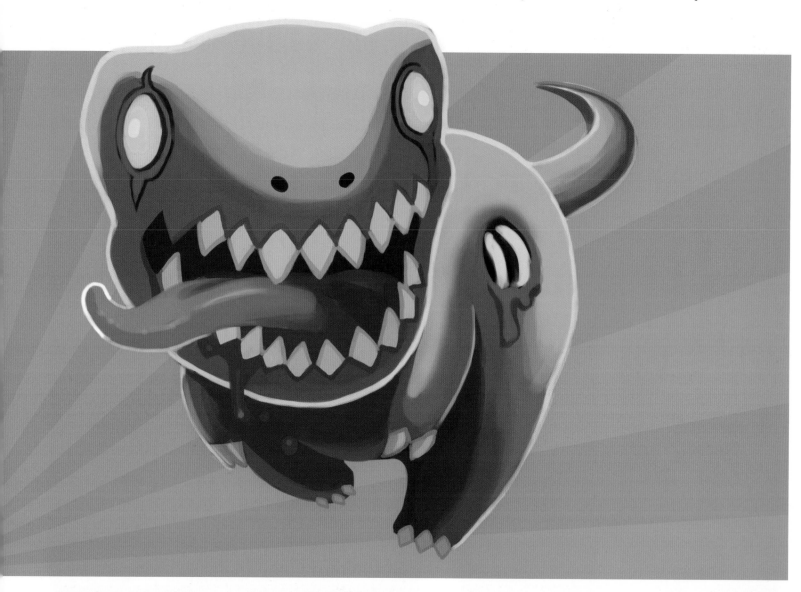

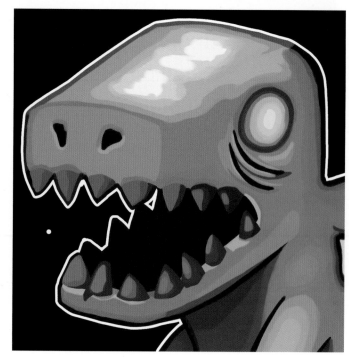

EVERYWHERE, EVERYWHEN

From the dawn of time to the technologically advanced future, there are zombies everywhere and everywhen!

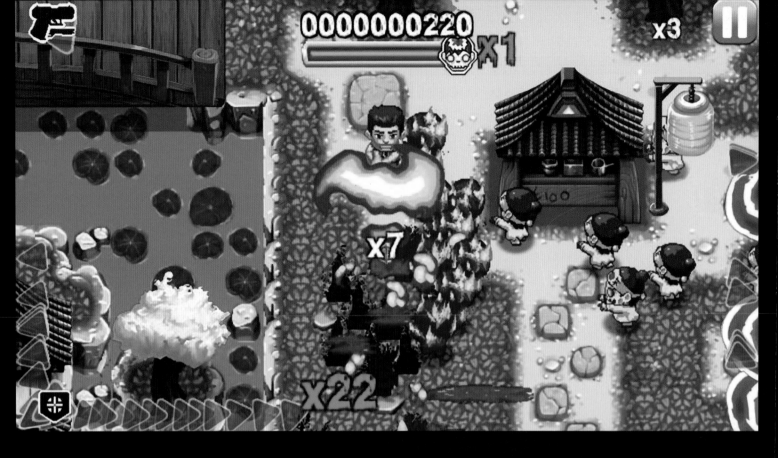

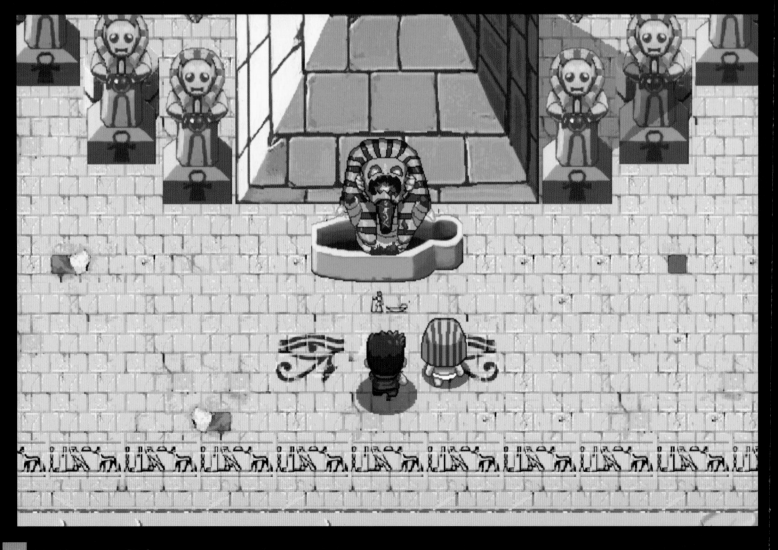

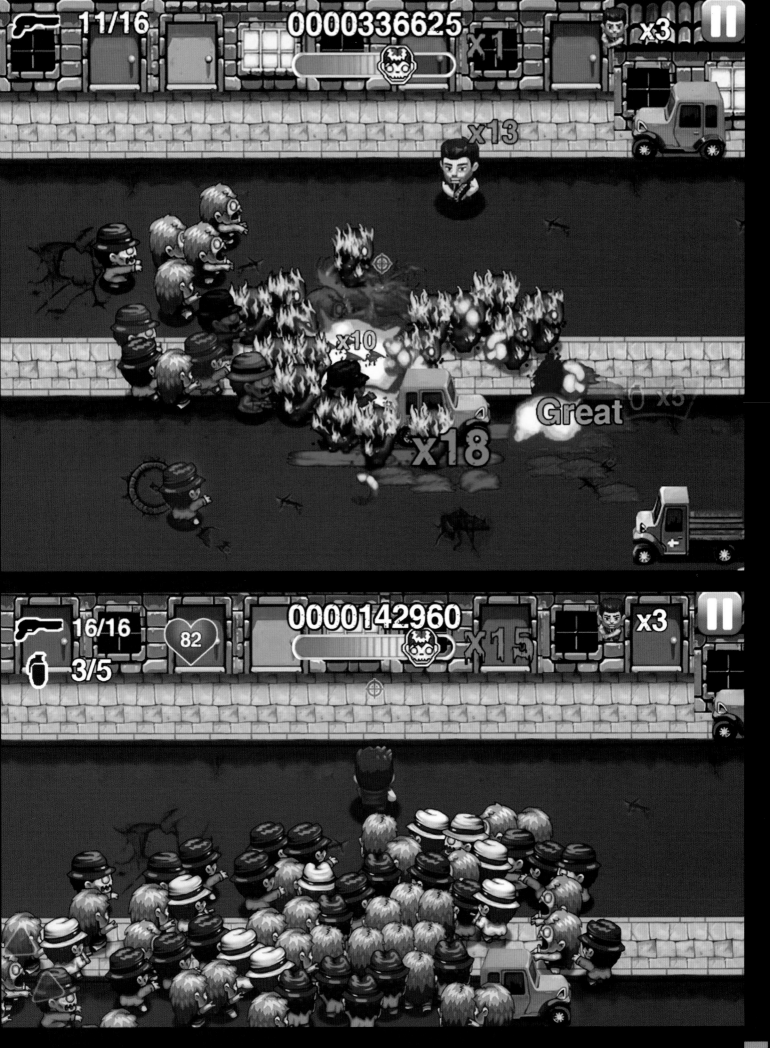

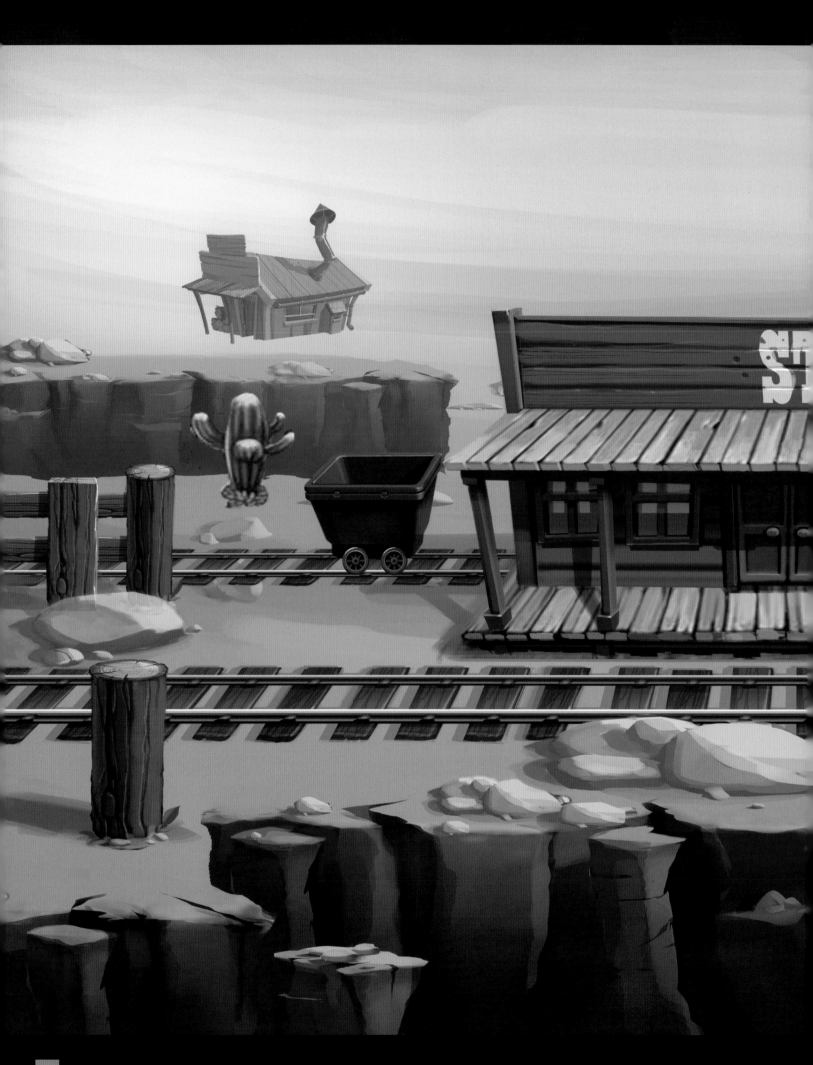

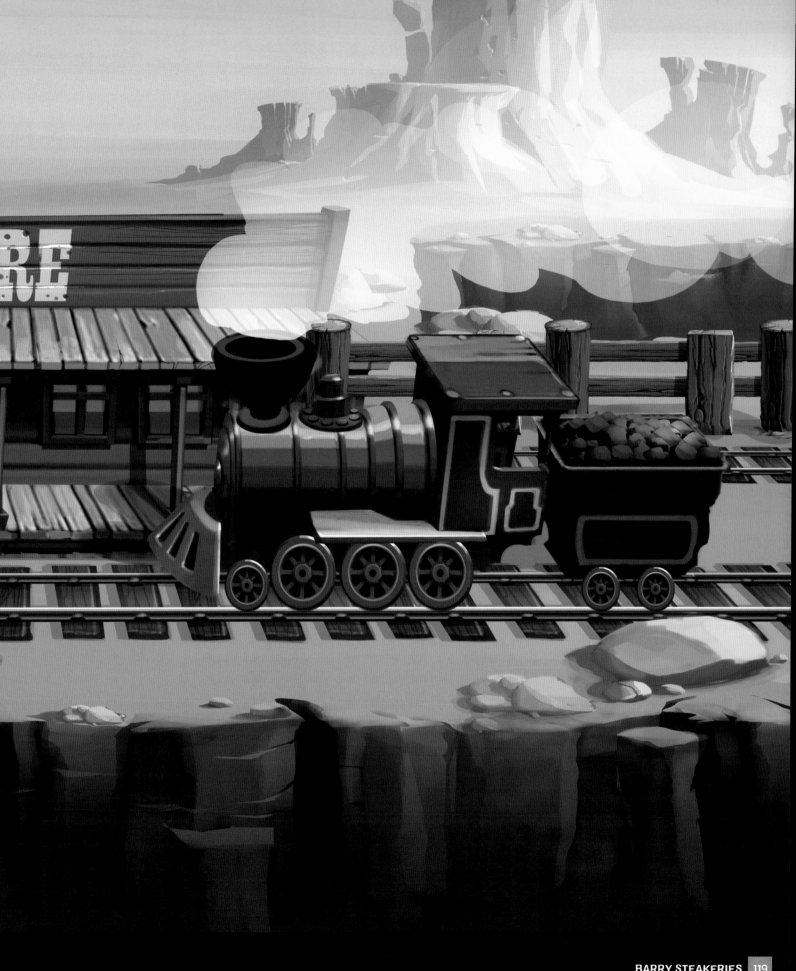

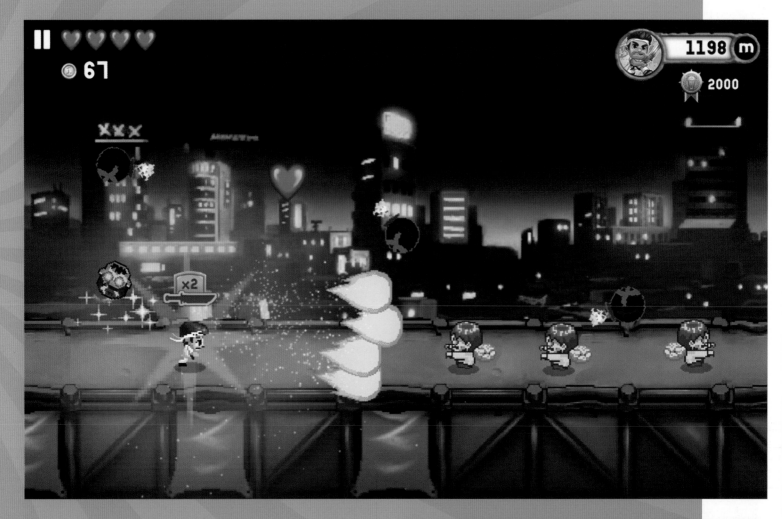

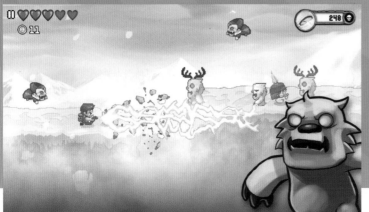

MONSTER DASH

Monster Dash is a side-scrolling runner in which players control Barry Steakfries as he runs and guns his way through hordes of monsters. As he runs, Barry gets faster and faster, collecting awesome weapons to aid him in this epic battle of good-ish versus evil. With abominable snowmen, zombies, vampires, and more, there's something for every creature-lover to enjoy blasting.

An interesting connection to other Halfbrick games is hidden in the backstory of *Monster Dash*. According to Rod Wong, concept and games artist at Halfbrick, Barry is pursuing Doctor Brain from *Age of Zombies* when he gets sucked into a time vortex. That time vortex shoots him into the universe of *Monster Dash*, where he must now dash not just from zombies, but from all types of ghoulish creatures.

Fun Fact: *Monster Dash* is the birthplace of the jetpack used in *Jetpack Joyride*. Called the "Machine Gun Jetpack," it shoots monsters automatically as Barry flies high above the carnage.

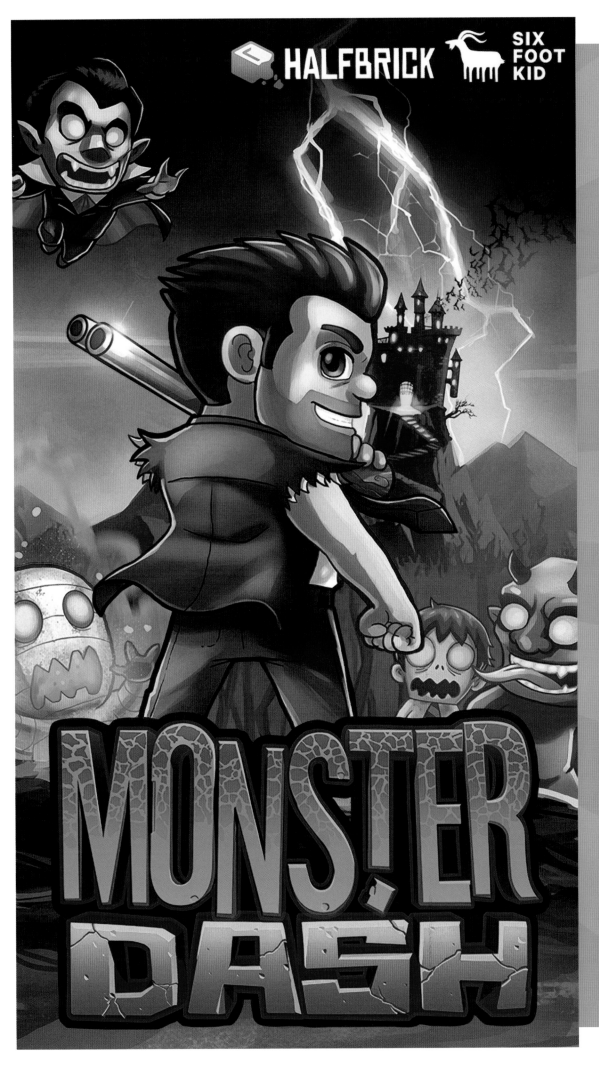

HALFBRICK SIX FOOT KID

MONSTER DASH

ARTIST INTERVIEW WITH ROD WONG

Rod Wong is a concept and games artist who has been at Halfbrick for five years.

How would you describe your style?
I guess adaptable, being able to pick up a style guide and mimic that art style, but if it came down to personal preference, I'd say comic/action style genre, with a bit of stylization.

Favorite Monster:
Oni.

Favorite part of *Monster Dash* to work on:
Designing a hero piece banner for the relaunch of *Monster Dash*. I was given full creative influence on this, so I went crazy, coming up with a banner that paid homage to older, over-the-top zombie movies. There was a haunted Transylvania night background with a creepy forest, all types of monsters you can encounter in the game, and on top of the hill, right at the center of the image, is Barry with his shotgun in a cool hero pose. That was heaps of fun to render up.

- Original art with glossbar removed
- No other treatment.

- Added New Monster Skin on top test
- Added Arrows to end of DASH to promote the direction. (Back to the future)
- Added Purple hue to base text.

- Added Inverted colour idea
- Added pock marks and cracks to bottom text.

- Simplified to One colour silouhette
- Added Cracks and Blood splats
- Added snake tale and head to (S)
- Added Monster Silouhette inside (R)
- Added Barry Silouhette inside (A)

- Added Colour Overlay to one basic text.

Original

- *Vibrant variant on the Animal skin version with Pock Marked Stone look on DASH*
- *Heavy Stroke around logo*

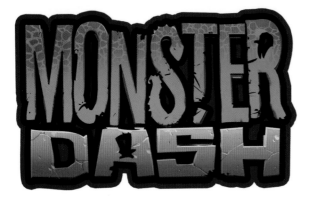

- *Blending all elements from all the previous ideas*

- *Simplified to One colour silouhette*
- *Barry in the D*

- *Paths version of above with layer fx*

BARRY, SLAYER OF MONSTERS

Barry Steakfries may not be the best monster slayer in the business, but he's the one with the most heart. As in, he really would like his heart to stay mostly in his body where it belongs.

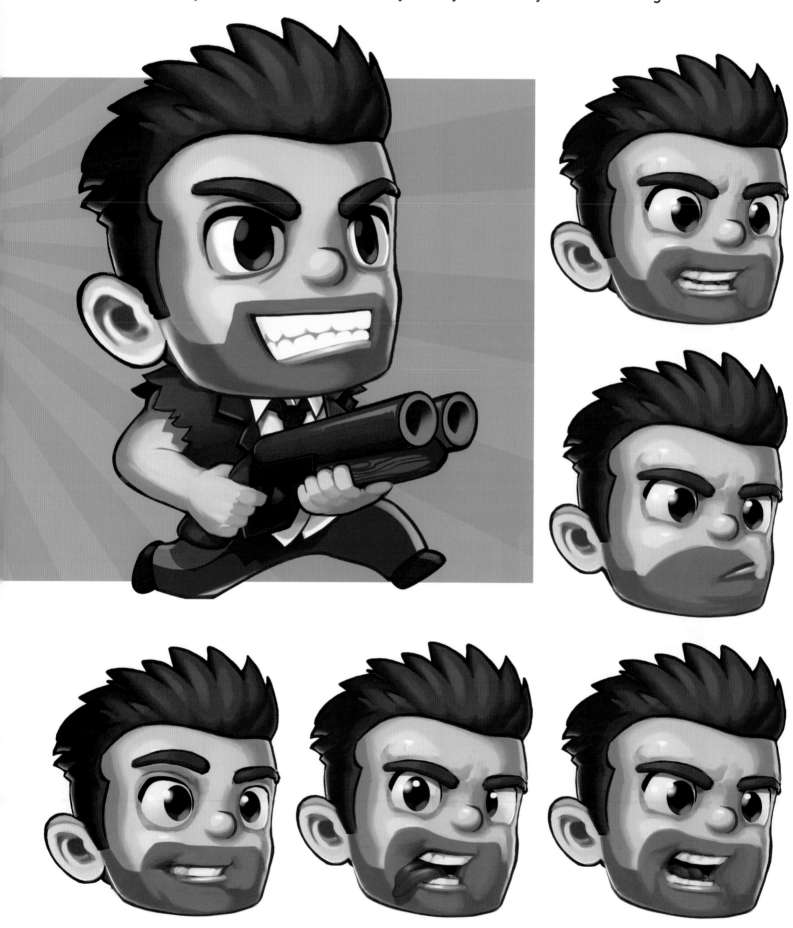

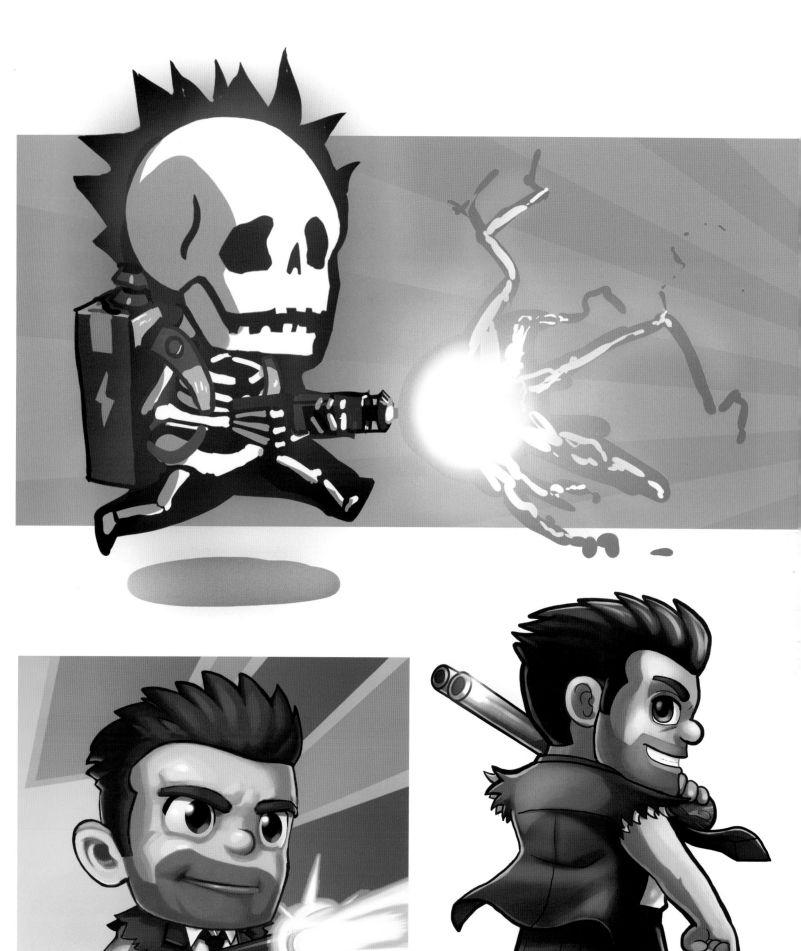

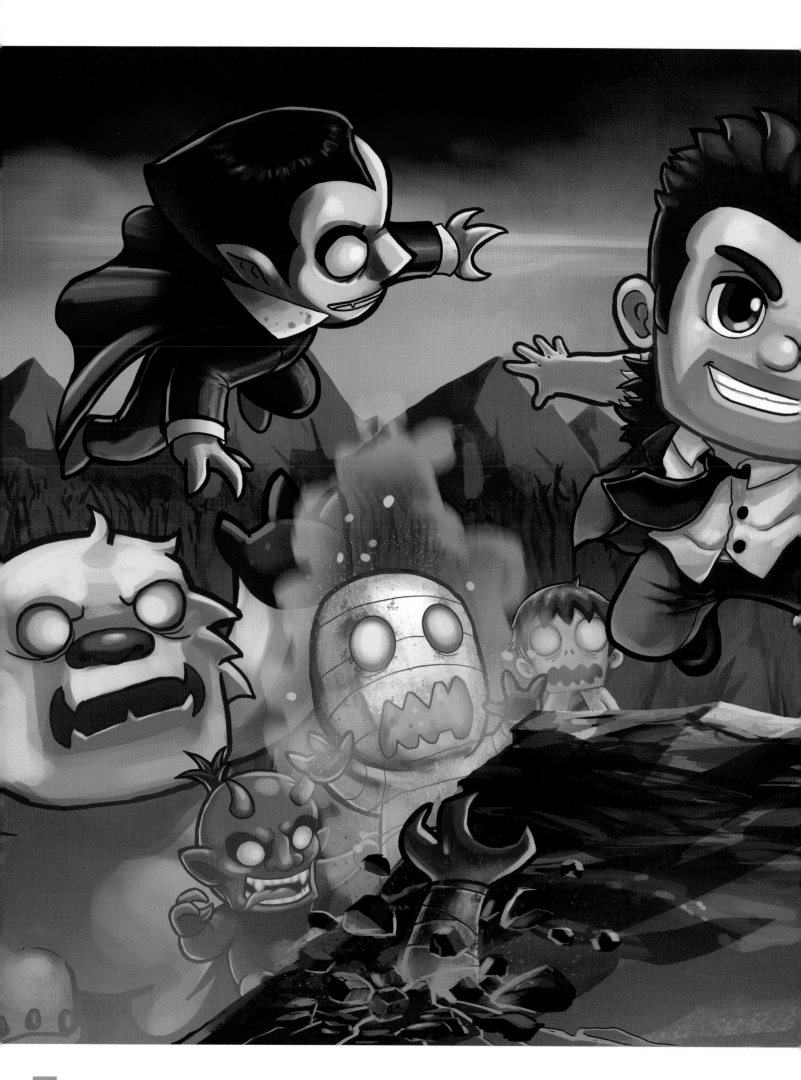

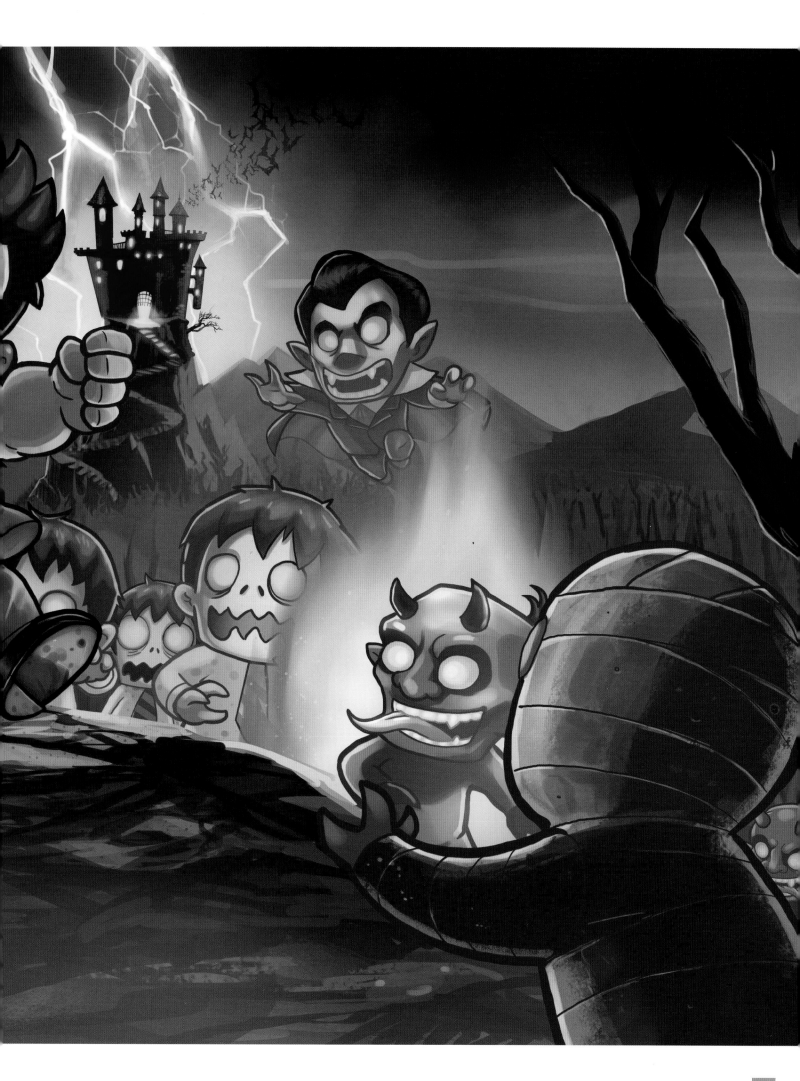

MONSTERS!

It wouldn't be a "Monster Dash" without these hideous creatures. It would just be a "Dash."

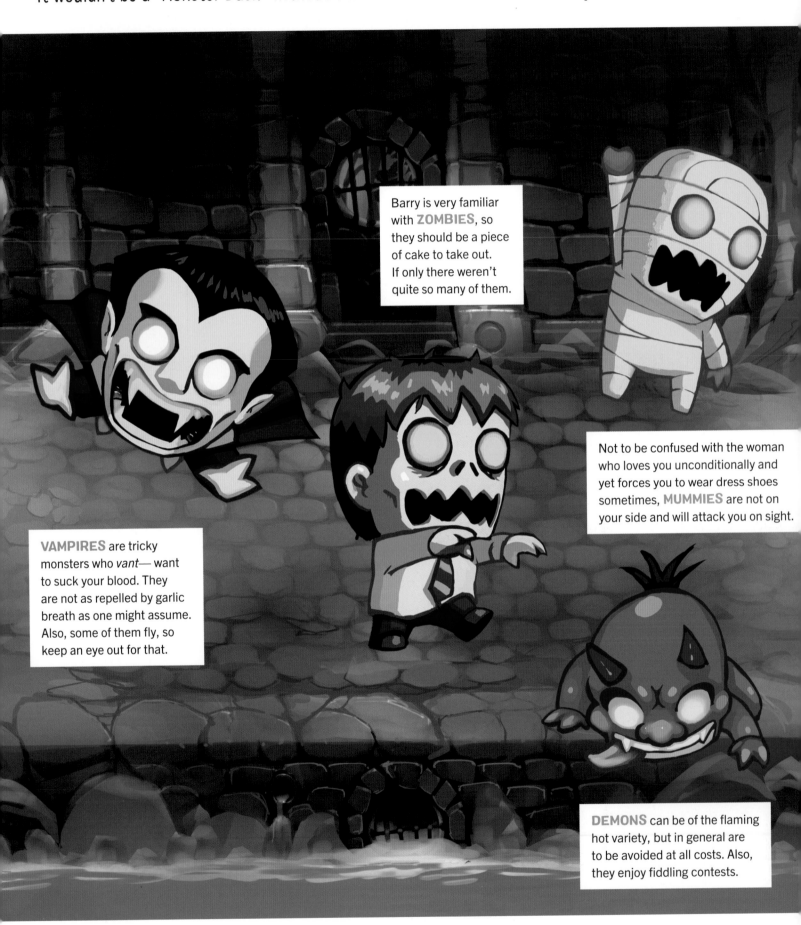

Barry is very familiar with **ZOMBIES**, so they should be a piece of cake to take out. If only there weren't quite so many of them.

Not to be confused with the woman who loves you unconditionally and yet forces you to wear dress shoes sometimes, **MUMMIES** are not on your side and will attack you on sight.

VAMPIRES are tricky monsters who *vant*— want to suck your blood. They are not as repelled by garlic breath as one might assume. Also, some of them fly, so keep an eye out for that.

DEMONS can be of the flaming hot variety, but in general are to be avoided at all costs. Also, they enjoy fiddling contests.

ABOVE: Concept art for various levels of *Monster Dash*, released in August 2010.

SPOOKY HAUNTS

Barry is transported to a different level every thousand yards, just to keep him on his toes. What awaits him in each monster-infested locale?

There's a series of runners, with the levels changing each time Barry visits them. Players must navigate gaping pits, menacing spikes, and of course, spooky monsters. The four original locations are Demon Dynasty, Tomb Town, Vampire Kingdom, and Zombie Metropolis, with Yeti Heights added in a later update. Each location features unique enemies, environmental hazards, and rocking music to set the monster-killing mood.

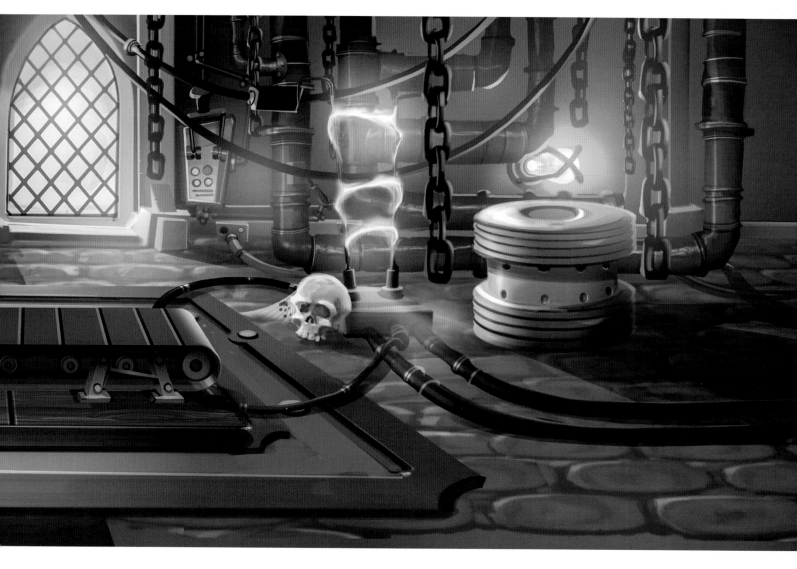

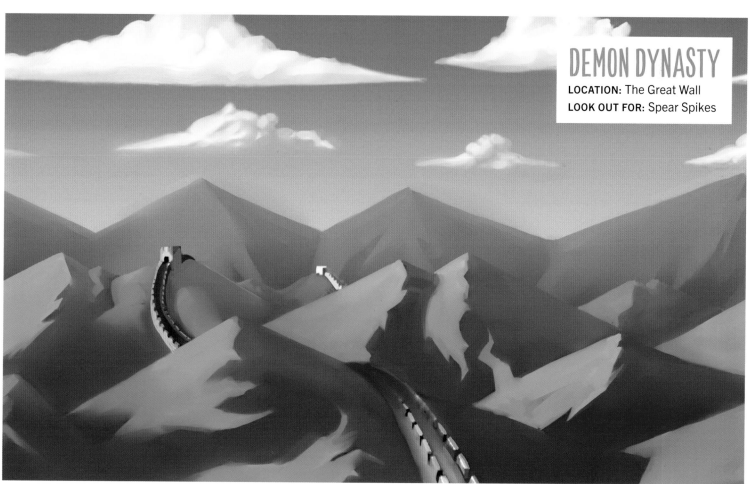

DEMON DYNASTY
LOCATION: The Great Wall
LOOK OUT FOR: Spear Spikes

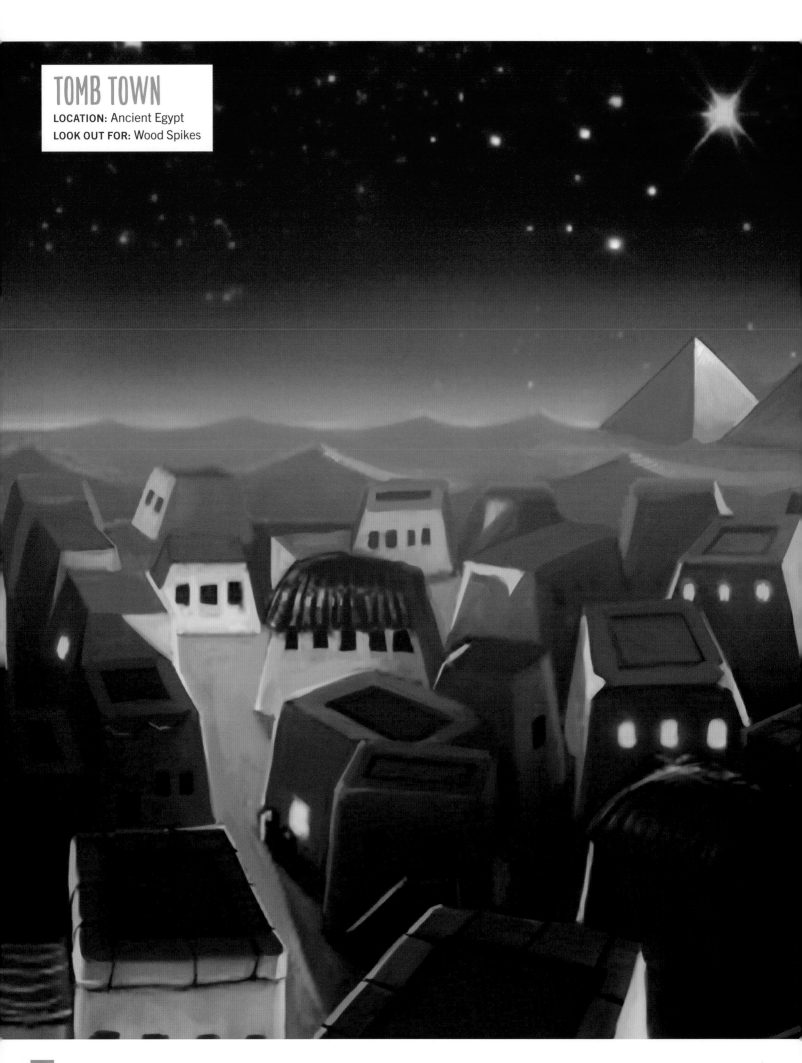

TOMB TOWN

LOCATION: Ancient Egypt
LOOK OUT FOR: Wood Spikes

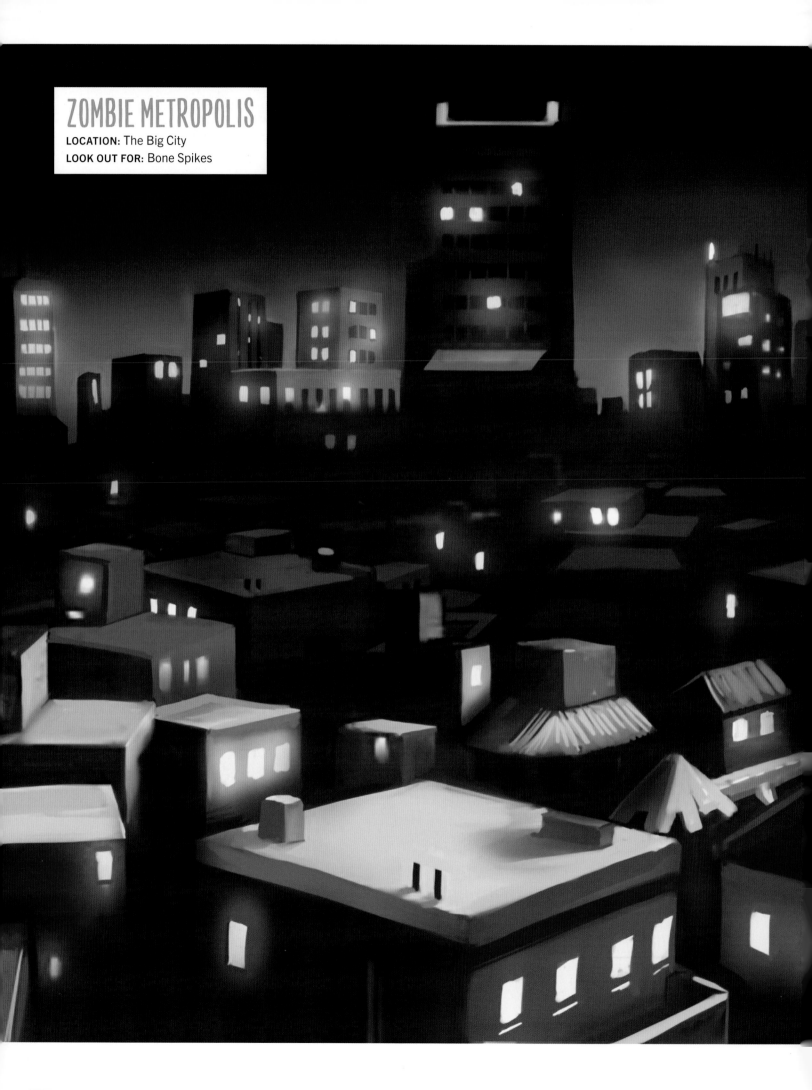

WEAPONS

Every monster slayer needs a trusty weapon to take on the hordes of evil, and *Monster Dash* has several to choose from!

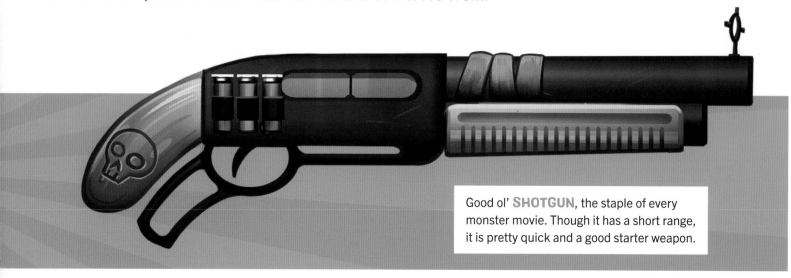

Good ol' **SHOTGUN**, the staple of every monster movie. Though it has a short range, it is pretty quick and a good starter weapon.

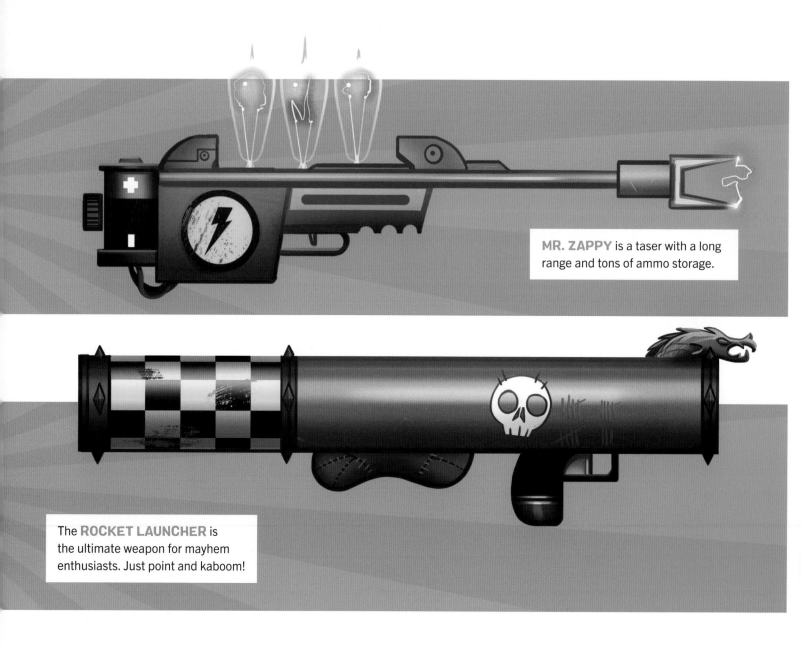

MR. ZAPPY is a taser with a long range and tons of ammo storage.

The **ROCKET LAUNCHER** is the ultimate weapon for mayhem enthusiasts. Just point and kaboom!

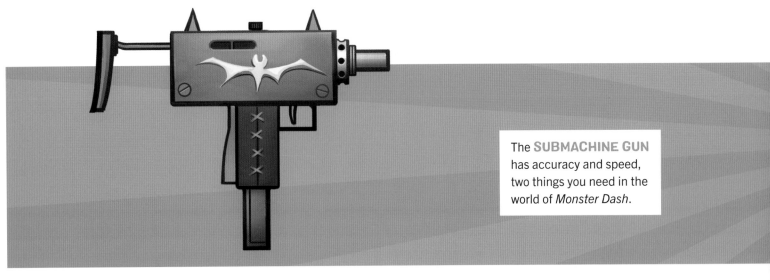

The **SUBMACHINE GUN** has accuracy and speed, two things you need in the world of *Monster Dash*.

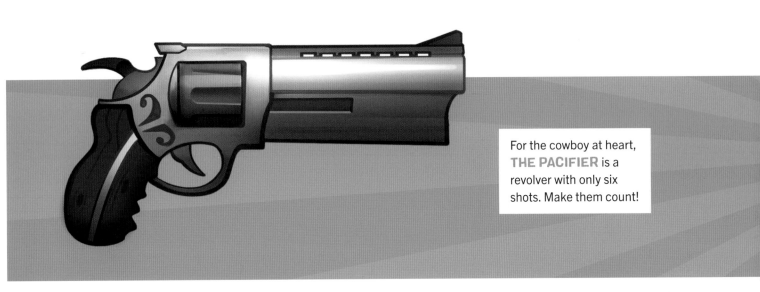

For the cowboy at heart, **THE PACIFIER** is a revolver with only six shots. Make them count!

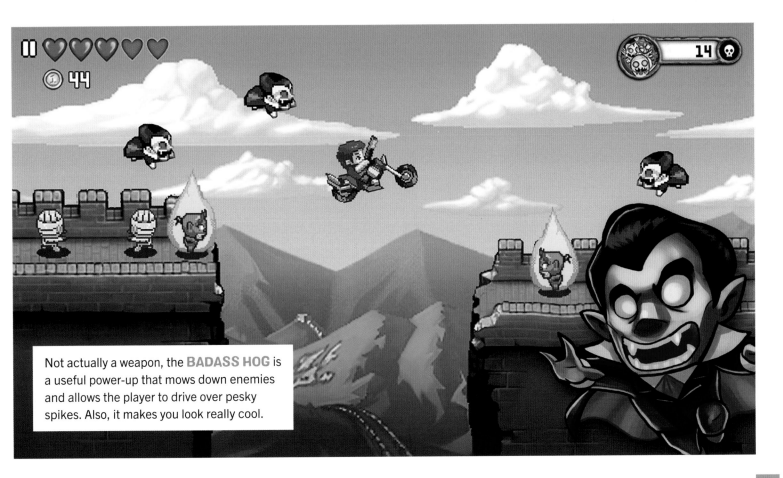

Not actually a weapon, the **BADASS HOG** is a useful power-up that mows down enemies and allows the player to drive over pesky spikes. Also, it makes you look really cool.

JETPACK JOYRIDE

Barry Steakfries blasts his way into a secret lab to steal a jetpack, kickstarting an epic joyride through this side-scrolling endless runner. Commandeering experimental jetpacks, gadgets, and vehicles from potentially evil scientists, players must control Barry as he collects coins, completes missions, and commits mayhem. A joyride is defined as being out-of-control, illegal, fast, and fun— and that's just what this game is all about.

An Apple Design Award Winner with over 750 million downloads and 1.1 million daily players, *Jetpack Joyride* was the number one mobile game in ninety-nine countries when it was released. The concept and controls are simple yet addictive, and the cathartic, mindless joy of destruction is at the forefront in this retro and colorful mobile game.

Jetpack Joyride is different from most endless runners in that the protagonist is running *toward* danger, not from it. To understand why, you'd have to understand the mind of Barry.

BUT WHY DOES HE HATE SLEEVES?

Barry Steakfries was once a downtrodden gramophone salesman. As he door-knocked for interested customers, Barry stumbled upon the Legitimate Research Facility. From the corner of his eye, Barry caught a glimpse of some scientists working on a jetpack inside the building. It was love at first sight—Barry rips off his sleeves, breaks into the lab, and steals the Jetpack, blasting his way through the walls looking for the nearest exit.

Barry is a guy who seems to have a bit of a mayhem streak within him. He wants to do good, and never means to cause any harm to anyone, but he tends to get carried away because he lives in the moment. How did such a quirky character find his home in *Jetpack Joyride*?

Luke Muscat, designer of *Fruit Ninja*, came up with the concept of *Jetpack Joyride*. He liked the idea of endless runner games and wanted to create a new one with extremely simple interactions. Muscat set out to design a game that used only one-touch controls, but still had a ton of depth and replay value.

He pitched *Jetpack Joyride* to the company, it was greenlit, and the rest is history. Though Halfbrick had experience with endless runners via *Monster Dash*, *Jetpack Joyride* brought a new twist to the gameplay, creating something uniquely addictive. And no one was better suited for the job than Barry Steakfries, a character eager to escape the normalcy of life. This is the fourth game to feature Barry Steakfries, the everyman with a strong sense of adventure.

Jetpack Joyride was originally going to be titled *Machine Gun Jetpack*, after the popular vehicle in *Monster Dash*.

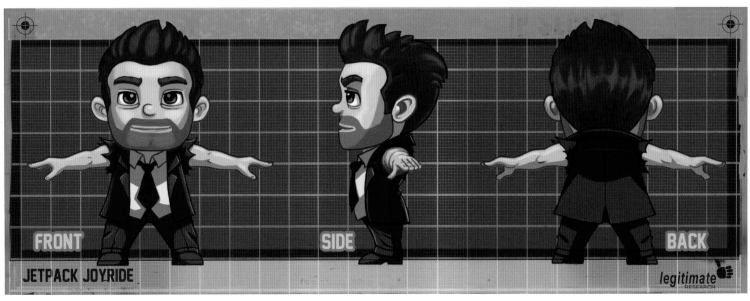

JETPACK JOYRIDE

FRONT SIDE BACK

legitimate RESEARCH

The in-game art style came from Sierra Asher, who was a fan of older, retro-style pixel games. As the game progressed through development, it required collaboration from a number of artists who worked hard to ensure that the style was consistent throughout the game.

Throughout development, it was reiterated that *Jetpack Joyride* is a game about throwing off the shackles of everyday life, blowing up the rules, and just going for "it," whatever it is. The world is creative—from the wacky inventions of the scientists to the insane use Barry finds for them, the creativity is a hint to players to try their own unique combinations of gadgets and vehicles. *Jetpack Joyride* is a mobile game meant to be liberating, irreverent, and optimistic. Just like Barry.

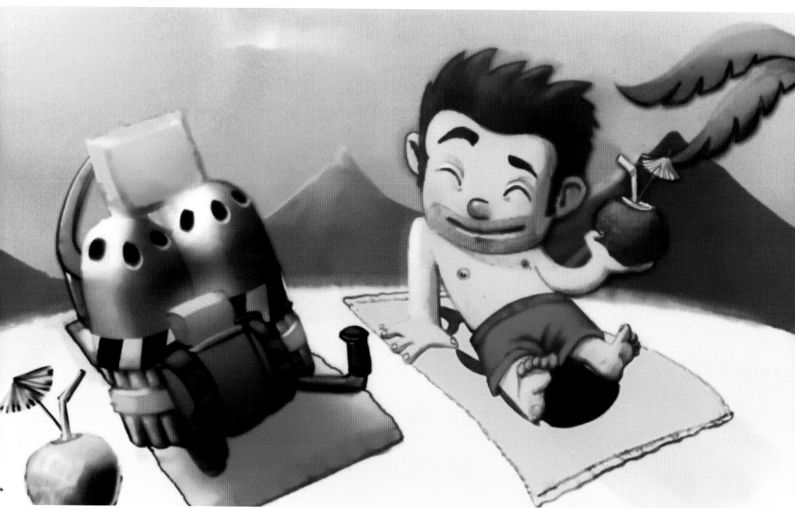

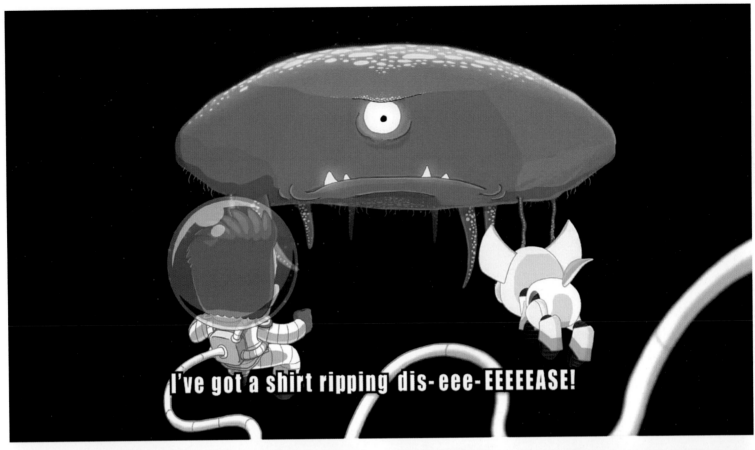

I've got a shirt ripping dis-eee-EEEEEASE!

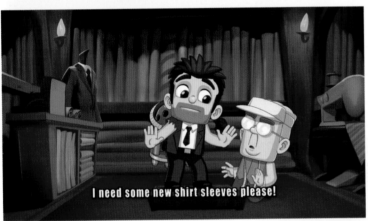

I need some new shirt sleeves please!

ROCKING THEME SONG!

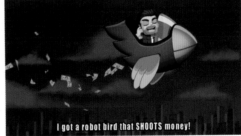

I got a robot bird that SHOOTS money!

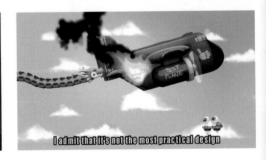

I admit that it's not the most practical design

ABOVE: Images from the *Jetpack Joyride Rock Opera*, released in 2015.

ROCK OUT

Halfbrick is known for thinking outside of the box when it comes to game marketing. With the *Barry Steakfries Rock Operas*, they hit it out of the park.

Released on YouTube and amassing over 80 Million views, the songs were not only successful, but they also helped to bring the characters of *Jetpack Joyride* to life. The gorgeous animation and catchy lyrics were a match made in gaming heaven. The series even introduced a few new characters, such as Barry's ex-girlfriend and his tailor. The videos also gave a little more insight into why the scientists create what they create, and why Barry never has any sleeves.

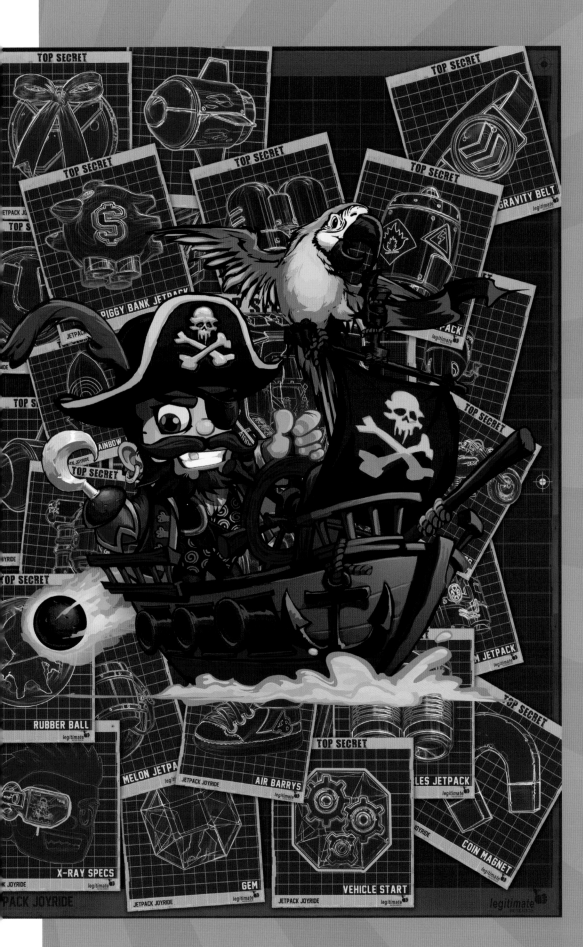

ARTIST INTERVIEW WITH BOB JONES

Bob Jones is an illustrator, concept artist, and marketing artist at Halfbrick. He has been at Halfbrick for six years and worked on the marketing of *Jetpack Joyride*.

How would you describe your style?
I try to retain classic, old, cartoon styles, but I also try to keep the style of the game if it has one already. This current game I am working on, for example, requires a lot of very realistic looking styles.

Favorite Jetpack or Gadget?
Flash the robotic wonder dog. Flash is inspired by the real-life Flash, a dog owned by a past producer of *Jetpack Joyride*. Flash has since passed away, but he lives on in the hearts of fans and in *Jetpack Joyride*.

Favorite part of *Jetpack Joyride* to work on?
The publicity, marketing art, and story ideas are my favorite part. It is more fun creating and fleshing out the world story than adjusting subtle variations of small items.

FOR SCIENCE!

When Barry breaks into the lab to steal the Jetpack, he quickly finds that he is not alone. From the scientists who are trying to stop him to the unexpectedly cuddly robotic companion, these are the characters of *Jetpack Joyride*.

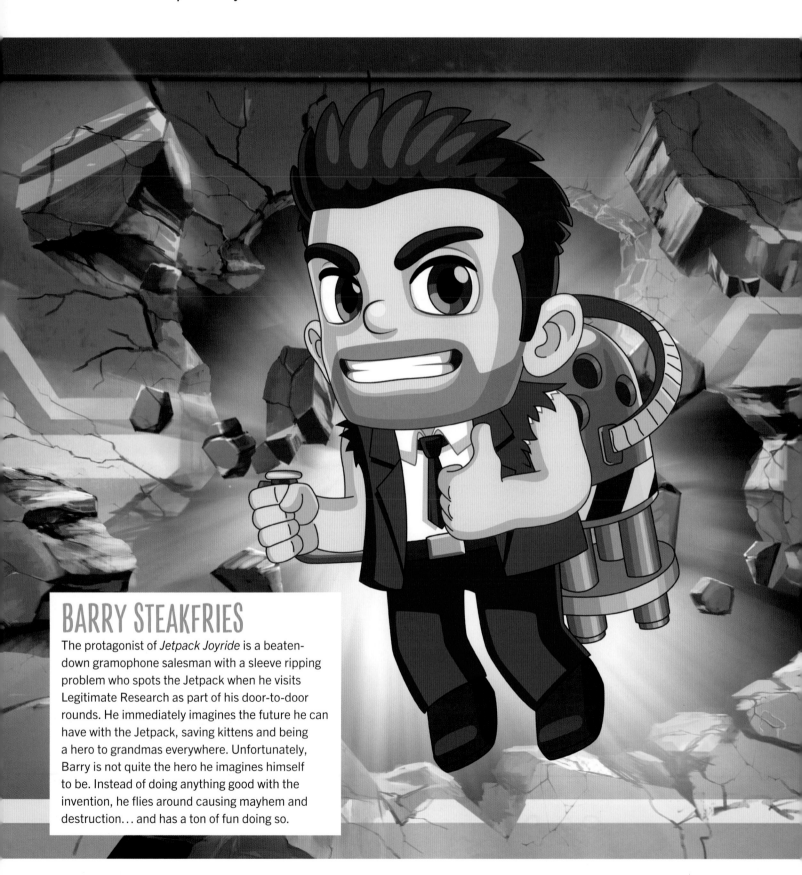

BARRY STEAKFRIES

The protagonist of *Jetpack Joyride* is a beaten-down gramophone salesman with a sleeve ripping problem who spots the Jetpack when he visits Legitimate Research as part of his door-to-door rounds. He immediately imagines the future he can have with the Jetpack, saving kittens and being a hero to grandmas everywhere. Unfortunately, Barry is not quite the hero he imagines himself to be. Instead of doing anything good with the invention, he flies around causing mayhem and destruction… and has a ton of fun doing so.

SCIENTISTS

Employed by Legitimate Research, these scientists work hard to create awesome vehicles and gadgets. Unfortunately, they don't often think through their ideas, and as a result, most of their inventions are useless. But these scientists won't let that stop them from trying.

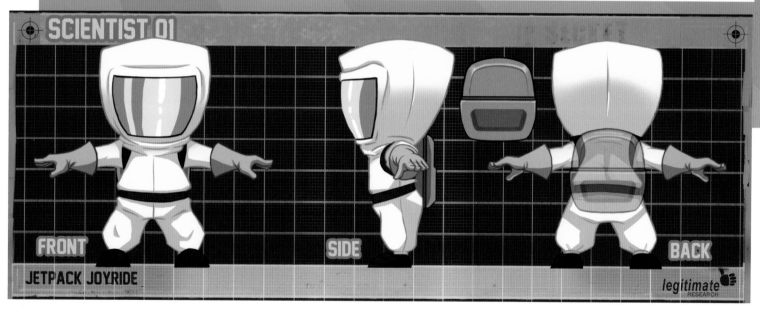

SCIENTIST 01

FRONT SIDE BACK

JETPACK JOYRIDE

legitimate RESEARCH

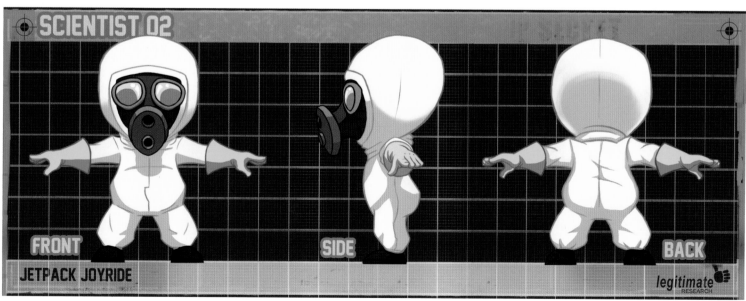

SCIENTIST 02

FRONT SIDE BACK

JETPACK JOYRIDE

legitimate RESEARCH

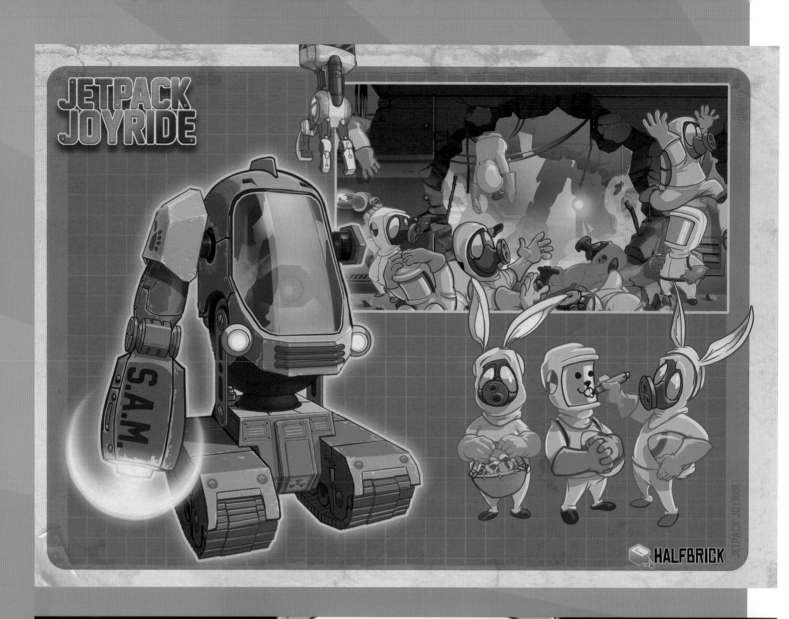

BARRY'S TAILOR

Barry's Tailor is the man Barry turns to when he needs his sleeves sewn back on. Barry has a bit of a shirt ripping disease and cannot seem to help himself. Luckily for him, the Tailor charges a very reasonable fee. It is a mutually beneficial relationship, as Barry keeps the Tailor in business and the Tailor keeps Barry supplied with sleeves— for a short amount of time.

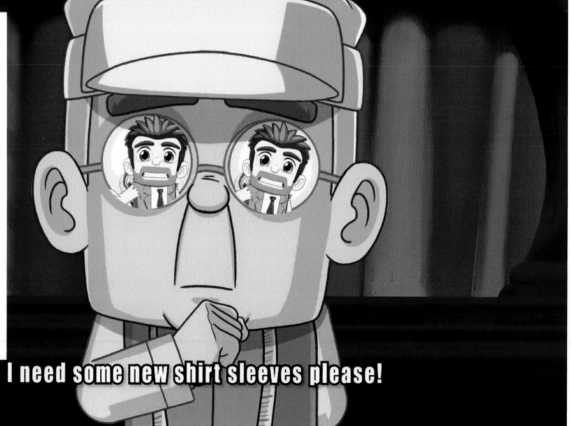

I need some new shirt sleeves please!

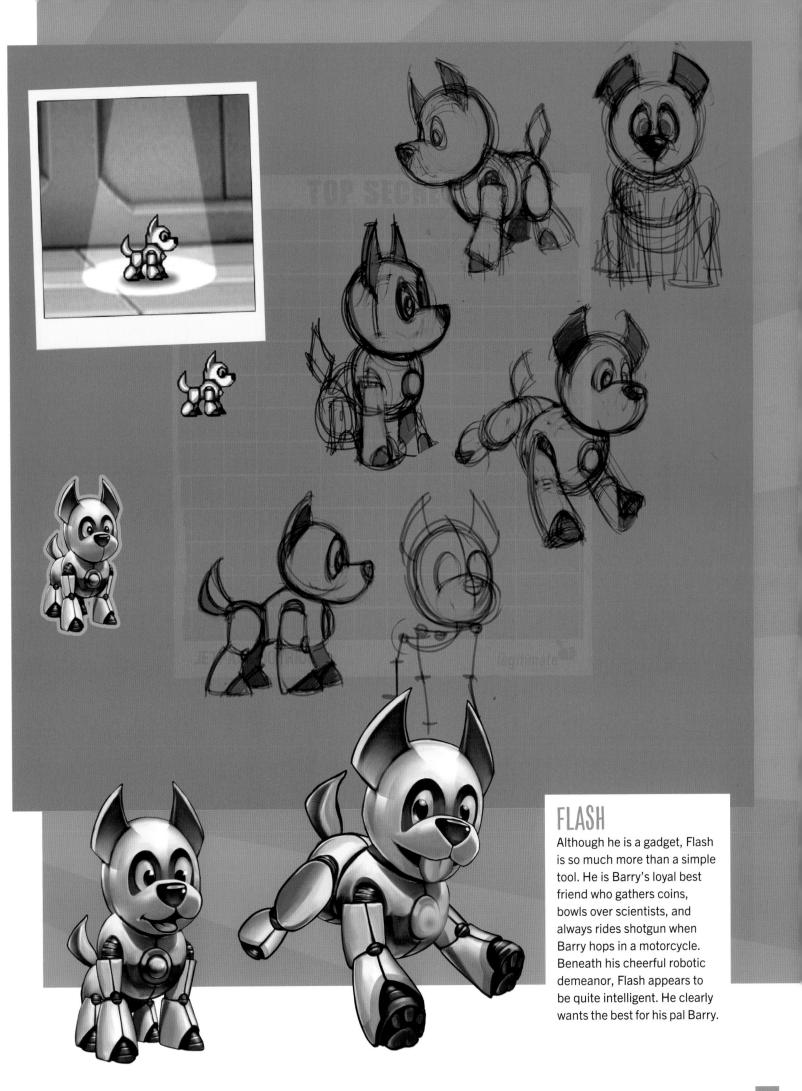

FLASH

Although he is a gadget, Flash is so much more than a simple tool. He is Barry's loyal best friend who gathers coins, bowls over scientists, and always rides shotgun when Barry hops in a motorcycle. Beneath his cheerful robotic demeanor, Flash appears to be quite intelligent. He clearly wants the best for his pal Barry.

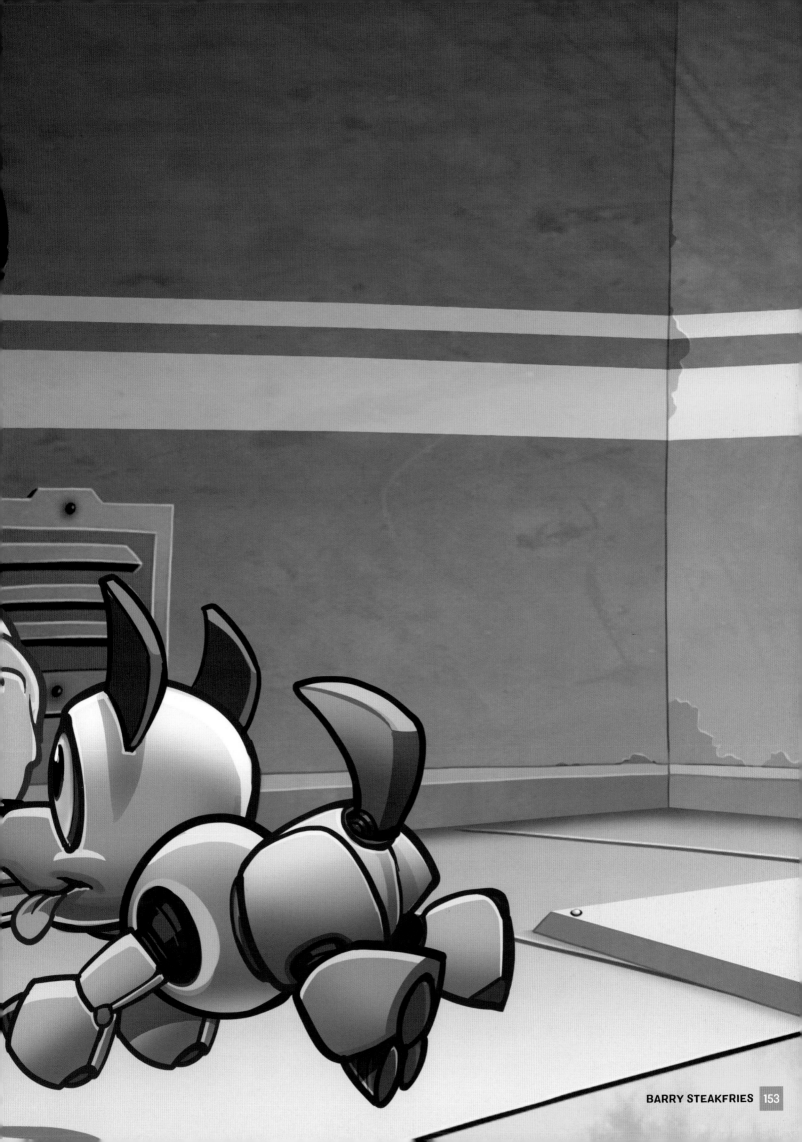

JETPACKS FOR DAYS

The Machine Gun Jetpack wasn't the only exotic propulsion device Barry found at the Legitimate Research lab.

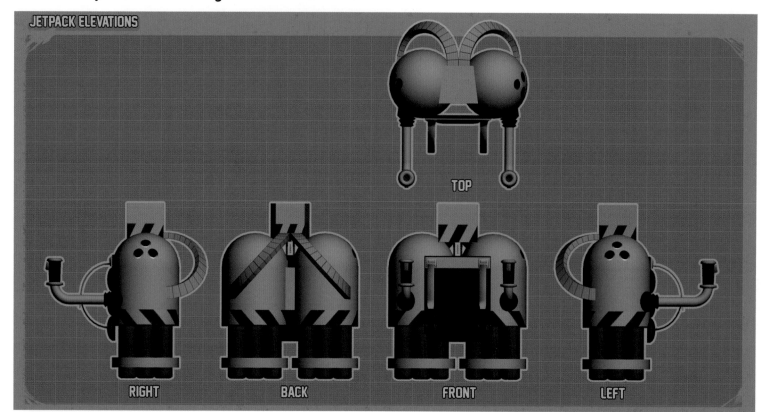

JETPACK ELEVATIONS

TOP

RIGHT BACK FRONT LEFT

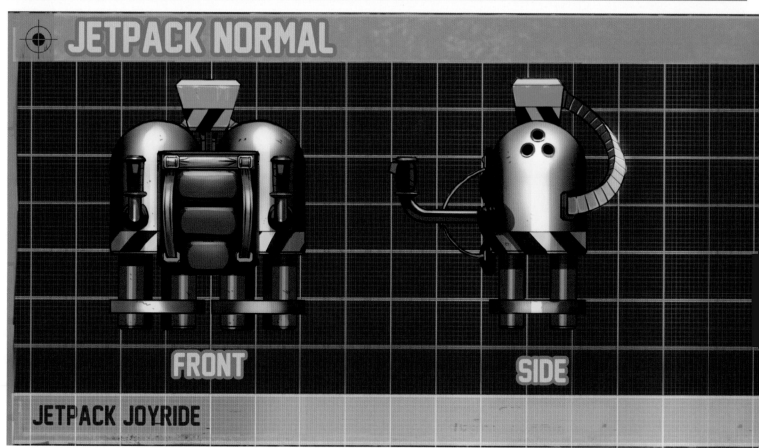

JETPACK NORMAL

FRONT SIDE

JETPACK JOYRIDE

MACHINE GUN JETPACK

This is the jetpack that started it all. The original jetpack is part machine gun, part flying device.

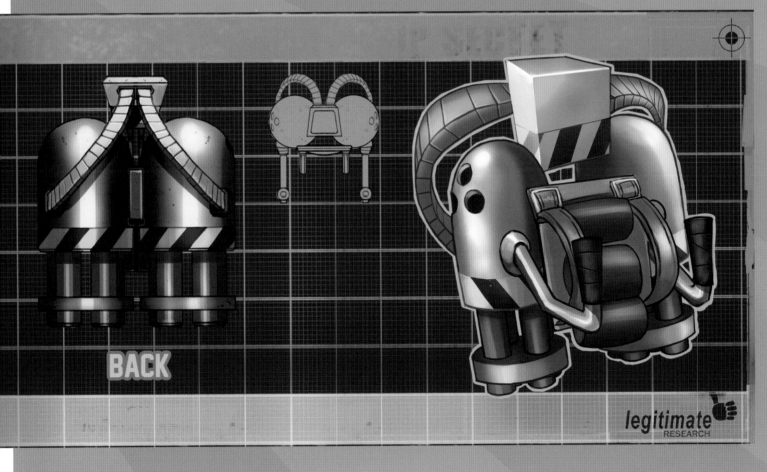

BACK

legitimate RESEARCH

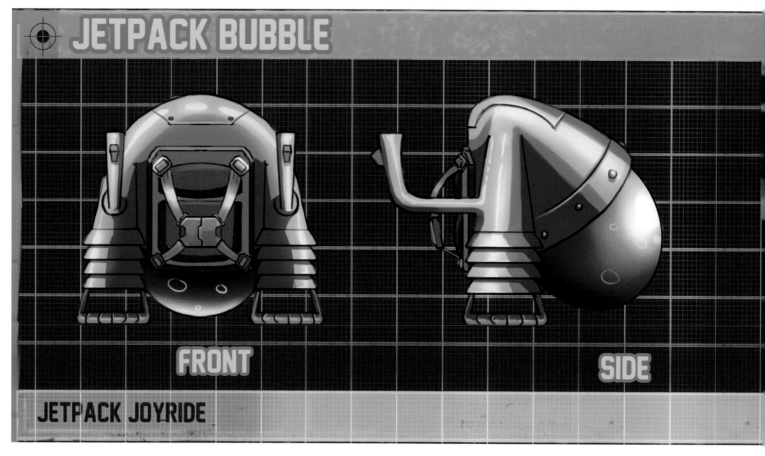

JETPACK BUBBLE

FRONT

SIDE

JETPACK JOYRIDE

BUBBLE GUN JETPACK
Not to be confused with bubble gum, bubble gun shoots bubbles.

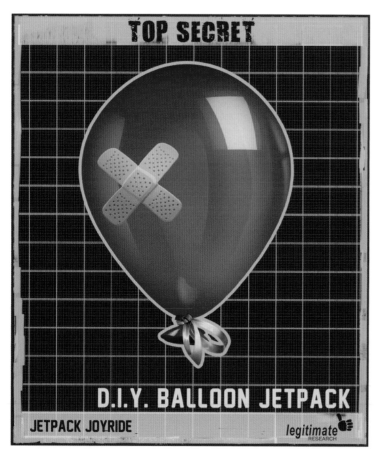

TOP SECRET

D.I.Y. BALLOON JETPACK

JETPACK JOYRIDE legitimate RESEARCH

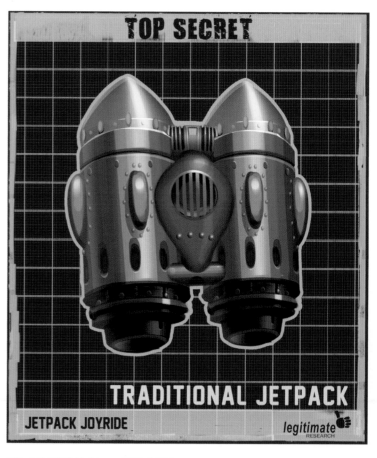

TOP SECRET

TRADITIONAL JETPACK

JETPACK JOYRIDE legitimate RESEARCH

DIY JETPACK
Do NOT try this at home. The Do-It-Yourself Jetpack is made of duct tape and dreams.

TRADITIONAL JETPACK
Back in your gran's day, this was the only trusted method of jetpacking.

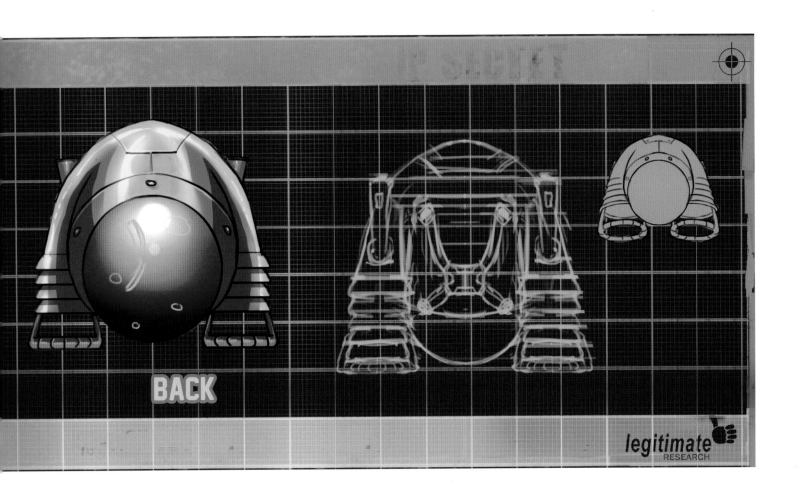

legitimate RESEARCH

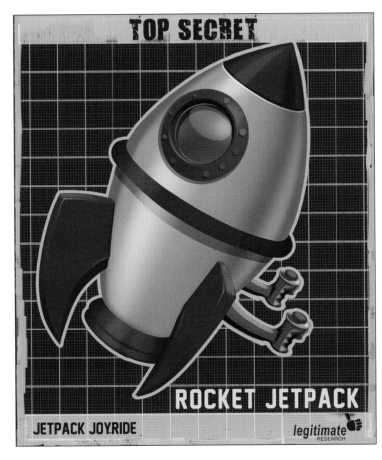

TOP SECRET

ROCKET JETPACK

JETPACK JOYRIDE legitimate RESEARCH

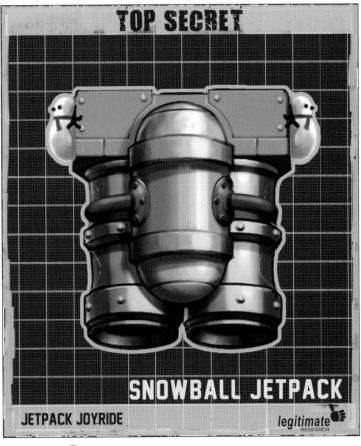

TOP SECRET

SNOWBALL JETPACK

JETPACK JOYRIDE legitimate RESEARCH

BLAST OFF JETPACK

An adorable space rocket design sets this jetpack apart from the rest of the packs.

SNOW MACHINE JETPACK

The ultimate winter revenge. This cool jetpack shoots snow at your enemies.

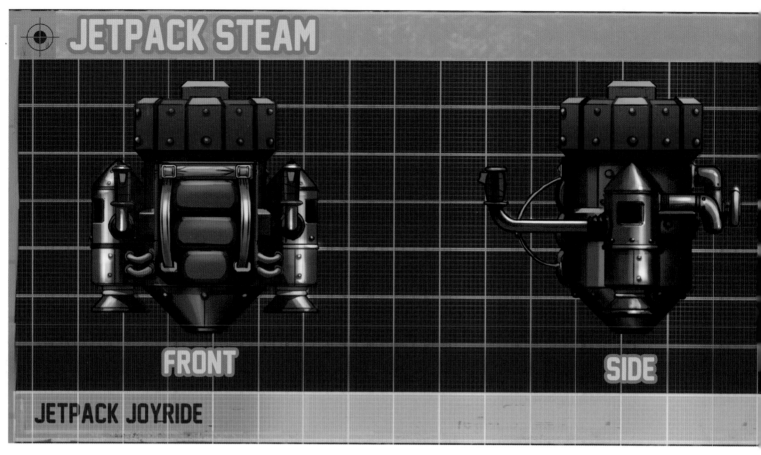

STEAM JETPACK

An old steam train that was re-purposed into this industrial age-esque jetpack.

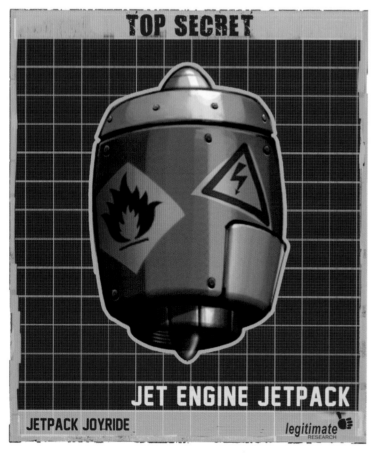

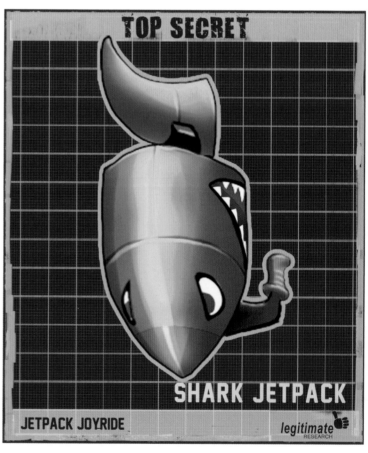

CHROME PLATED AFTERBURNER JETPACK

Nothing beats a jetpack made from an old fighter jet—especially one made of chrome.

GOLDEN SHARK HEAD JETPACK

What's better than a shark? A golden shark.

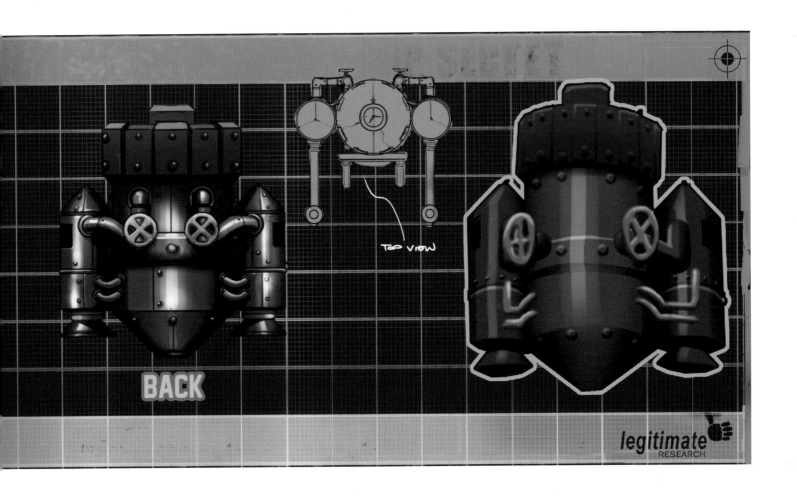

BACK

TOP VIEW

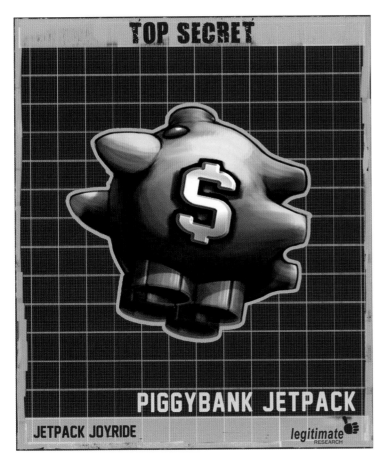

PIGGYBANK JETPACK

JETPACK JOYRIDE

PARTY JETPACK

JETPACK JOYRIDE

PIGGY BANK JETPACK

This disgustingly lavish jetpack launches 1928 issue $1,000 bills.

PARTY JETPACK

There's always time to party when the party is in your jetpack.

JETPACK FRUIT

FRONT

SIDE

JETPACK JOYRIDE

FRUIT JETPACK

Use the abilities of fruitjitsu with this juicy jetpack. Probably created by Sensei.

TOP SECRET

WATER JETPACK

JETPACK JOYRIDE

legitimate RESEARCH

TOP SECRET

LEAFBLOWER JETPACK

JETPACK JOYRIDE

legitimate RESEARCH

WATER JETPACK

Although the scientists failed to make a lightning-fast gardening tool, they succeeded at making a water jetpack that blasts into the air on H2O.

LEAF BLOWER JETPACK

How do you make yard chores and escaping from scientists' clutches fun? Use this jetpack to blow boring housework away.

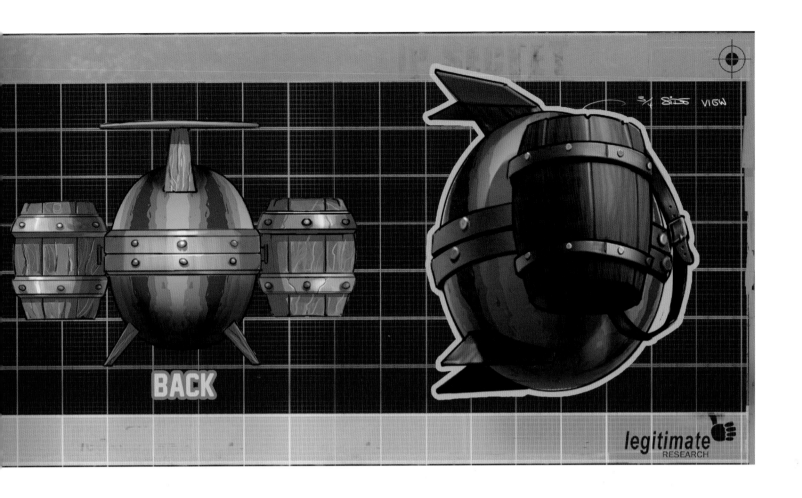

BACK

legitimate RESEARCH

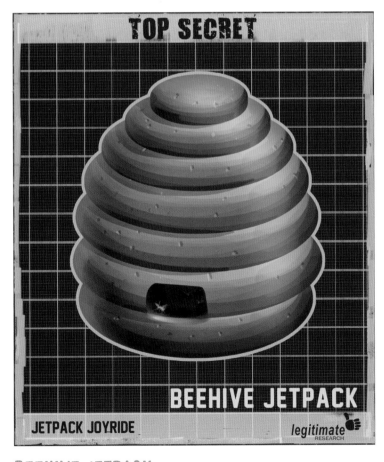

TOP SECRET

BEEHIVE JETPACK

JETPACK JOYRIDE

legitimate RESEARCH

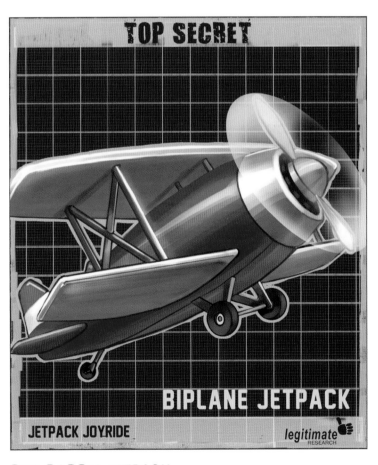

TOP SECRET

BIPLANE JETPACK

JETPACK JOYRIDE

legitimate RESEARCH

BEEHIVE JETPACK

Not the bees. Not the bees! To which this jetpack replies, yes, the bees.

RED BARRY JETPACK

Scientific rumor has it that this jetpack was once a full-sized and very famous plane.

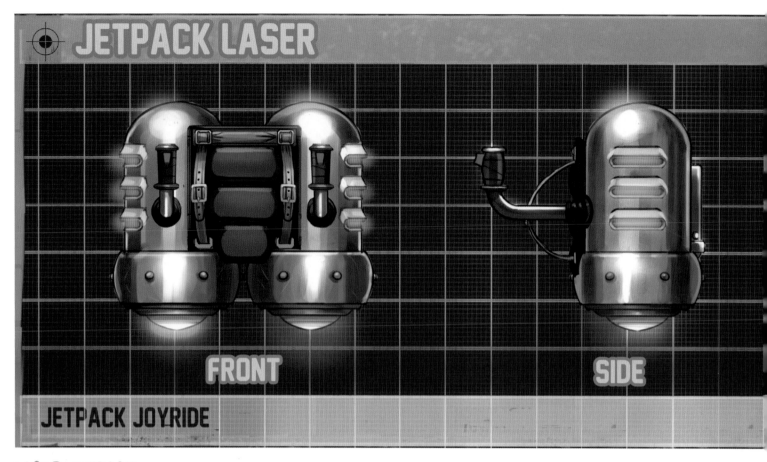

LASER JETPACK

This unholy union of laser and flight machine was both unnecessary and very cool.

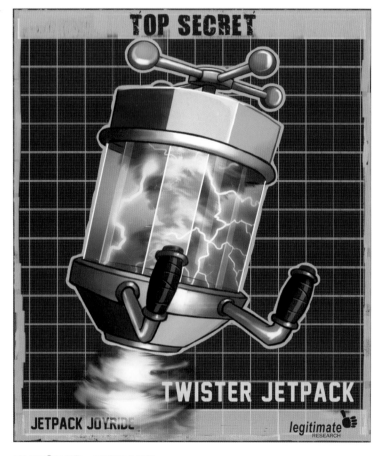

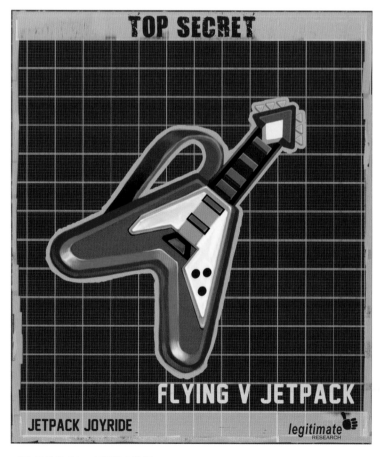

TWISTER JETPACK

This jetpack contains an F3 tornado and is not messing around!

FLYING V JETPACK

When you need to rock out, this is the jetpack to use. Warning: may cause lightning.

legitimate RESEARCH

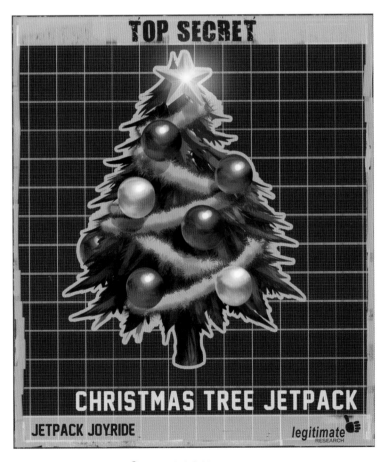

TOP SECRET

CHRISTMAS TREE JETPACK

JETPACK JOYRIDE

legitimate RESEARCH

TOP SECRET

PUMPKIN JETPACK

JETPACK JOYRIDE

legitimate RESEARCH

DECK THE HALLS JETPACK

Deck the halls with exploding baubles and tinsel with this Christmas Tree jetpack.

PUMPKIN JETPACK

Just like a regular Halloween pumpkin, this jetpack shoots candy and helps you fly.

JETPACK SHARK

FRONT

SIDE

JETPACK JOYRIDE

SHARK HEAD JETPACK

Sharks are really cool, so it makes sense that someone would make a jetpack that looks like one.

TOP SECRET

TEDDY JETPACK

JETPACK JOYRIDE — legitimate RESEARCH

TOP SECRET

GOLD MGJP JETPACK

JETPACK JOYRIDE — legitimate RESEARCH

TEDDY JETPACK

Hang on for dear life as you gallivant about while being powered by the innocent love of a stuffed bear.

GOLDEN MACHINE GUN JETPACK

Like a machine gun jetpack, but golden. Golden things are inherently better.

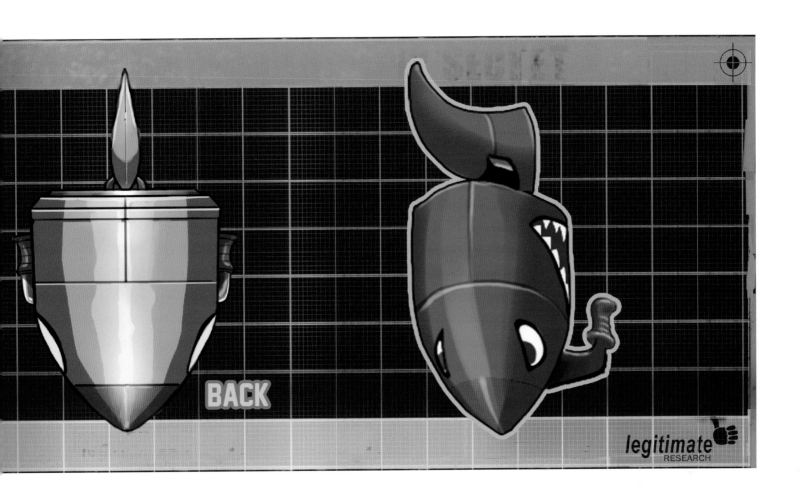

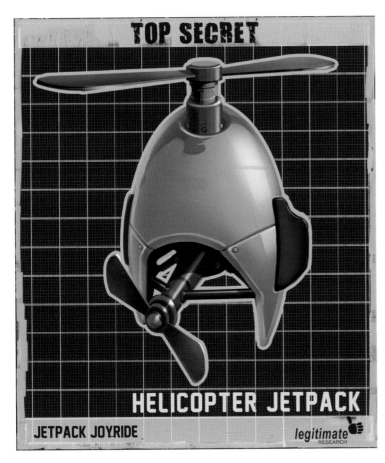

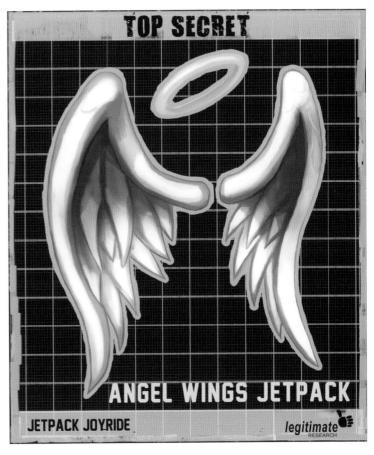

HELICOPTER JETPACK
Become the copter of your dreams with the helicopter jetpack.

ANGEL WINGS JETPACK
Rise to the heavens on this beautiful jetpack, complete with chorus and halo.

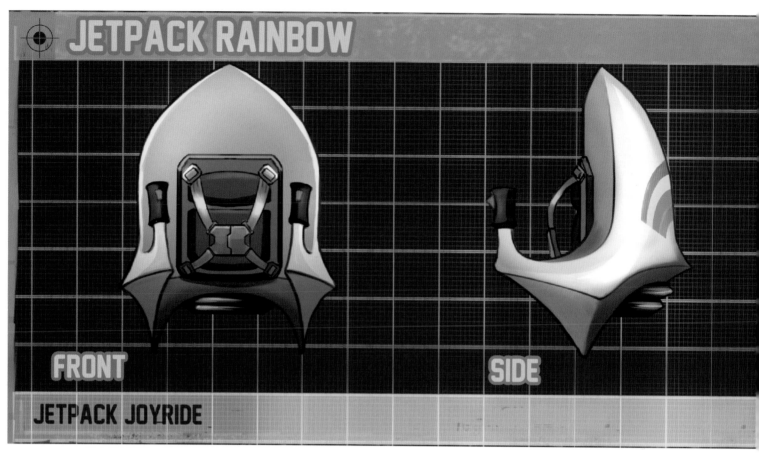

FRONT

SIDE

JETPACK JOYRIDE

RAINBOW JETPACK

The most fabulous mode of transportation, defy physics with the power of refracted light.

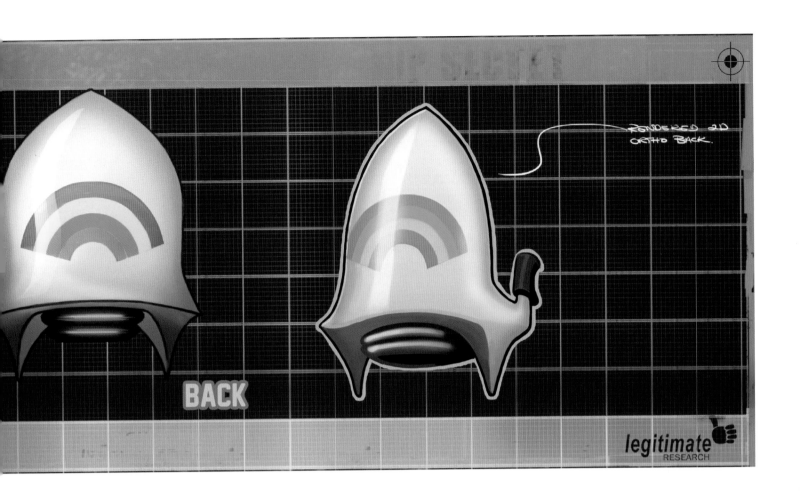

RENDERED 2D
ORTHO BACK.

BACK

legitimate
RESEARCH

7424M

790

GADGETS AND SUCH

The Legitimate Research lab doesn't just specialize in jetpacks— they have all sorts of wacky gadgets and vehicles just laying around the office waiting for Barry to snatch them up! Try combining gadgets for even weirder results.

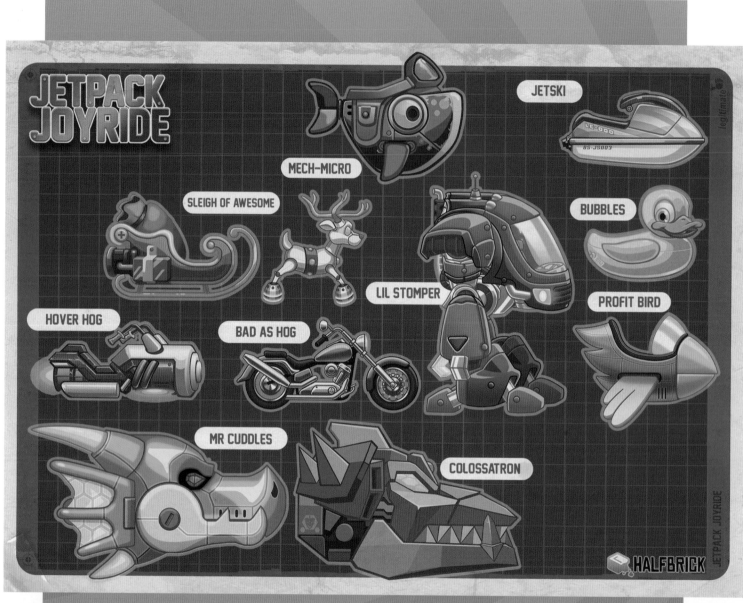

GADGETS

TOP SECRET

AIR BARRYS

JETPACK JOYRIDE legitimate RESEARCH

AIR BARRYS
Not all sneakers allow the wearer to spring smoothly over obstructions. That's what makes these "designer" shoes.

TOP SECRET

JETPACK JOYRIDE legitimate RESEARCH

NERD REPELLENT
Unfortunately, the nerds who created this did not really think this repellent through.

TOP SECRET

RUBBER BALL

JETPACK JOYRIDE legitimate RESEARCH

INSTA-BALL
Instead of landing with a splat, land with a bounce in this safety ball.

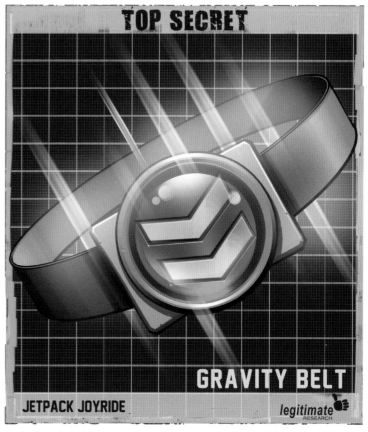

TOP SECRET

GRAVITY BELT

JETPACK JOYRIDE legitimate RESEARCH

GRAVITY BELT
Fall quicker than ever with this gravity belt. Combine it with other gadgets for interesting results.

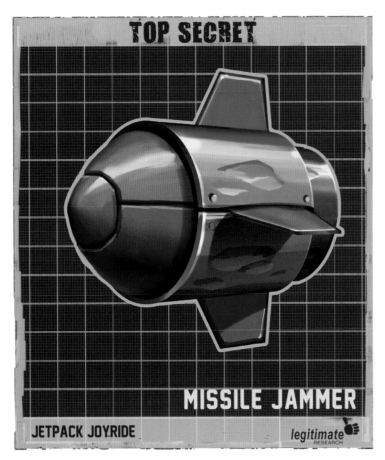

MISSILE JAMMER

Misguide some missiles with this jammer.
Warning: does not always work.

TOKEN GIFT

Not a token gift in the traditional sense, but in the
sense that it is the gift of a Spin Token.

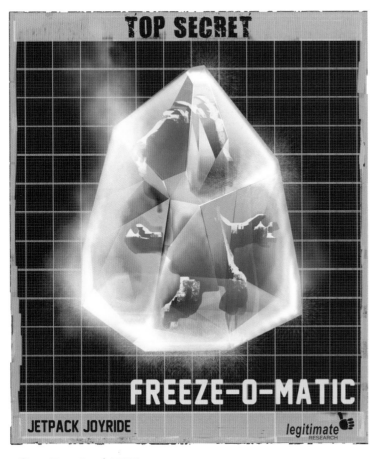

FREEZE-O-MATIC

Keep Barry on ice. Well, in ice, allowing him to slide
gracefully away from danger like a speedy popsicle.

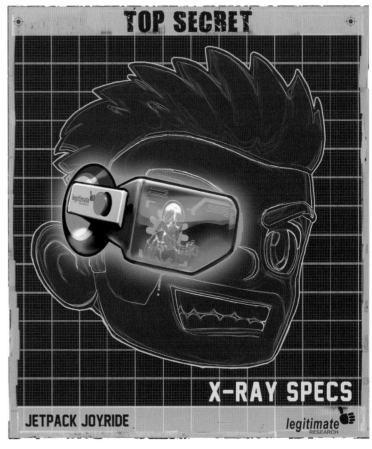

X-RAY SPECS

Grants x-ray vision, allowing Barry to see important
and unimportant hidden things.

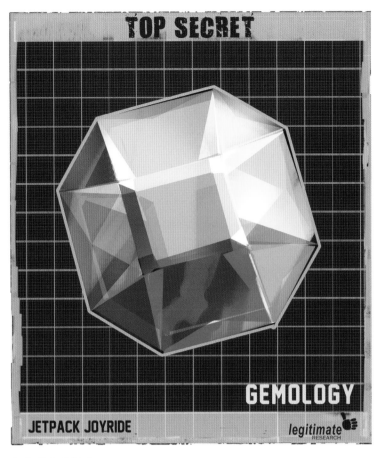

TOP SECRET

GEMOLOGY

JETPACK JOYRIDE

legitimate
RESEARCH

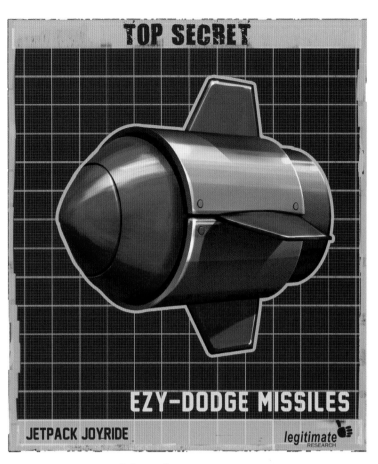

TOP SECRET

EZY-DODGE MISSILES

JETPACK JOYRIDE

legitimate
RESEARCH

GEMOLOGY

This gadget turns all coins minted after 1985 into high-value gems.

EZY-DODGE MISSILES

Slows missiles to a more manageable dodging speed.

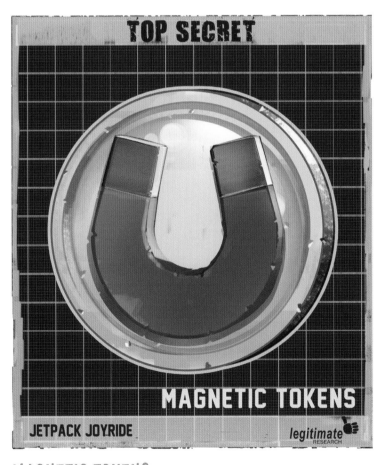

TOP SECRET

MAGNETIC TOKENS

JETPACK JOYRIDE

legitimate
RESEARCH

TOP SECRET

FLYING PIG

JETPACK JOYRIDE

legitimate
RESEARCH

MAGNETIC TOKENS

Magnets, how do they work? We're not sure,
but they make tokens easier to snag.

FLYING PIG

This highly-unstable coin transporter is quite fragile, so be careful.

FREE RIDE

Get the chance to start your chase the right away—
by crashing through the lab with your vehicle.

COIN MAGNET

Don't go chasing coins, make the coins chase you.

LUCKY LAST

Utilizing the power of Fortunium, the world's luckiest
element, this gadget improves your final Spin Token.

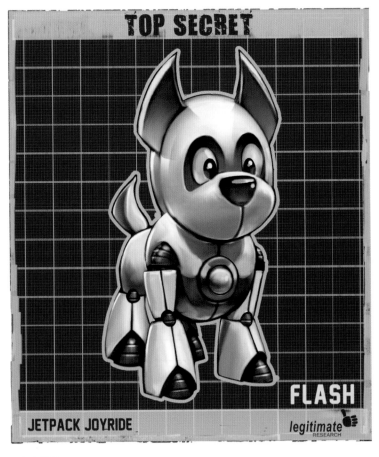

FLASH

The best friend any Barry could ask for! Flash fetches coins and
steam-rolls over scientists, clearing the way for you like a true BFF.

VEHICLES

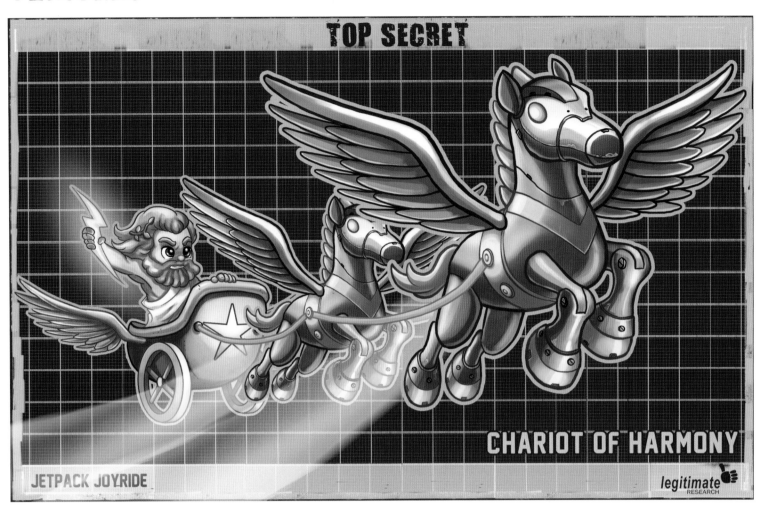

TOP SECRET

CHARIOT OF HARMONY

JETPACK JOYRIDE

legitimate RESEARCH

CHARIOT OF HARMONY

Fly though levels on this magical chariot that gives the "Sleigh of Awesome" a mythical new skin.

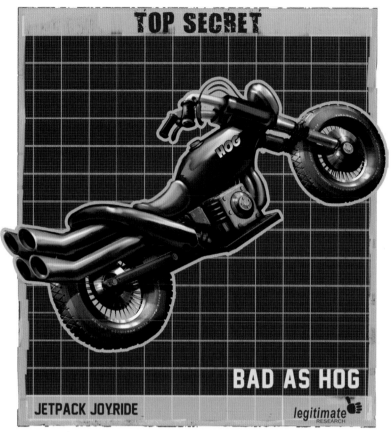

BAD AS HOG

Making its return from *Monster Dash*, this speedy motorcycle comes complete with leather jacket and shotgun for peak 80's nostalgia.

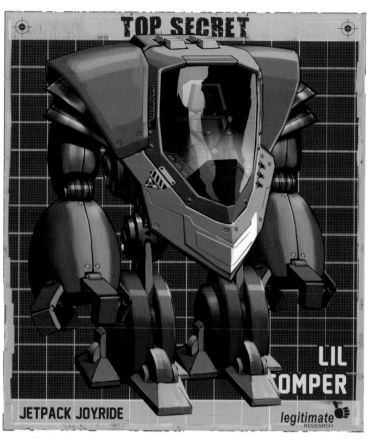

LIL STOMPER

A cute little mech suit stomping its way into the hearts of players everywhere.

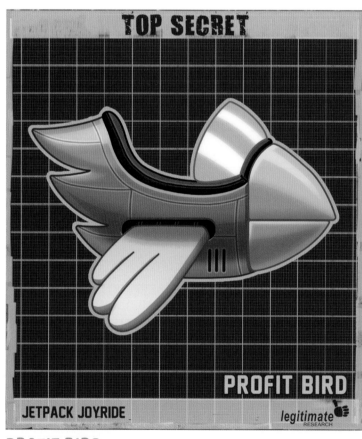

PROFIT BIRD

Originally designed as a flying ATM, this vehicle is a bit unwieldy and shoots money out of its backside.

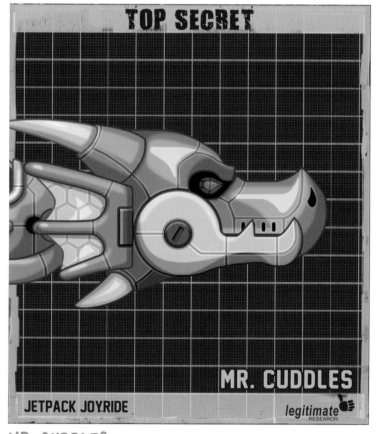

MR. CUDDLES

Designed for high altitude midair welding, this mecha dragon is very loving and shoots fire out of its mouth.

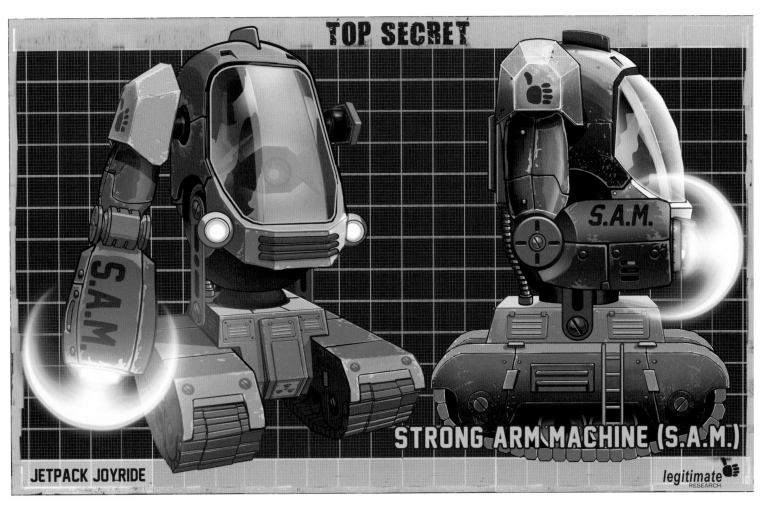

STRONG ARM MACHINE (S.A.M.)

JETPACK JOYRIDE

legitimate RESEARCH

STRONG ARM MACHINE (S.A.M.)

A huge mechanical suit named S.A.M. that is built for smashing rockets and chewing gum, and it's all out of gum.

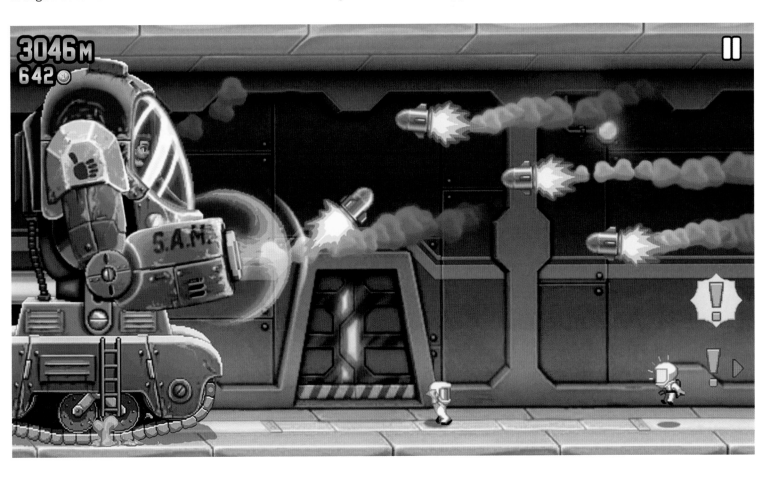

3046M
642

LEVEL UP!

Jetpack Joyride takes place within Legitimate Research, the underground lab devoted to creating strange inventions. The laboratory has a defense system in place to deal with intruders. With moving lasers, huge missiles, and plenty of scientists, the lab's defenses would be more than a match for most would-be thieves. Unfortunately for them, Barry is not like most guys. Also, he keeps breaking their wall.

While it may seem simple to keep the action in one location, the "runner" style of game has to have a very well-thought-out background. The loop must be seamless and organic looking, and it must also be interesting enough to keep gamers coming back for more.

In *Jetpack Joyride*, the location changes subtly over time, with signs, enemy placement, and other background elements. Some of the changes are a result of choices the player makes with various gadgets, and some are affected by a vehicle or lack of vehicle.

The defense system in particular has patterns that can be discovered by strategic players, who in turn can manipulate them with combinations of various gadgets to complete missions.

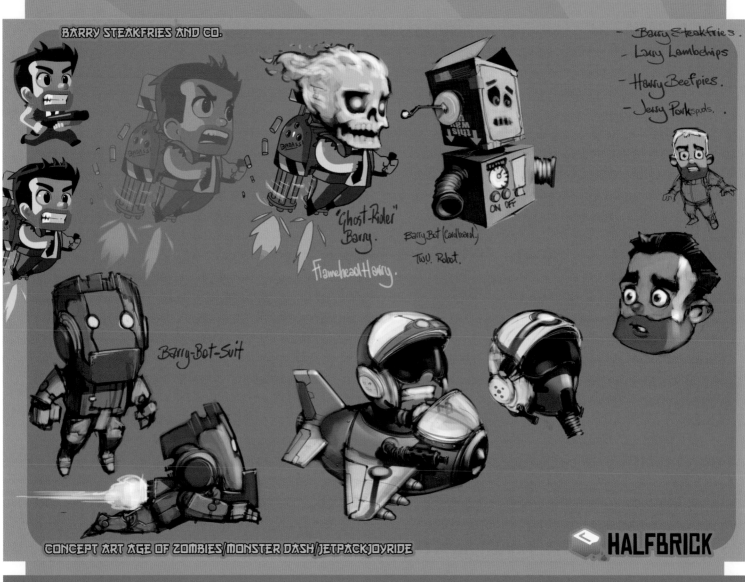

BARRY STEAKFRIES AND CO.

- Barry Steakfries.
- Larry Lambchips
- Harry Beefpies.
- Jerry Porkspuds.

"Ghost-Rider" Barry.

Flamehead Harry.

Barry Bot (Cardboard).
Two. Robot.

Barry-Bot-Suit

CONCEPT ART AGE OF ZOMBIES/MONSTER DASH/JETPACKJOYRIDE

HALFBRICK

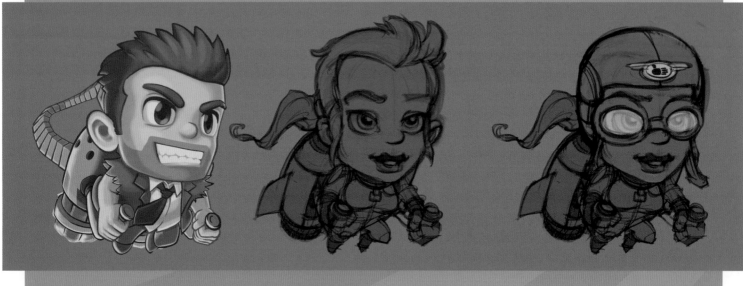

ABOVE: Unused
character concepts
for *Jetpack Joyride*.

DRESS FOR THE JOB YOU WANT

Barry has an undeniable sense of style that cannot be contained. "My favorite part of working on *Jetpack Joyride* was getting to create the card art for all of the different costumes," said Rod Wong, Concept Artist at Halfbrick.

"Barry has a ton of costumes and I had a blast doing them. At one stage, I even got to work on a few concepts for a female heroine for the *Jetpack Joyride* universe."

TOP SECRET

STITCHED UP OUTFIT

JETPACK JOYRIDE · legitimate RESEARCH

HULA OUTFIT

JETPACK JOYRIDE · legitimate RESEARCH

SUPER OUTFIT

JETPACK JOYRIDE · legitimate RESEARCH

KING OUTFIT

JETPACK JOYRIDE · legitimate RESEARCH

PIRATE

JETPACK JOYRIDE · legitimate RESEARCH

BALLER OUTFIT

JETPACK JOYRIDE · legitimate RESEARCH

FRAGGER OUTFIT

JETPACK JOYRIDE · legitimate RESEARCH

NERD OUTFIT

JETPACK JOYRIDE · legitimate RESEARCH

DIGI OUTFIT

JETPACK JOYRIDE · legitimate RESEARCH

TOP SECRET

GRIDIRON OUTFIT

JETPACK JOYRIDE legitimate RESEARCH

TOP SECRET

FEMALE OUTFIT

JETPACK JOYRIDE legitimate RESEARCH

TOP SECRET

ELVIS OUTFIT

JETPACK JOYRIDE legitimate RESEARCH

TOP SECRET

FIGHTER PILOT OUTFIT

JETPACK JOYRIDE legitimate RESEARCH

TOP SECRET

VIKING

JETPACK JOYRIDE legitimate RESEARCH

TOP SECRET

WIZARD OUTFIT

JETPACK JOYRIDE legitimate RESEARCH

TOP SECRET

ADVENTURER OUTFIT

JETPACK JOYRIDE legitimate RESEARCH

TOP SECRET

NINJA OUTFIT

JETPACK JOYRIDE legitimate RESEARCH

TOP SECRET

FLIGHT OUTFIT

JETPACK JOYRIDE legitimate RESEARCH

POLAR OUTFIT

JETPACK JOYRIDE

legitimate RESEARCH

COWBOY OUTFIT

JETPACK JOYRIDE

legitimate RESEARCH

DEVIL OUTFIT

JETPACK JOYRIDE

legitimate RESEARCH

MIME OUTFIT

JETPACK JOYRIDE

legitimate RESEARCH

WONDER OUTFIT

JETPACK JOYRIDE

legitimate RESEARCH

CRAB OUTFIT

JETPACK JOYRIDE

legitimate RESEARCH

CAVEMAN

JETPACK JOYRIDE

legitimate RESEARCH

SPACESUIT

JETPACK JOYRIDE

legitimate RESEARCH

DOCTOR OUTFIT

JETPACK JOYRIDE

legitimate RESEARCH

TOP SECRET

POOR OUTFIT

JETPACK JOYRIDE legitimate RESEARCH

TOP SECRET

GENERAL OUTFIT

JETPACK JOYRIDE legitimate RESEARCH

TOP SECRET

SKELETON OUTFIT

JETPACK JOYRIDE legitimate RESEARCH

TOP SECRET

SNOWMAN OUTFIT

JETPACK JOYRIDE legitimate RESEARCH

TOP SECRET

WOLF MAN OUTFIT

JETPACK JOYRIDE legitimate RESEARCH

TOP SECRET

ANGEL OUTFIT

JETPACK JOYRIDE legitimate RESEARCH

TOP SECRET

ZOMBIE OUTFIT

JETPACK JOYRIDE legitimate RESEARCH

TOP SECRET

BATH TIME OUTFIT

JETPACK JOYRIDE legitimate RESEARCH

TOP SECRET

CLOWN OUTFIT

JETPACK JOYRIDE legitimate RESEARCH

TOP SECRET

CONSTRUCTION OUTFIT

JETPACK JOYRIDE legitimate RESEARCH

TOP SECRET

SAILOR OUTFIT

JETPACK JOYRIDE legitimate RESEARCH

TOP SECRET

ROBOT OUTFIT

JETPACK JOYRIDE legitimate RESEARCH

TOP SECRET

CLASSY OUTFIT

JETPACK JOYRIDE legitimate RESEARCH

TOP SECRET

MATRIX OUTFIT

JETPACK JOYRIDE BARRY "NEO" STEAKFRIES legitimate RESEARCH

TOP SECRET

SANTA OUTFIT

JETPACK JOYRIDE legitimate RESEARCH

TOP SECRET

PUNK OUTFIT

JETPACK JOYRIDE legitimate RESEARCH

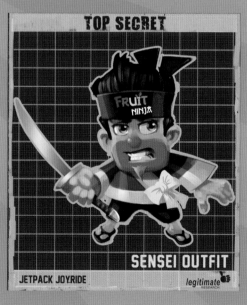

TOP SECRET

SENSEI OUTFIT

JETPACK JOYRIDE legitimate RESEARCH

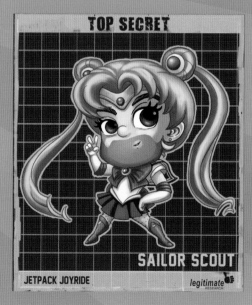

TOP SECRET

SAILOR SCOUT

JETPACK JOYRIDE legitimate RESEARCH

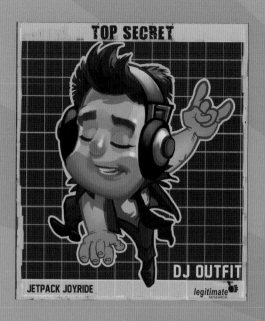

TOP SECRET

JETPACK JOYRIDE

DJ OUTFIT

legitimate RESEARCH

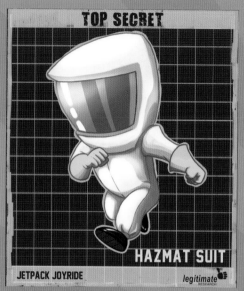

TOP SECRET

JETPACK JOYRIDE

HAZMAT SUIT

legitimate RESEARCH

TOP SECRET

JETPACK JOYRIDE

PHIL OUTFIT

legitimate RESEARCH

TOP SECRET

JETPACK JOYRIDE

MAGNET MAN

legitimate RESEARCH

TOP SECRET

JETPACK JOYRIDE

BLING IT ON OUTFIT

legitimate RESEARCH

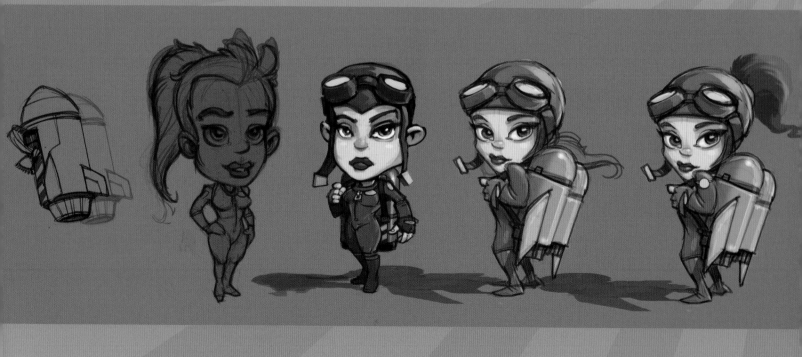

HALFBRICK PRESENTS

JETPACK JOYRIDE 2.0

ABOVE: Unused *Jetpack Joyride* logo and concepts.

FREE TO PLAY

Jetpack Joyride sold a tremendous 350,000 units in its first week. But then, during Christmas, Halfbrick decided to make *Jetpack Joyride* free-to-play for a limited time. The change was so successful that Halfbrick never changed it back, and the rest is history.

Free-to-play was very new at the time, and the new model was quickly transforming the mobile games industry. Different companies may use slightly different models, but at its core the idea is that the main game is free, with parts of the game that players can spend money on, such as adding more levels and making it easier to progress via quicker access to weapons or coins, etc. Free-to-play has become extremely common in the time since then, and many gamers enjoy the freedom of choice inherent in this model.

Jetpack Joyride saw amazing success with free-to-play, and Halfbrick used the lessons learned from that fateful Christmas decision to influence their future game design.

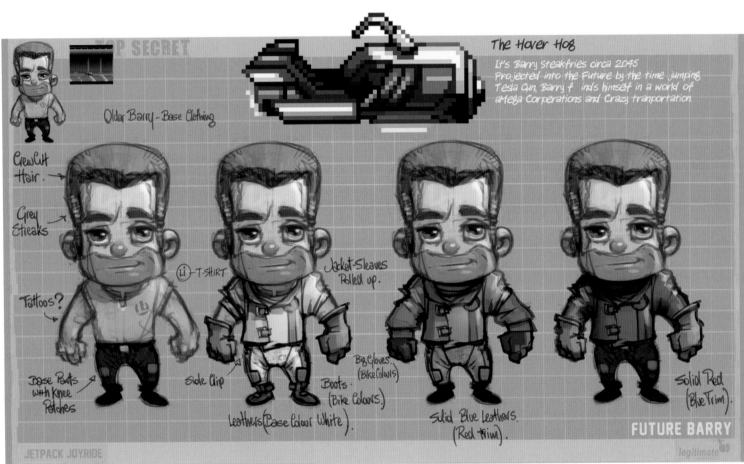

The Hover Hog

It's Barry Steakfries circa 2045. Projected into the future by the time jumping Tesla Gun, Barry finds himself in a world of aMega Corperations and crazy tranportation.

Older Barry - Base Clothing

CrewCut Hair.

Grey Streaks

T-SHIRT

Jacket-Sleaves Rolled up.

Tattoos?

Big Gloves. (Bike Colours)

Side Clip

Boots. (Bike Colours.)

Base Pants with Knee Patches

Leathers (Base Colour White).

Solid Blue Leathers. (Red Trim).

Solid Red (Blue Trim).

JETPACK JOYRIDE

FUTURE BARRY

legitimate

Futuristic Mumpsuit Leathers 001 Futuristic Mumpsuit Leathers 002 Futuristic Mumpsuit Leathers 003

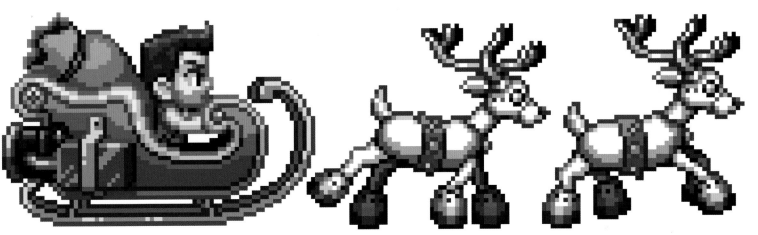

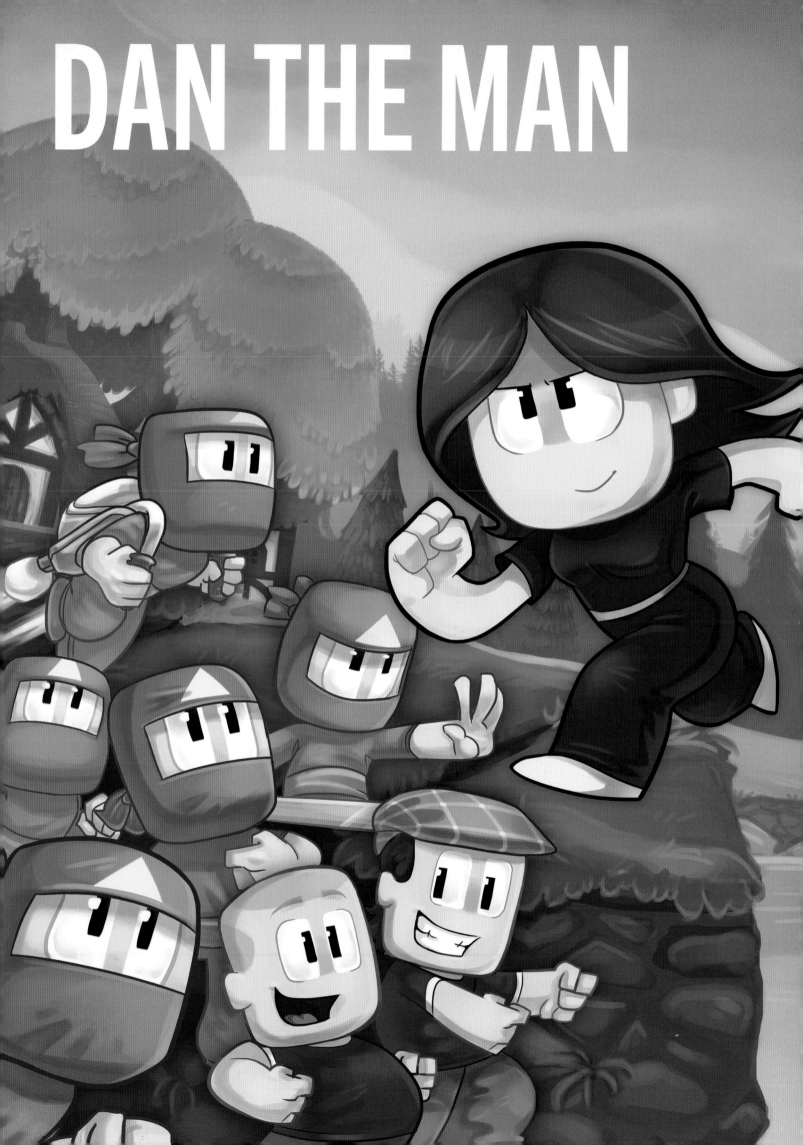

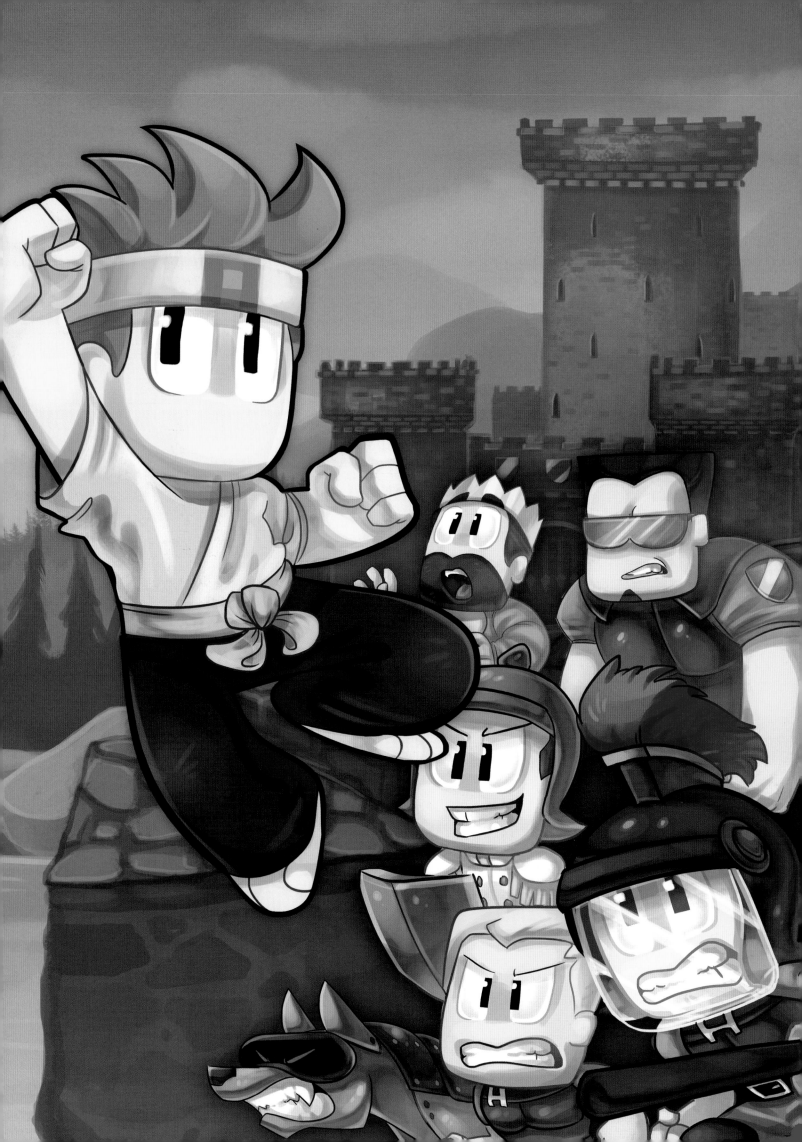

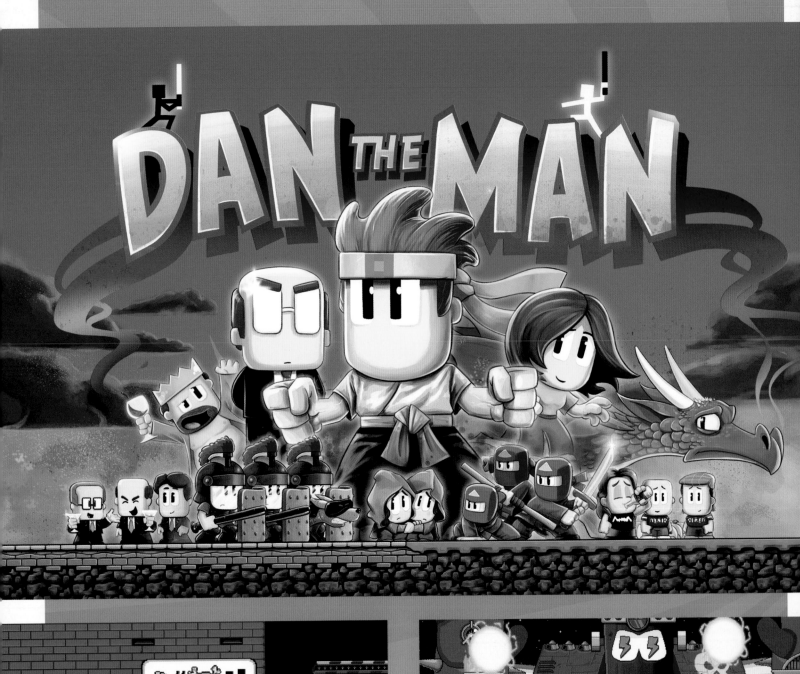

DAN IS THE MAN!

With a style and gameplay that takes players all the way back to the golden age of gaming, *Dan the Man* is an excitingly familiar yet completely modern action platformer. Surprisingly deep at times, incredibly crude at others, *Dan the Man* is fun, simple, and hilarious. Players control Dan, Josie, Barry Steakfries or a custom character that uses kicks, punches, and an epic arsenal of weapons to beat down the baddies and save the day. Maybe.

With more than ten million installs and growing each day, it's easy to see why *Dan the Man* was celebrated as one of the "Best of Games for 2016" across major mobile platforms!

The art of *Dan the Man* is retro and nostalgic, with a pixelated look and a color-palette reminiscent of the 16-bit games of the 90's.

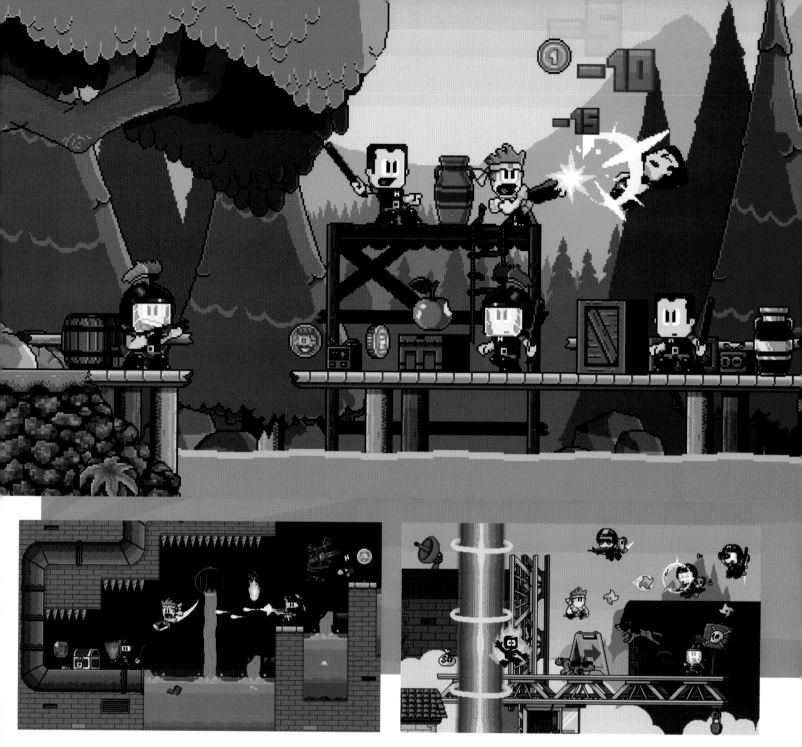

MAKETH THE MAN

Before Dan was an expert destroyer of evil robots, he was an idea: the thought of the disparity between being the so-called hero of a game and the player's actual actions while controlling that hero.

"*Dan the Man* came from a lifetime of beating-up unsuspecting NPCs who were really just trying to go about their business," explained Joe Brumm, founder of StudioJoho and the animator of the *Dan the Man* series.

"The series just grew out of that really, a whole world of NPC's expecting some slightly bored player to act in a heroic way."

Taking that basic idea, the game became a tongue-in-cheek nod to gamers who didn't play by the rules— whether that's walking away from a quest giver before they finished explaining something important or testing out the ability to hit random village folk.

"I wanted to make a game that you could complete on the first screen if you did the really counterintuitive thing to do, i.e. refused to go and get involved with a bunch of violent reactionaries," said Brumm.

"But you'd have to play through that experience to know to do that."

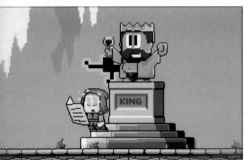

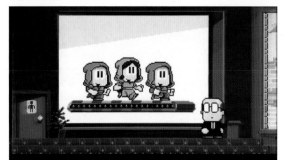

NEW RETRO

Dan The Man leans heavily on platformers of the past, and nowhere is that more apparent than with the eight webisodes created in partnership with StudioJoho. Available on YouTube, the series fills in the backstory of each of the characters, with cheeky nods to popular video game tropes. *Dan The Man* turns these tropes on their heads using gameplay to tell a unique and smart story to invoke unexpected emotions.

The hero wins the day and gets the girl? Well, having a princess for a girlfriend might not be all it's cracked up to be. The protagonists kill the bad guys? Time to deal with feelings of loss and regret. These short episodes pack a powerful punch, and part of the strength behind them is the juxtaposition of the unexpected with the completely familiar.

One of the best traits of the series is the use of video games as a vehicle for the story. Dan must learn the proper sequence of buttons to press to communicate his love for Josie. A drunken and belligerent NPC's story is told using an old arcade game. Stages must be replayed when Dan dies, and he doesn't always make different choices the second time around.

The innovative series ends with "Stage 8," which is actually the start of the game! So the real ending to the tale is up to the players.

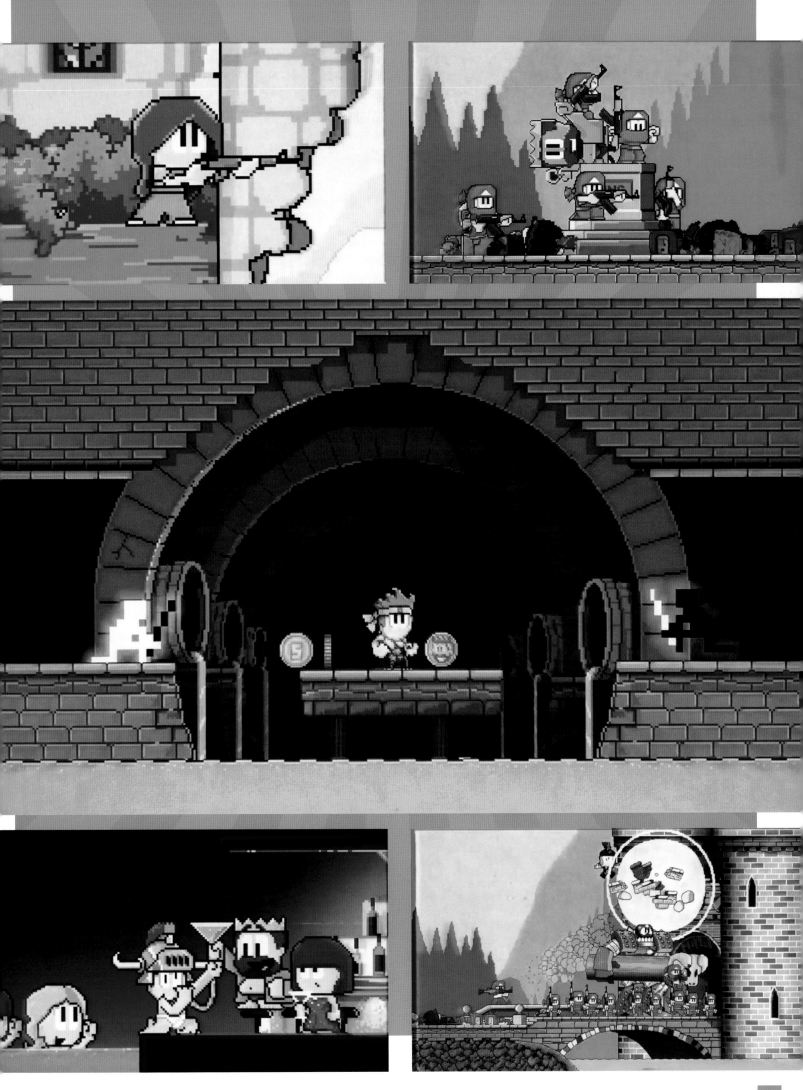

BUILDS CHARACTER

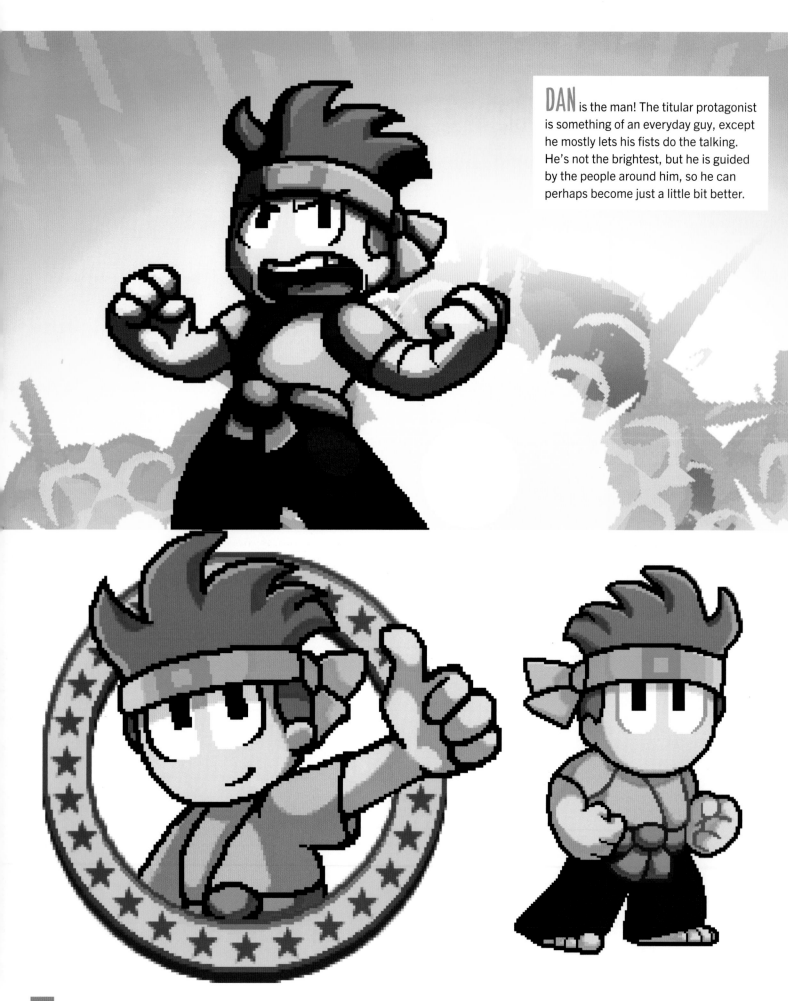

DAN is the man! The titular protagonist is something of an everyday guy, except he mostly lets his fists do the talking. He's not the brightest, but he is guided by the people around him, so he can perhaps become just a little bit better.

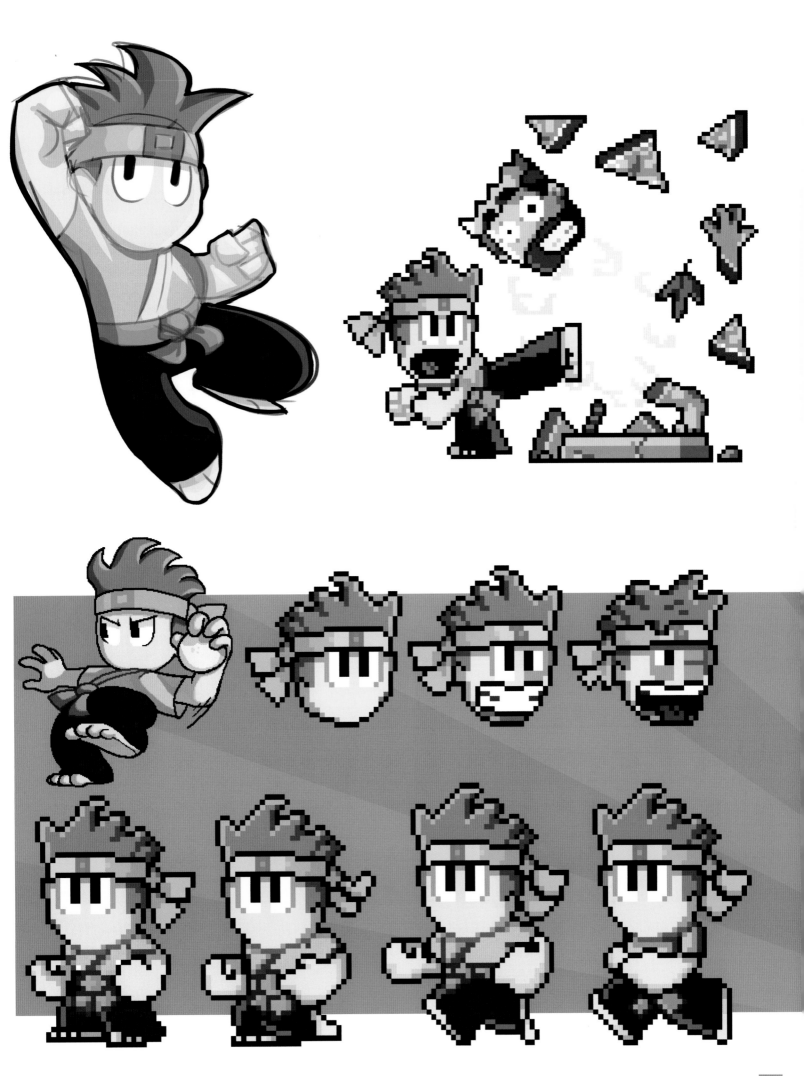

JOSIE is Dan's girlfriend who is locked up in the castle dungeon—but she's no damsel in distress! She's a fighter for the Resistance who isn't afraid to grab a weapon and hop into the fight, but her tough practicality is balanced by her sensitive soul. Josie does not like to see anyone suffer needlessly. She loves Dan, but thinks he is dead so that's a bit of a problem area.

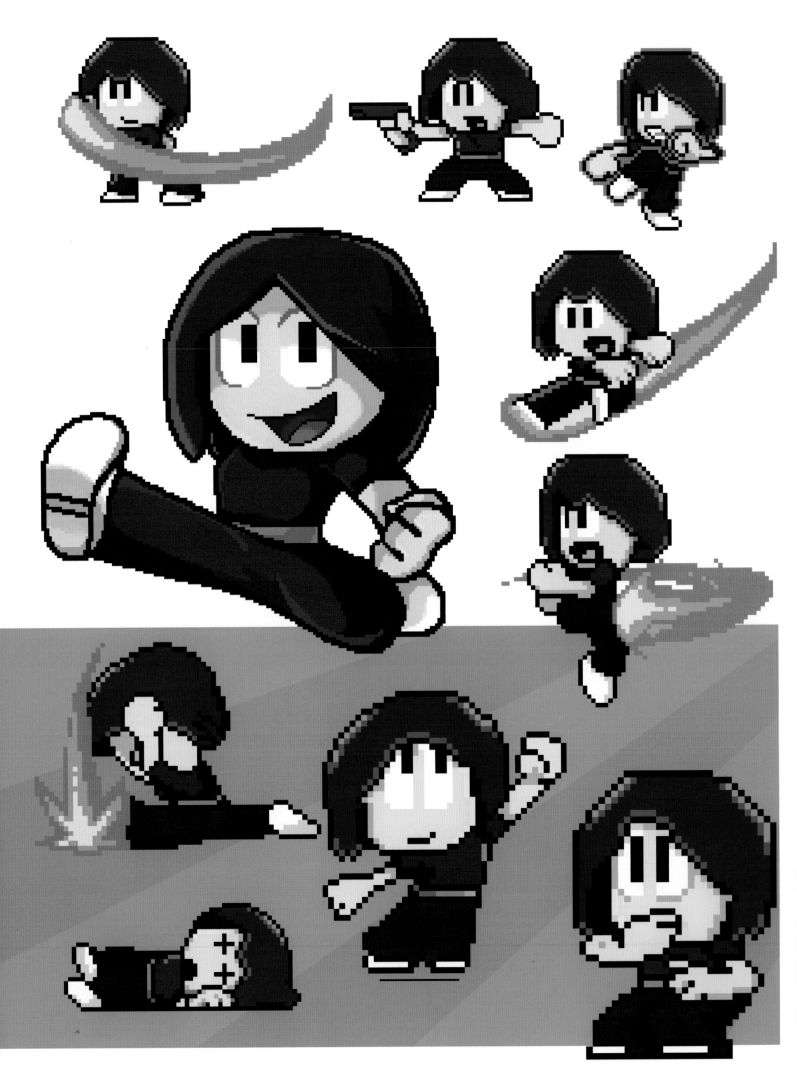

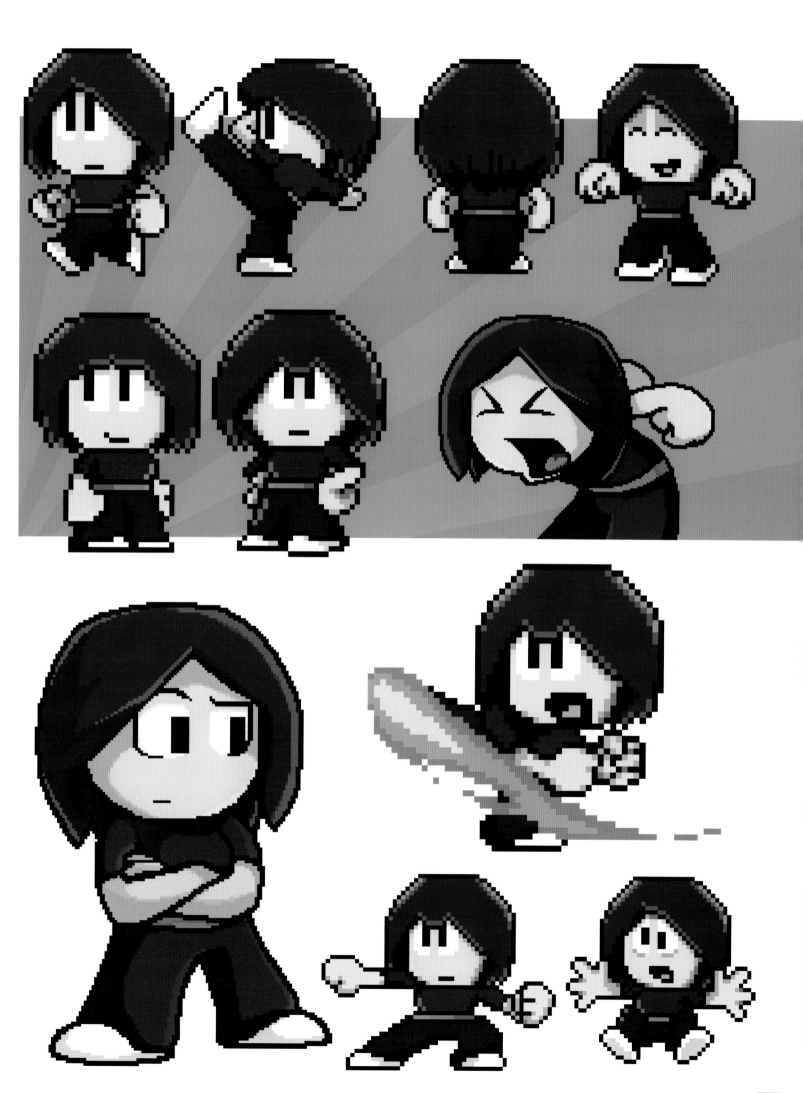

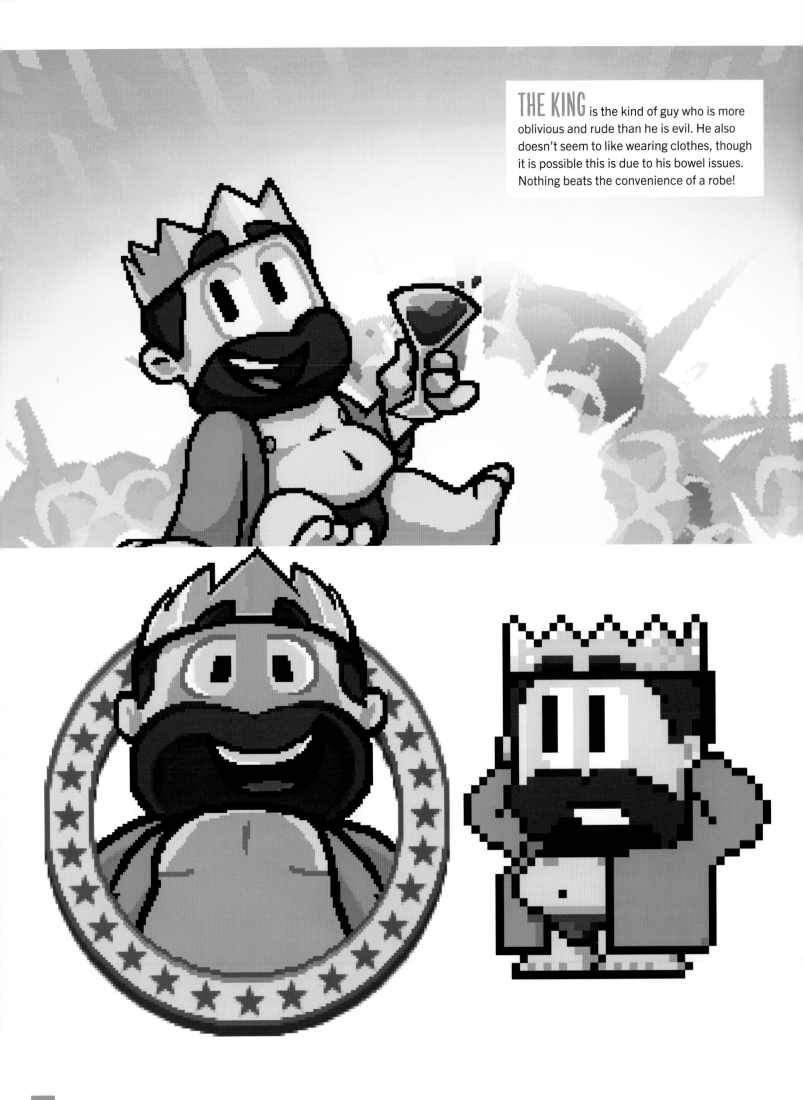

THE KING is the kind of guy who is more oblivious and rude than he is evil. He also doesn't seem to like wearing clothes, though it is possible this is due to his bowel issues. Nothing beats the convenience of a robe!

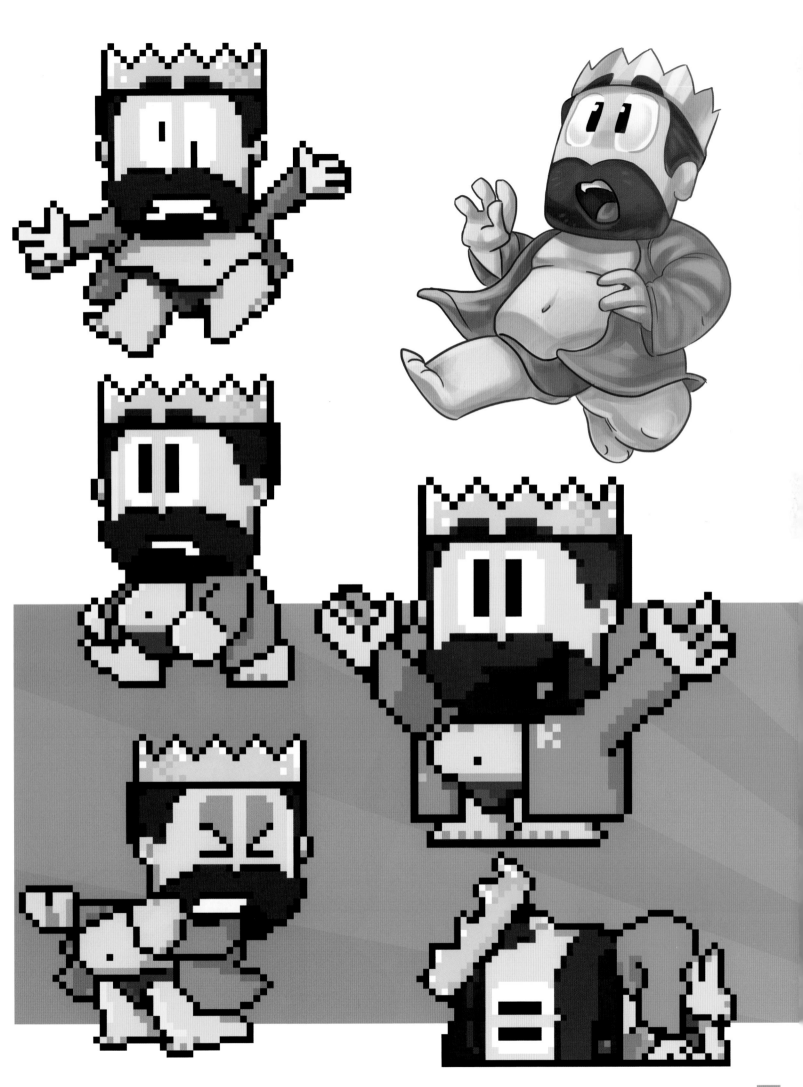

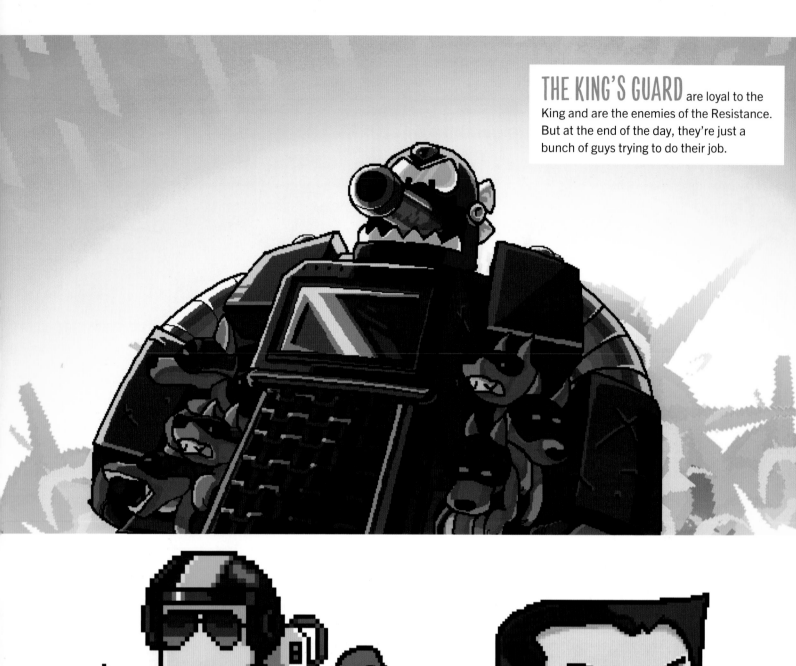

THE KING'S GUARD are loyal to the King and are the enemies of the Resistance. But at the end of the day, they're just a bunch of guys trying to do their job.

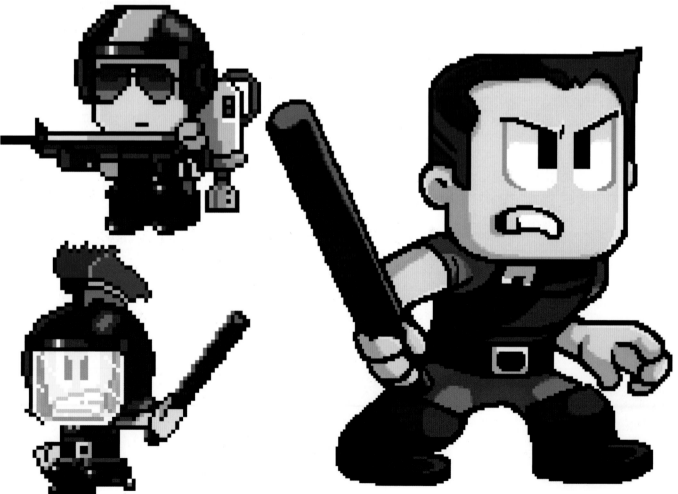

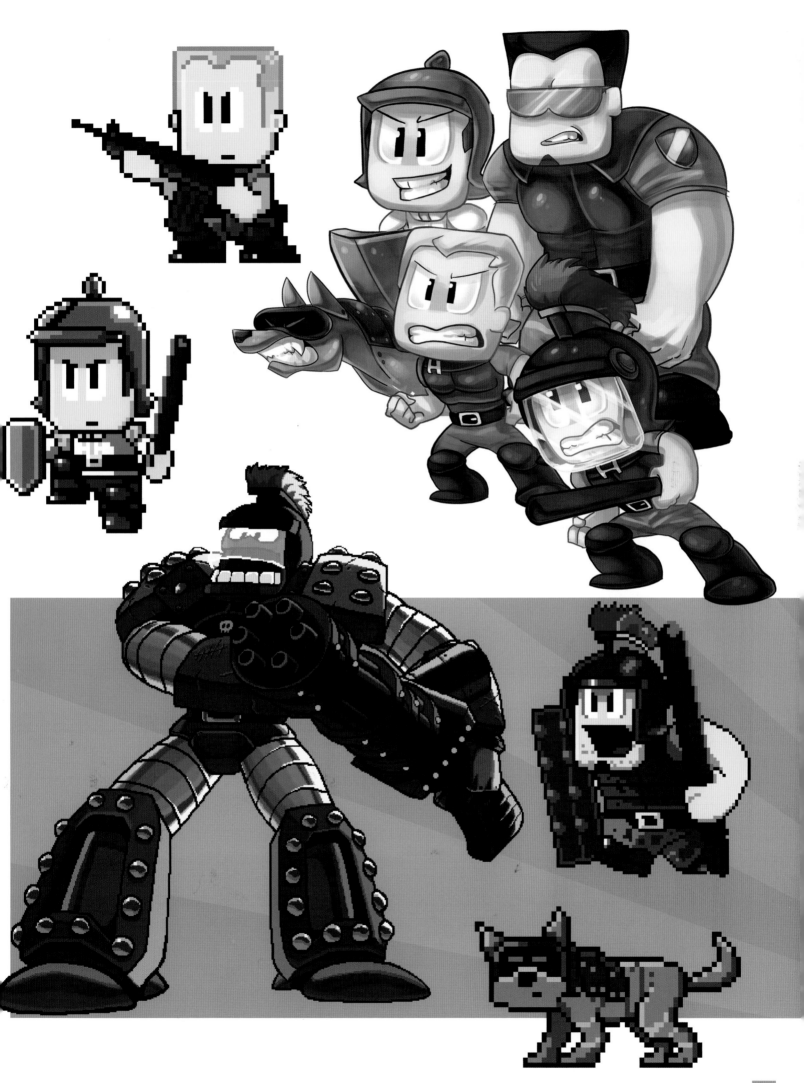

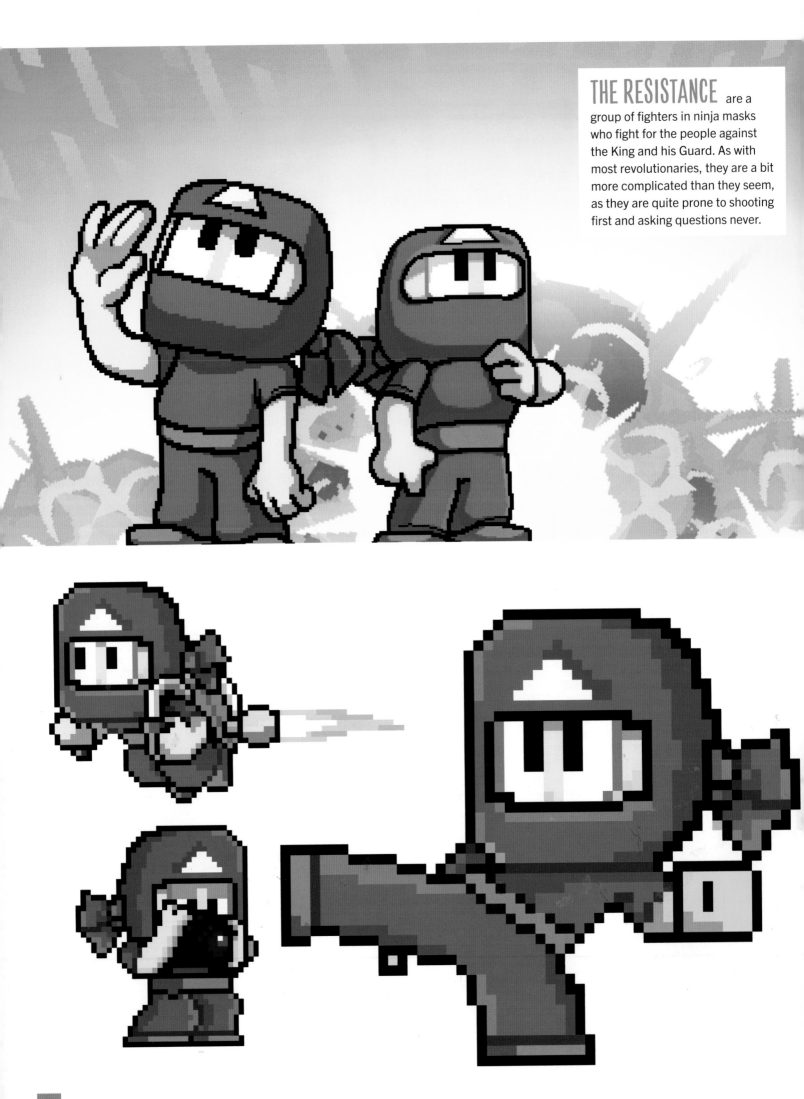

THE RESISTANCE are a group of fighters in ninja masks who fight for the people against the King and his Guard. As with most revolutionaries, they are a bit more complicated than they seem, as they are quite prone to shooting first and asking questions never.

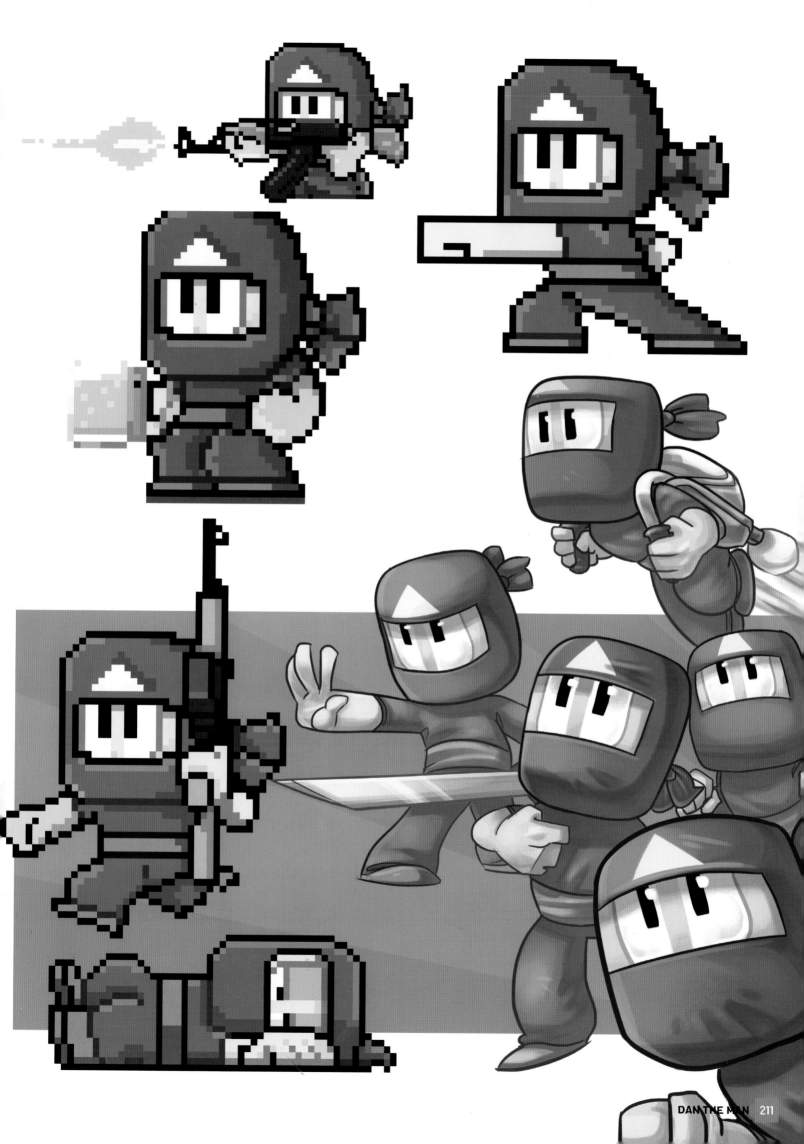

THE GEEZERS are two best friends and patrons of the town bar, where they love to play pool and drink the day away. Though they may seem to have one-track minds, they are truly loyal friends who care deeply for Dan and Josie.

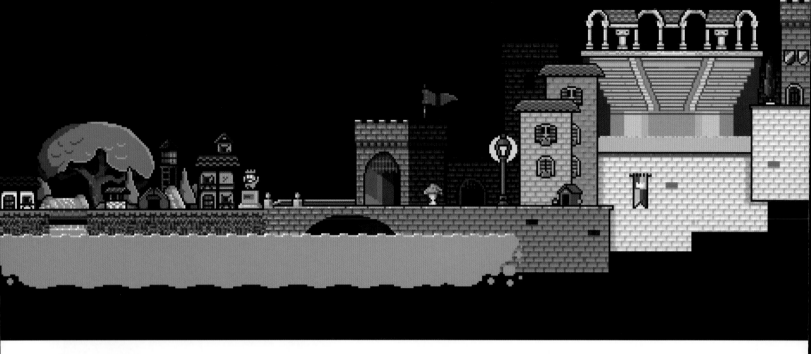

JUST A STAGE

Putting the platform in action-platformer, the levels in *Dan the Man* manage to find the perfect balance between challenging and fun. Each level is filled with secret areas, secret items, disappearing surfaces, and all the classic features of a 90's platformer. As a result, there's really no need for tutorials in the game, it will feel intuitive to anyone who has played similar games in the past.

Players start at Stage 8, which is filled with multiple levels to conquer, including a lovely forest, dark caves, and a magnificent castle. As players progress, levels begin to add new content in ways that keep the game exciting.

Speaking of exciting, it wouldn't be a retro style game without nostalgia-inspiring music. The music and sound effects, from the sound of walking to the "secret item" noise, along with the pixelated art style, blend to turn a modern mobile game into a seamless classic.

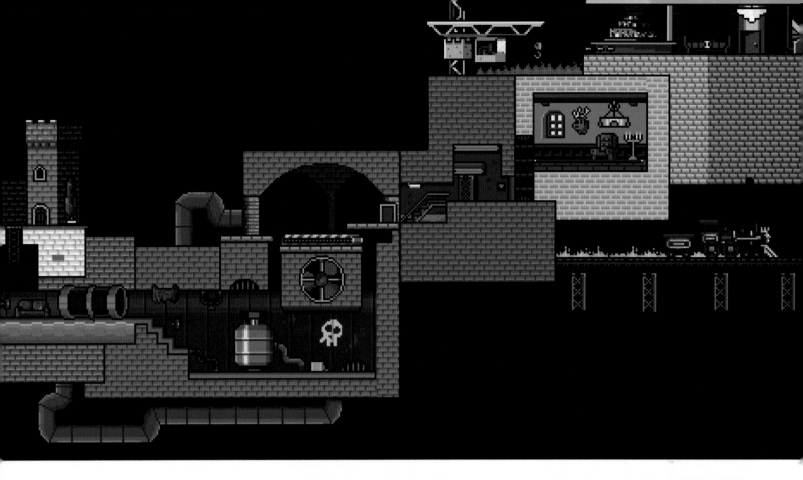

The details put into the background of each level also tell a story. There are baby birds in trees and fishing poles near rivers in the forest, suggesting a normally peaceful place. The caves have toxic sewer water pouring into them from above, showing that all is not as idyllic as it might seem, even without the violence of the uprising. The palace has winged "gargoyles" with the king's head all over the castle walls, and the king's bejeweled "K" initial makes an appearance on everything from gates to walls, showing his self-centered and luxurious nature.

The setting also contributes to the "action" part of action-platformer, with challenging enemies: including giant robots and unexpected boss battles. When multiple classes of enemies are combined with moving platforms and other obstacles, it's time for Dan's karate skills to take center stage.

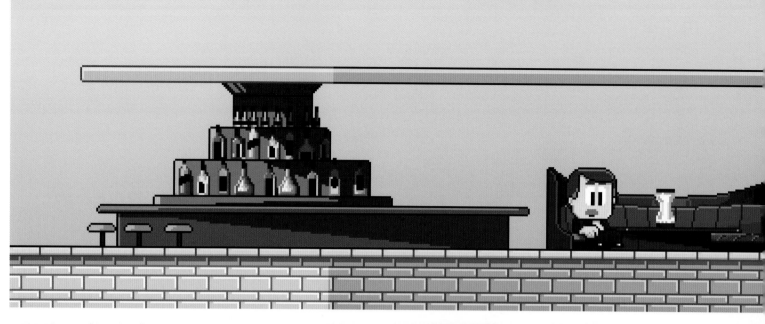

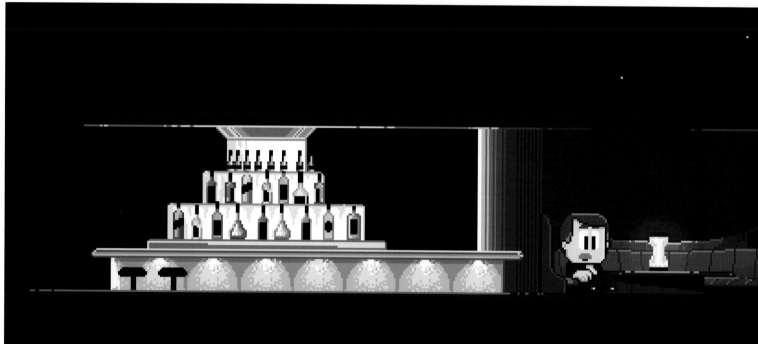

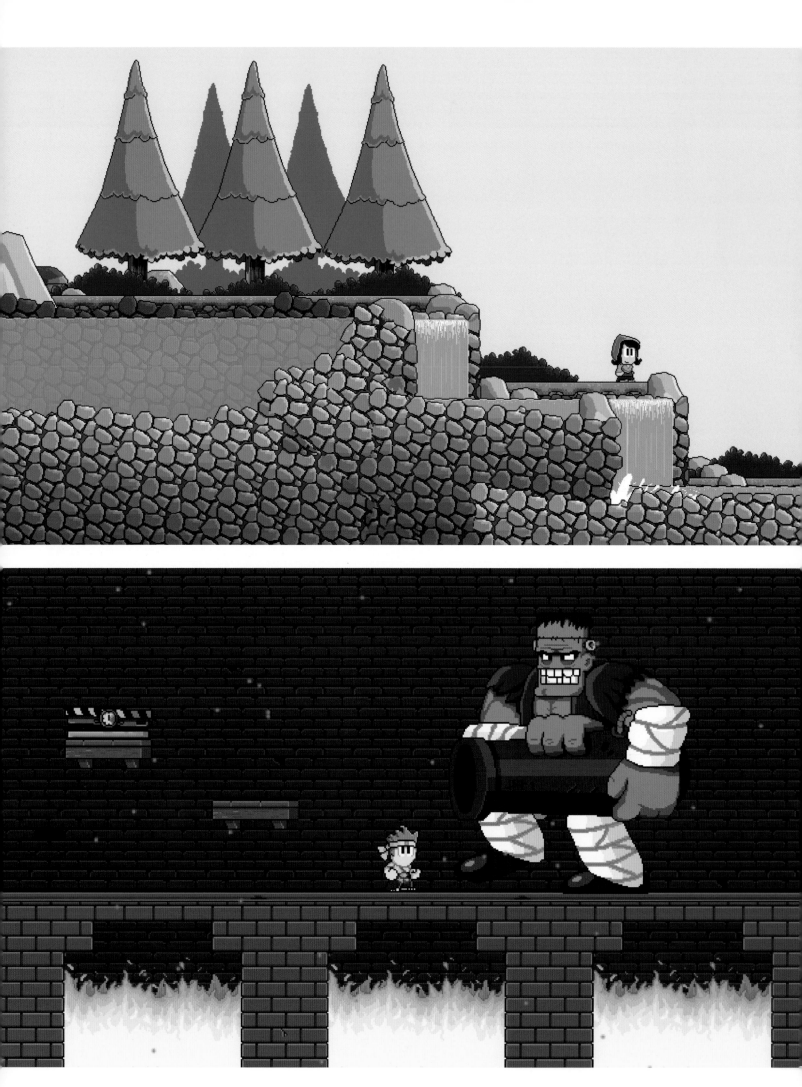

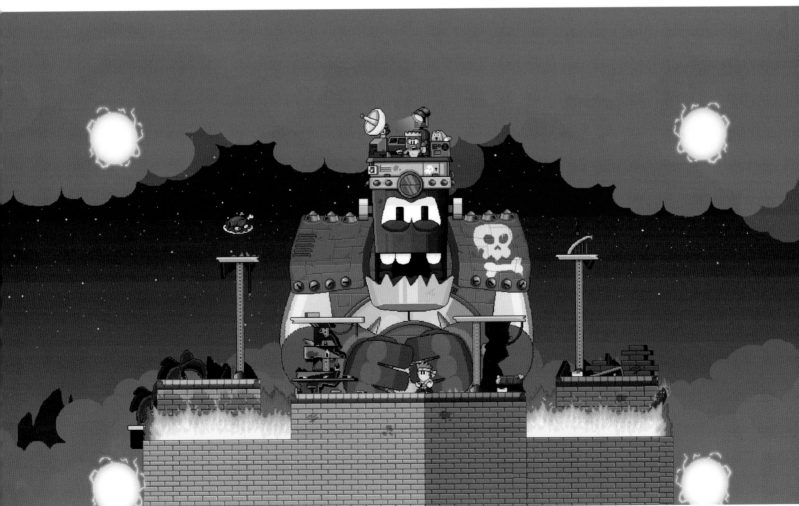

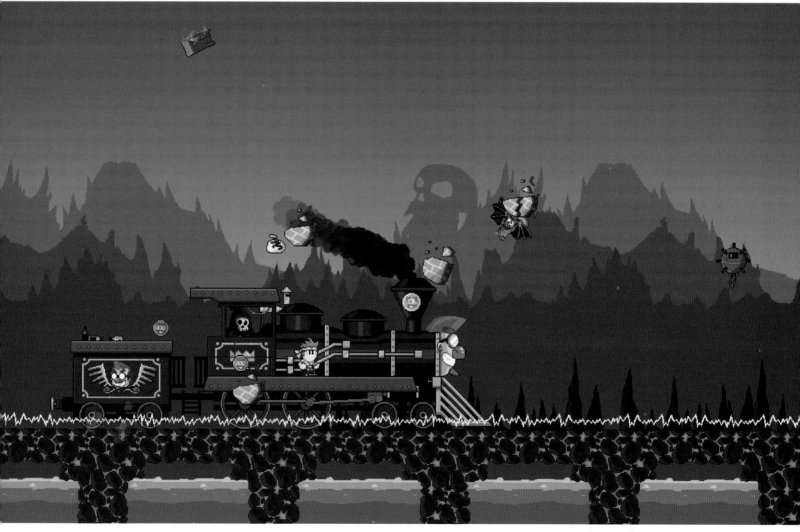

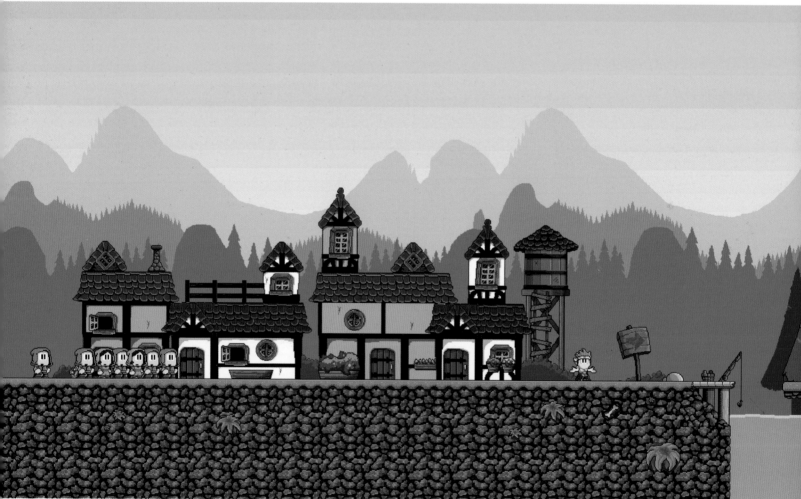

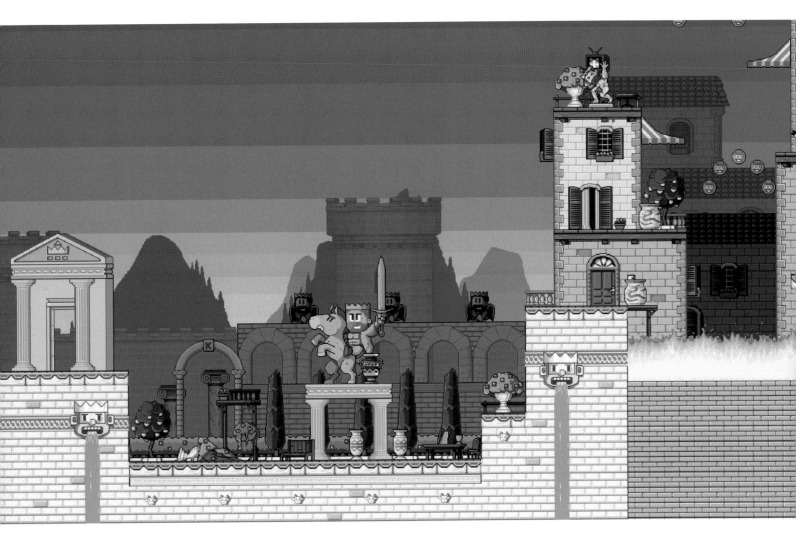

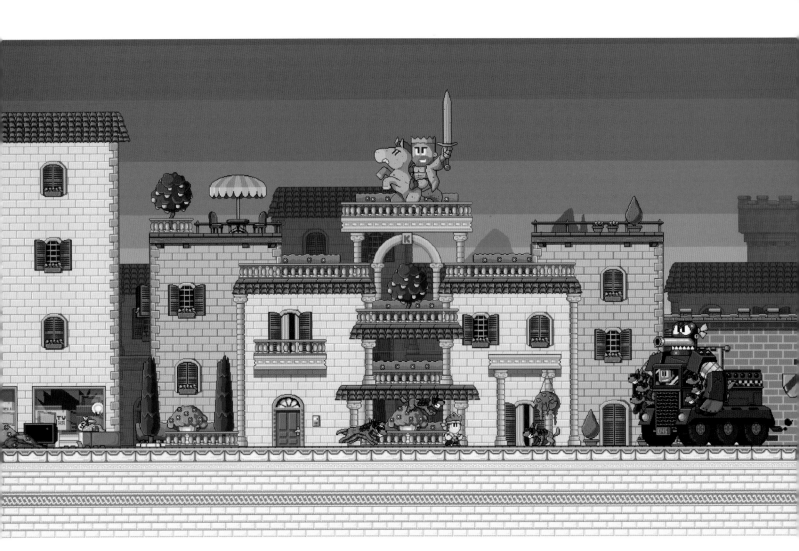

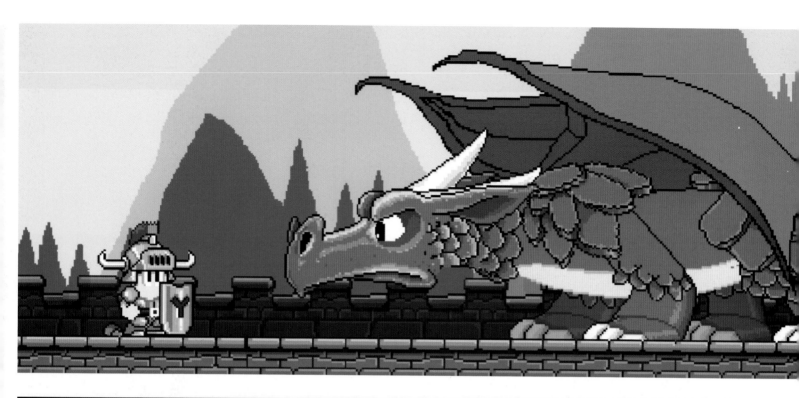

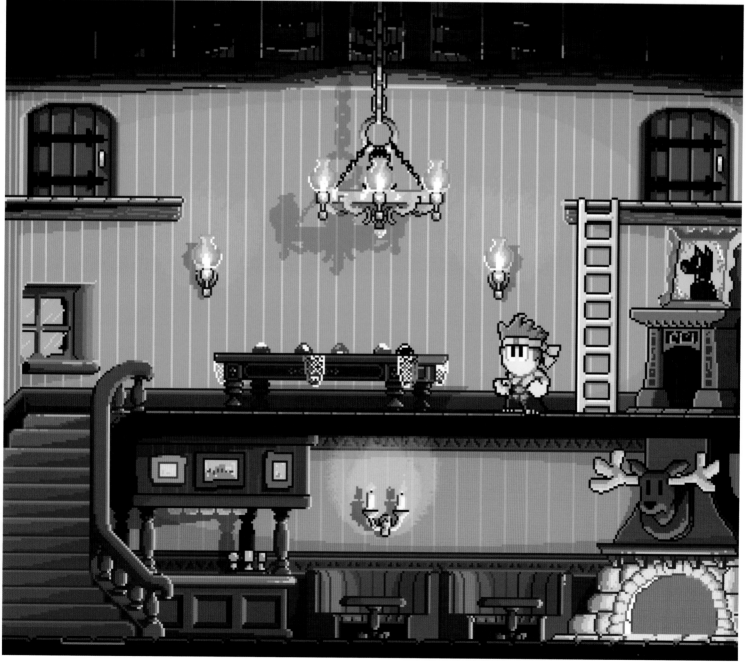

CUSTOM CHARACTERS!

In *Dan the Man*, players can create a hero of their very own and collect hundreds of rad outfits to customize their character. Each article of clothing also comes with bonus stats to take your creation to the next level.

DISCARDED IDEAS

UNUSED LOGO IDEAS

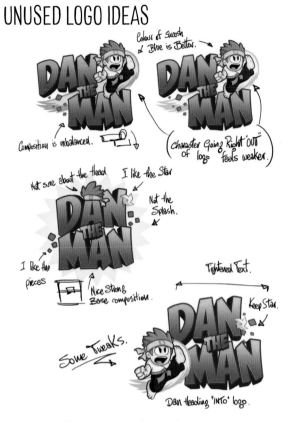

Composition is unbalanced.

Colour of Swoosh & Blue is Better.

Character Going Right "OUT" of logo feels weaker.

Not sure about the Head

I like the Star

Not the Splash.

I like the pieces

Nice Strong Base composition.

Some Tweaks.

Tightened Text.

Keep Star.

Dan Heading "INTO" logo.

LEVEL PROTOTYPES

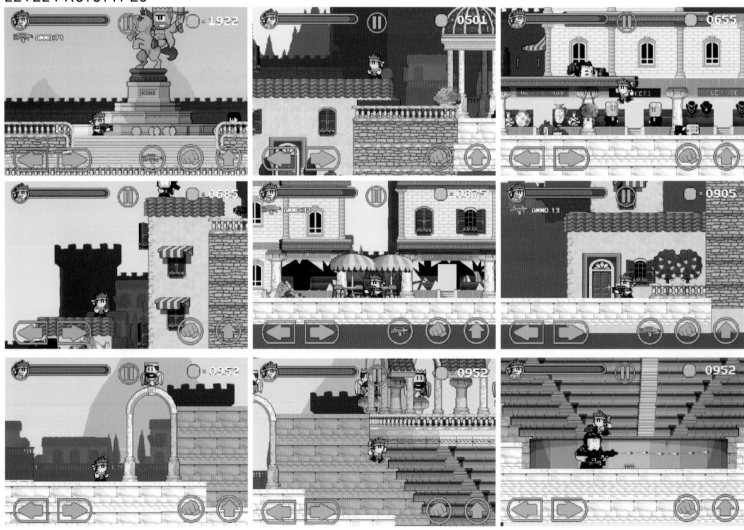

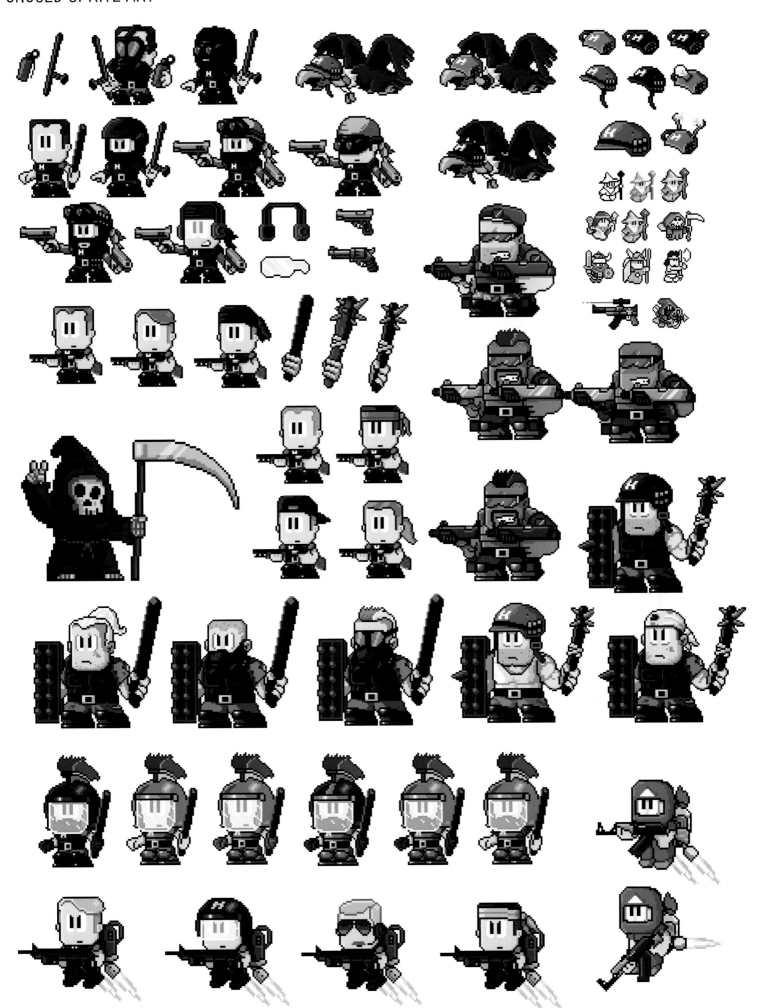

KEEPING IT HALFBRICK

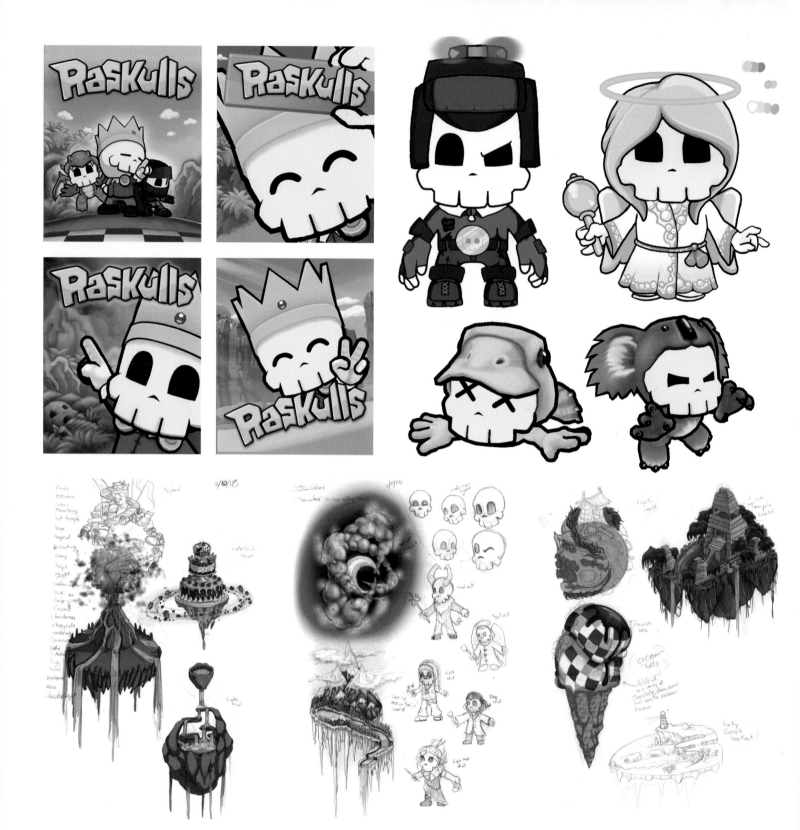

ABOVE & OPPOSITE PAGE:
Art and images from *Raskulls*,
released in December 2010.

RASKULLS

No bones about it, *Raskulls* is one crazy action platformer.
Players leap, smash, and swim through a series of perilous obstacles
as one of many little boneheads, in both single and multiplayer.

Raskulls has a huge cast of characters to choose from: including a fire-breathing dragon, a smashing knight, an intoxicated wizard, and even a flippy ninja. Each character has their own set of skills, which affects the way players can solve problems or get ahead of the competition.

Part platformer, part race, and part puzzle, the bright, colorful world of *Raskulls* keeps players on their toe bones.

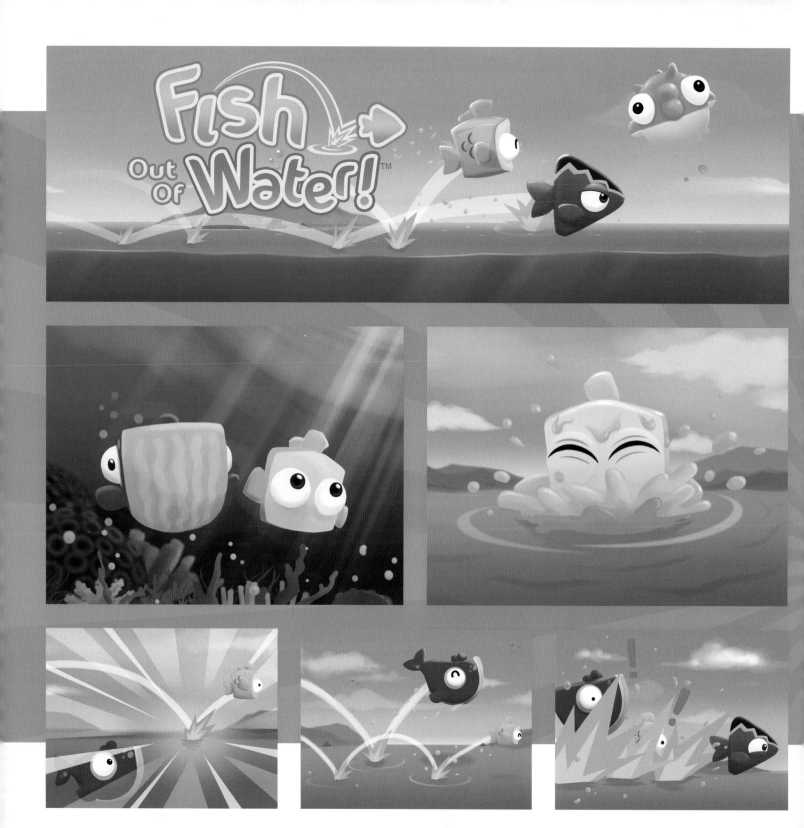

FISH OUT OF WATER

Fish Out of Water is a runner—er, swimmer, featuring a
diverse group of fishy and mammalian companions.

Play as Olympus the goldfish, Finlay the dolphin, Rocket the red fish, Micro the whale, Errol
the pufferfish, or the Brothers, a group of flying fish. Each creature has advantages and
disadvantages, especially when combined with the adorable yet useful costumes.

Soar through the air and under the seas as players compete for the panel of crab judges and the
prestige that comes with victory. Each judge takes certain aspects of the run into account, including
the weather, distance leapt out of the water, and much more.

The splashy fun of this bright, colorful game is enjoyable for all ages.

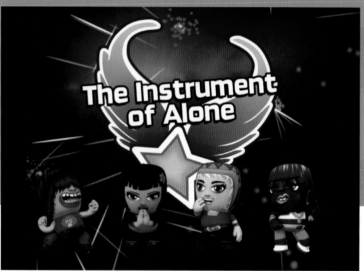

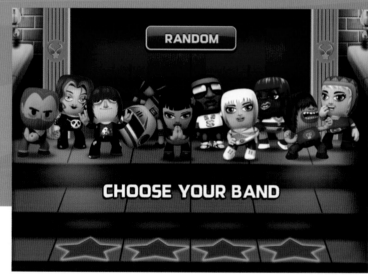

ABOVE & OPPOSITE PAGE: Art and images from *Band Stars*, released via soft launch in June 2012, then followed up with a global mobile release in December 2013.

BAND STARS

Become a music sensation with *Band Stars*, the simulation game that lets players form a band, hit the studio, and start recording.

Train your band and complete challenges to make your way to the top of the local, national, and global music charts.

With fifty band members, tons of gear, and plenty of studios to choose from, *Band Stars* has an impressive level of customization, including the ability to blend different genres and lyrical styles. Players can compete against their friends for the highest chart position and the most fans. They can also customize their studios with items like a hot tub to keep their trained musicians content.

The unique art style and easy to pick-up-and-play game mechanics makes *Band Stars* a super-cool way to reach fame and fortune.

SOLO
+2

58 fps (6)

TOTAL +2

PICK A MIXER

0 DRINK

ADD

LYRICS	2	2	3	4		
CREATIVITY	2	2	2	3		
MELODY	4	2	4	2		
RHYTHM	5	4	3	2		
POLISH	1	4	2	3		

60 fps (3)

NEXT

The Instrument of Alone

2 2 4 5 1 2 2 2 4 4 3 2 4 3 2

4 3 2 2 3

59 fps (13)

AUDITION HIRE VIP LOUNGE

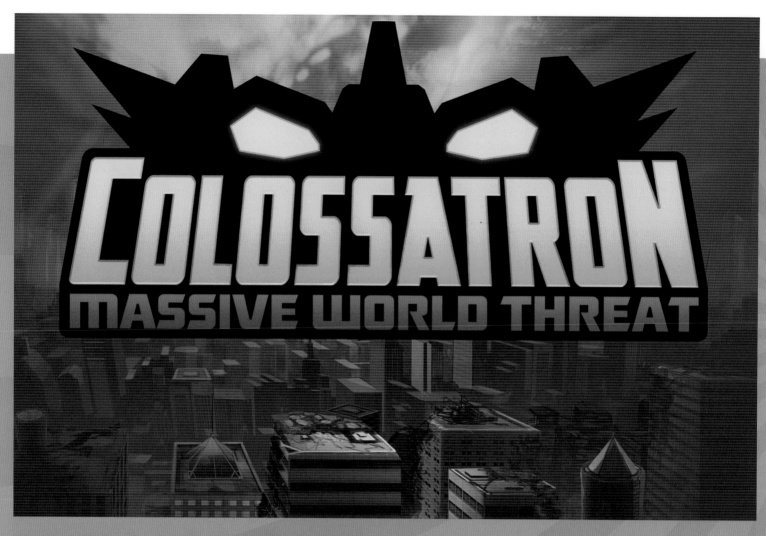

COLOSSATRON: MASSIVE WORLD THREAT

A giant robotic snake has crashed down to Earth in *Colossatron: Massive World Threat*. Players control the mechanical serpent to smash through cities, while defending against the planet's deadliest weapons and the military might of General Moustache.

Gameplay revolves around the construction and shaping of Colossatron to withstand tanks, aerial bombers, and more. The story is told via news reports from Rick Dalton and Katie Hazard, informing players of their progress and new challenges, while the colorful mechanical monster lays frenzied waste to cities.

Destroy everything, level up, get new gadgets, and be the biggest threat the world has ever seen. Sometimes, it feels good to be bad.

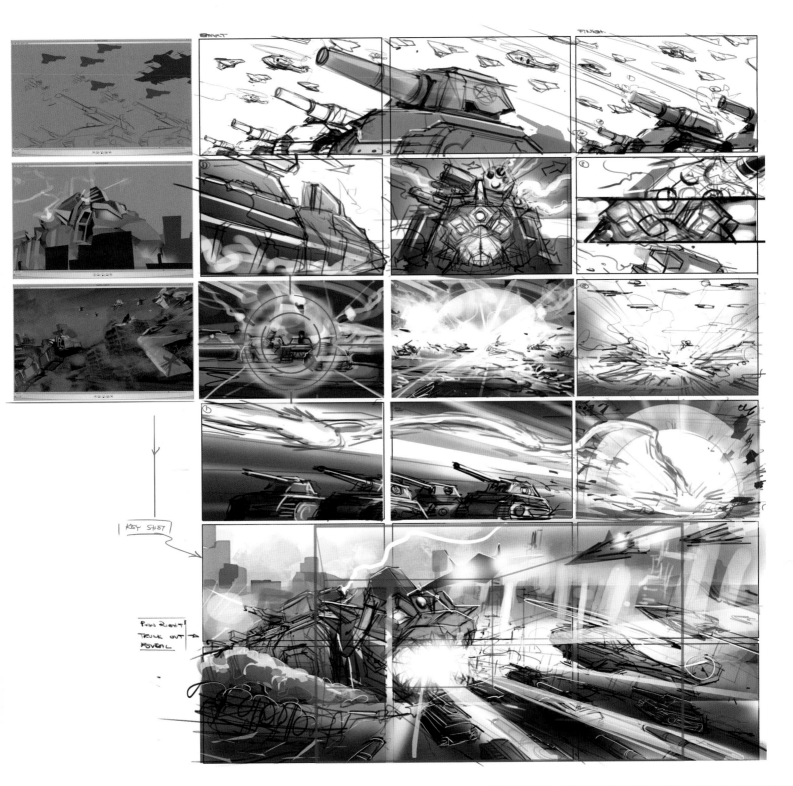

START FINISH

KEY SHOT

PAN RIGHT!
TRUCK OUT
TO REVEAL

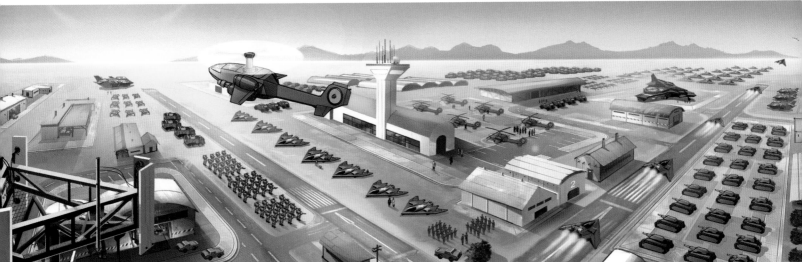

ABOVE & OPPOSITE PAGE:
Art and images from
Bears vs Art, released
in April 2015.

BEARS VS ART

Fight to protect the forest from the incredible surge of pretentious art galleries that are popping up everywhere and destroying the environment.

Bears vs Art is a puzzle game in which players try to shred art, while avoiding gallery obstacles such as lasers, spikes, security guards, thieves, and more. Players control Rory, a bear on a mission to destroy every single piece of art in every single gallery. There are 150 levels in six locations, including the forests of Grassy Woods and the jagged cliffs of Mount Molten.

This quirky game is Halfbrick's first purely puzzle-based game and is mind-bogglingly fun.

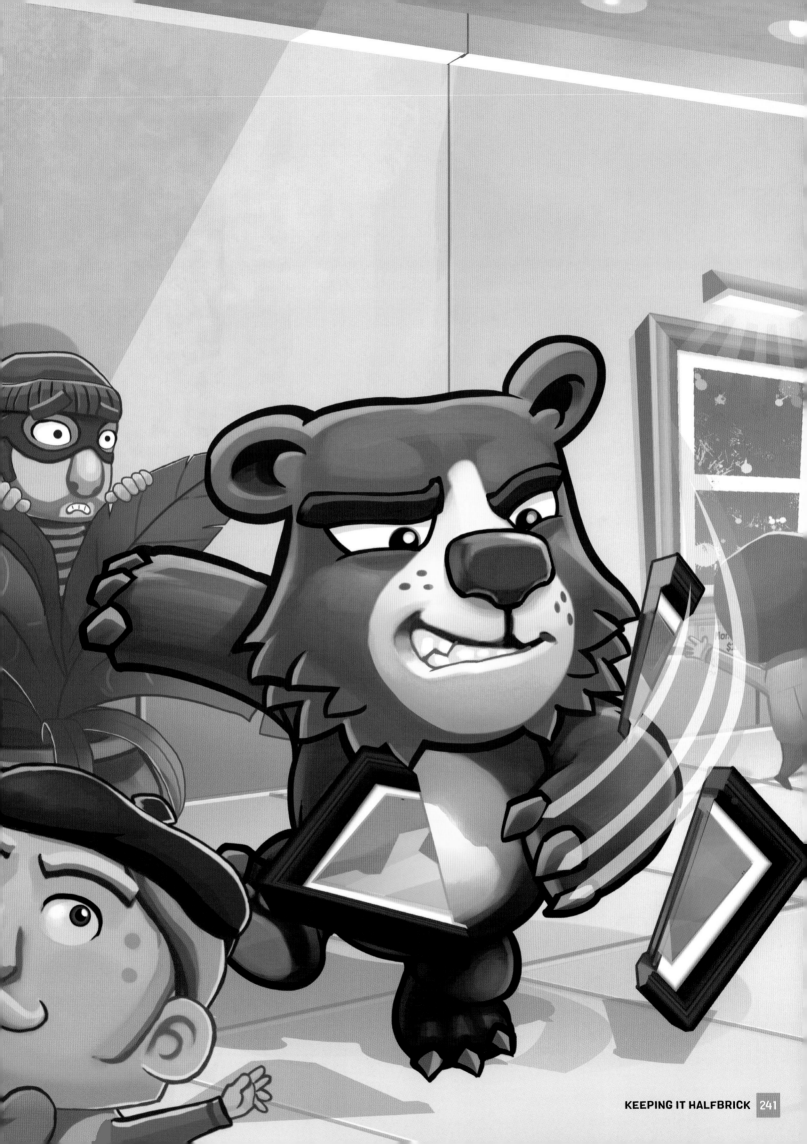

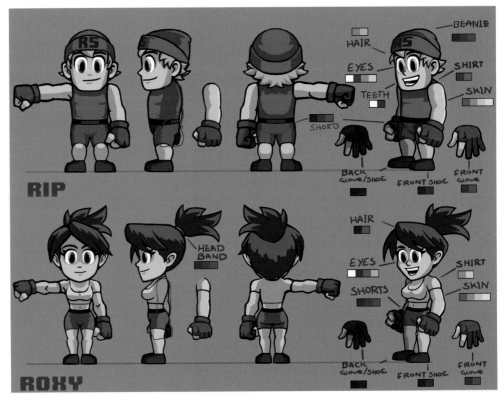

ABOVE & OPPOSITE PAGE:
Art and images from
Radical Rappelling,
released in June 2015.

RADICAL RAPPELLING

Mountains have never been so radical. Enter *Radical Rappelling*, a game that tests player reflexes as they guide their character down a perilous mountainside.

Using Rip or Roxy, players race down cliffs, avoiding obstacles and reaping the rewards to upgrade their characters. No two courses are the same, with levels such as the icecave, a jungle cliff, colorful bricks, and even a volcano. Rip and Roxy also have tons of costume options, ranging from superhero to super casual. Avoid the spikes, snag the coins, and get to the bottom before the lava gets to you.

The gameplay is fast, randomized, and addicting— which means the fun never gets old.

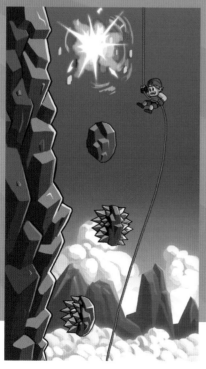
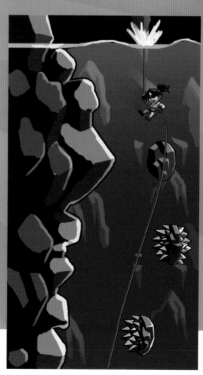
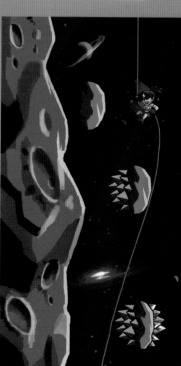

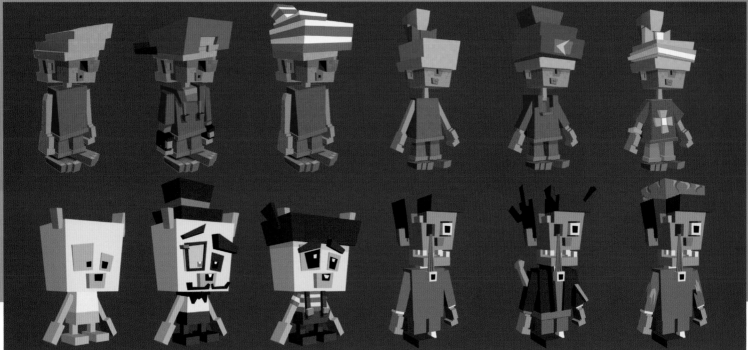

ABOVE & OPPOSITE PAGE:
Art and images from
Star Skater, released
in December 2015.

STAR SKATER

Skate through twisting mountain roads or clogged city streets but be careful not to crash in *Star Skater*.

Players seek to complete short courses in the fastest time possible to receive rewards and magical burritos, which can be used to unlock new costumes and power-ups. One of the most unique gameplay mechanics is the way turns are handled on the skateboard. Players must use their fingers to indicate the sharpness of the turn with a dragging motion. There are also several tricks to pull off, such as power-slides, switch-foots, and jumps, all while avoiding fast-moving cars and trucks. There's plenty of challenges in *Star Skater* to keep sk8trs coming back for more.

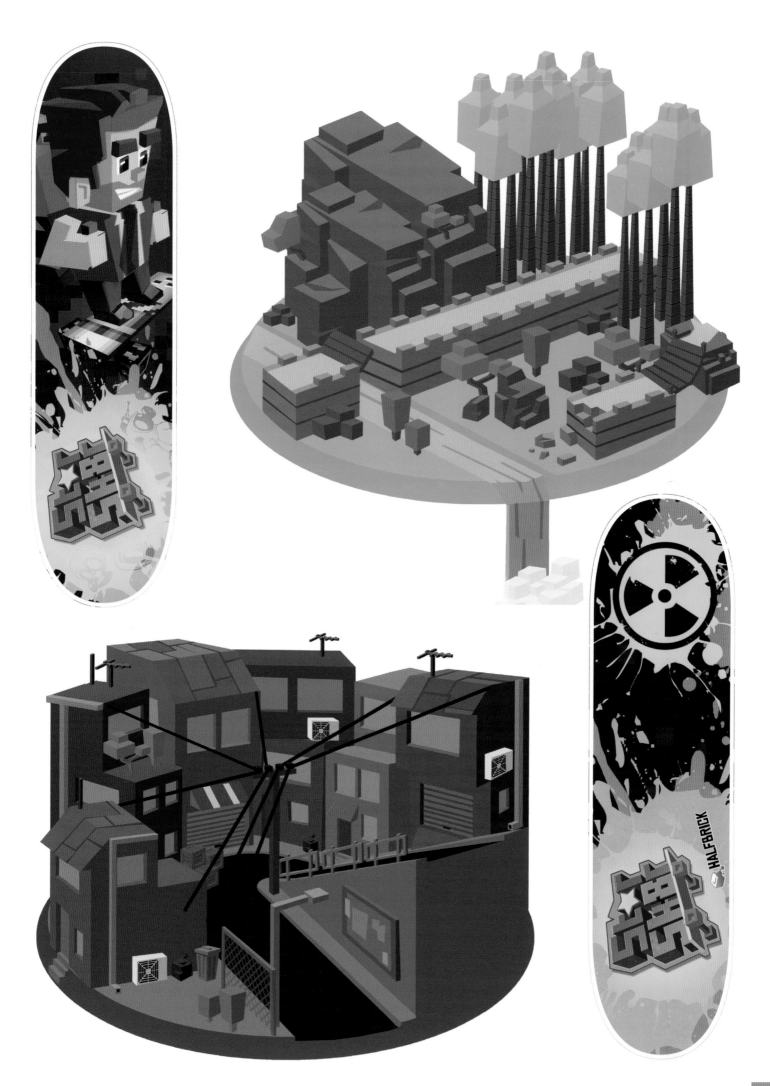

SHADOWS

An Augmented Reality Thriller

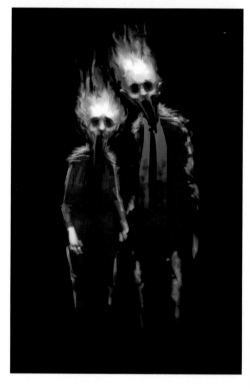

ABOVE & OPPOSITE PAGE: Art and images from *Shadows Remain*, released in November 2017.

SHADOWS REMAIN

Shadows Remain is a paranormal, story-driven puzzle adventure using the technology of augmented reality.

Augmented reality turns a mobile phone into a gateway to another world, and *Shadows Remain* uses this tech to solve puzzles, reveal optical illusions, and place the players directly inside the story. The tale revolves around Emma, a mother trying to save her child from an evil entity. The 3D environments blur the line between cinema, mobile gaming, and traditional AAA gaming as moving the gaming device shifts perspectives, revealing clues hidden in plain sight.

The game is an episodic adventure that leaves players chilled and wanting more.

Emma's surroundings completely morph to its condition in 1948. An old radio replaces the TV, continuing to play the song from the previous scene. A wall now separates the living room and kitchen, with a 1940s calendar hanging up beside the door. The door to the hallway is opened, engulfed in shadow. A child's shadow projects out of the hallway onto the floor of the living room. A small, incomplete wooden boy missing a leg sits on the couch. Next to the boy, leaning against the couch, is a grown man's prosthetic leg. There is a grandfather clock in the corner of the room, stuck mid-swing, frozen in time. A romantic novel written by Joyce Clark sits atop the bench next to the couch.

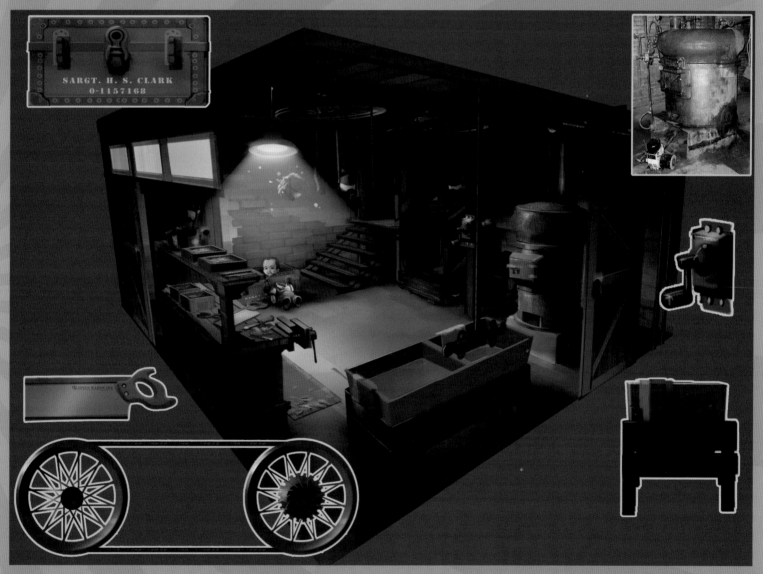

SARGT. H. S. CLARK
0-1157168

The Ruptured Duck

Joyce Clark

SIEGE BREAKERS

Launch catapults and blow up unsuspecting sheep in *Siege Breakers*,
an augmented reality, castle-crashing experience.

In this physics-based puzzle strategy game, players shoot cannon balls or rocket projectiles onto surfaces to eliminate all the flags in that particular castle. Players spawn castles anywhere they can think of, and then use their phones as a catapult to destroy levels in a blaze of joyous mayhem, using strategy for optimum destruction and loot. The areas are large, encouraging movement around the castle to try and decide where to strike next and best conserve ammunition.

In addition to the challenging levels, players can use the Sandbox Editor to create and play their own castle levels.

No sheep were harmed in the making of this game.

Demolish Cool Castles in AR!

Play in your World!

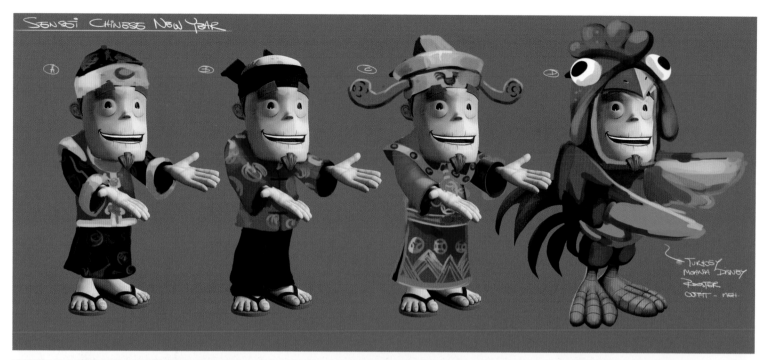

SENSEI CHINESE NEW YEAR

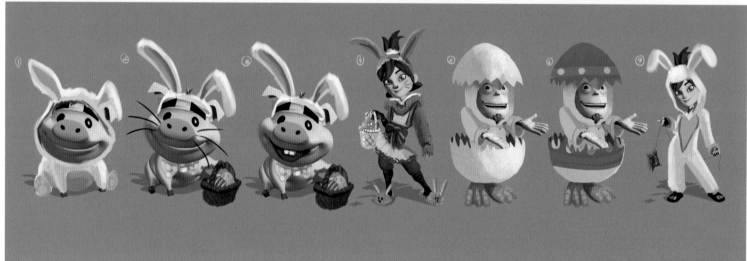

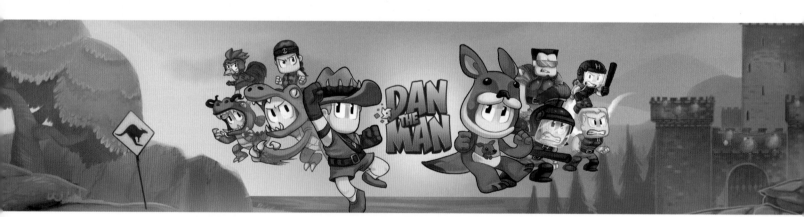

SEASON'S GREETINGS!

One of the best aspects of working on mobile games is the ability to update the game quickly and often to stay connected to the playing community. Halfbrick accomplishes this goal with the release of special content, such as Holiday themed levels, costumes, and more!

Bob Jones, illustrator and marketing artist at Halfbrick, said his favorite DLCs to work on were the 2017 Chinese New Year, St. Patrick's Day, Easter, and Pirate updates.

"A lot of new and interesting ideas came out of the collaborations, such as new backgrounds for the first time in years, plus new items and even a new way to create assets," said Jones.

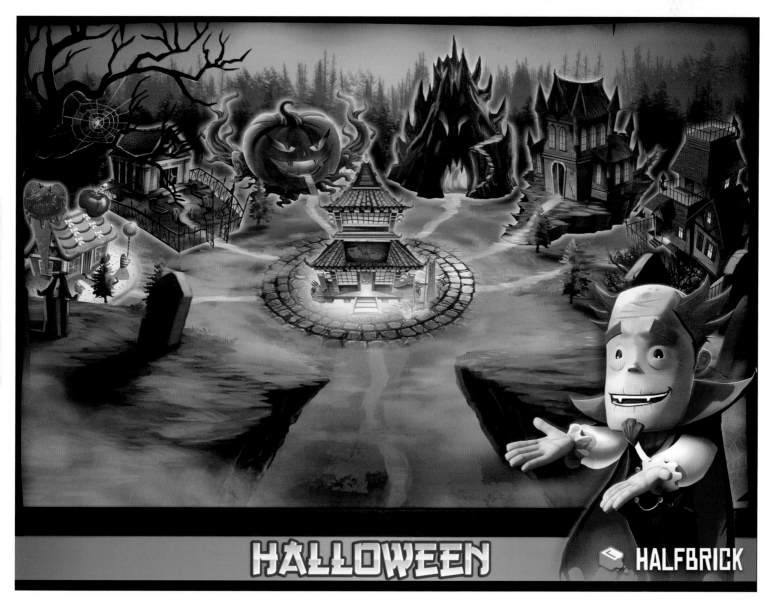

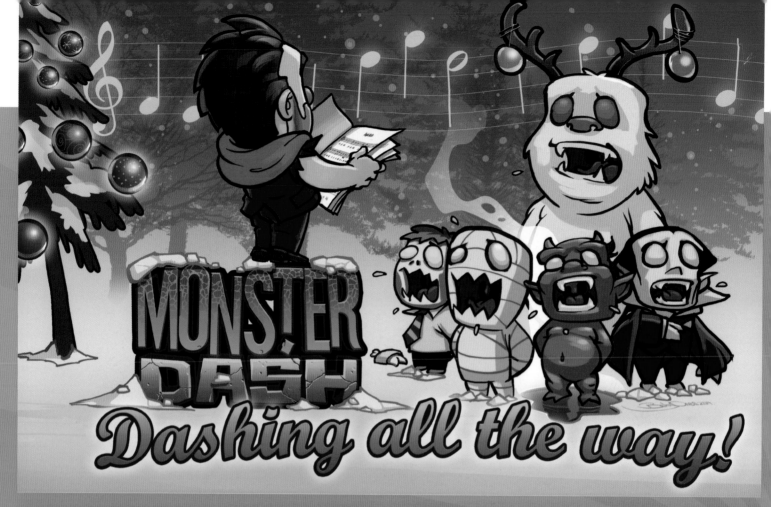

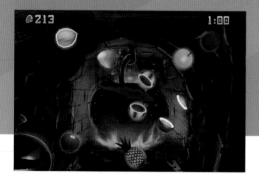

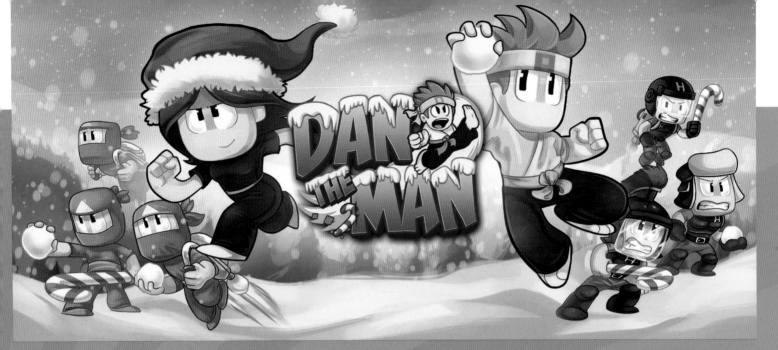

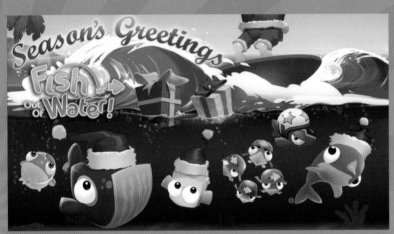

Season's Greetings

Fish out of Water!

I ♥ FRUIT NINJA FRENZY

♥ Happy Valentine's Day ♥

http://www.facebook.com/fruitninjafrenzy

Merry Christmas

FRUIT NINJA FRENZY
http://www.facebook.com/fruitninjafrenzy

THE FUTURE IS HALFBRICK!

In 2017, Halfbrick was inducted into the Queensland Business Leaders Hall of Fame. It is one of the most recent of many prestigious honors and awards the game developer has received. They are one of the top gaming companies in the world, and one of Australia's fastest growing companies.

From the swiping feature of *Fruit Ninja* to leading the way with augmented reality in *Shadows Remain*, Halfbrick has shown itself to be a leader among game developers. With several hit games under their belt, what is next for Halfbrick?

"Halfbrick is now focused squarely on its players. It is our customers that we now look to for insight and feedback to inform our game development decisions," said Sam White, Vice President of Entertainment and Licensing.

"We have been very privileged to build such a loyal and passionate player and fan base. We want to make sure we don't take that for granted and are working to be the most customer intimate game developer we can be for our players, by engaging them in discussion about what they love and the kinds of experiences they want in our games," he explained.

CEO Shainiel Deo agrees, and he thinks that Halfbrick will be focusing on the fans for the foreseeable future.

"My goal, always, when I started Halfbrick, was to build something that's going to be around for a long time, and even around after I'm no longer here," said Deo.

"It's been fifteen years already, and it's only a small step on the journey that we started on."

WE'RE WINNERS!
Halfbrick has quite a few things to be proud of!
Here are some of their many accolades.

2017 Queensland Business Leaders Hall of Fame
2016 e-Commerce Award [Premier of Queensland's Export Award]
2015 Online Sales Award [Australian Export Awards]
2015 QANTAS Freight Online Sales Award [Australian Export Awards]
2015 Finalist - Creative Industries Award [Premier of Queensland's Export Award]
2014 Online Sales Award [Australian Export Awards]
2014 Finalist - Creative Industries Award [Premier of Queensland's Export Award]
2014 Finalist - Information & Communication Technology Award [Premier of Queensland's Export Award]
2013 Studio of the Year [Game Developers Association of Australia]
2013 Creative Industries Award [Premier of Queensland's Export Award]
2013 Finalist - Information & Communication Technology Award [Premier of Queensland's Export Award]
2012 Most Popular Game [Global Mobile Internet Conference]
2012 Apple Design Award [Apple]
2012 Best Developer [Pocket Gamer]
2011 Top 50 Developer [Pocket Gamer Awards]
2011 Finalist - Most Outstanding Business [Westpac Business Excellence]

JETPACK JOYRIDE
2016 Honoree [20th Annual Webby Awards]
2013 Best Scoreloop Integrated Game [Blackberry Jam Americas]
2012 Best Action/Arcade Game of the Year [Pocket Gamer]
2012 iPhone/iPod Touch Game of the Year [Pocket Gamer]
2012 Overall Game of the Year [Pocket Gamer]
2012 Nominated for "Best Casual Game" [International Mobile Gaming Awards]
2012 "Apple Design Award" [WWDC 2012, Apple]
2011 Best App Ever [148Apps]
2011 Runner-up "iPhone Game of The Year" [App Store Rewind]
2011 Best IOS Run-for-your-life Game [Reviews on the Run]

FRUIT NINJA KINECT
Top 10 Best-Selling XBLA Game of All Time [Xbox Live Arcade]
2012 "Casual Game of the Year" [15th Annual Interactive Achievement Awards]

FRUIT NINJA KINECT 2
Mega Sales Award [ID @ Xbox]

FRUIT NINJA
2015 2nd Highest-Selling Game of all time on ioS
2011 50 Best iPhone Apps [Time Magazine]
2011 Nomination - Games - Handheld Devices [15th Annual Webby Awards]

DAN THE MAN
2016 Best Arcade Action Game [Apple TV]
2017 Android Excellence Award

AGE OF ZOMBIES
Bronze — PSP [Pocket Gamer Awards]
2011 Best PlayStation Networks Minis [PlayStation Network Gamer's Choice Awards]

ROCKET RACING
Silver — PSP [Pocket Gamer Awards]

FISH OUT OF WATER
2013 Excellence in Audio [Game Developers Association of Australia]

THANK YOU!

We have a few acknowledgments we'd like to share for the people and companies who helped make the success of Halfbrick and its games possible.

Thank you to MooseMouse Games, co-creators of *Star Skater*.

Thank you to Joe Brumm of StudioJoho for the creation of the epic *Dan the Man* web series.

And thank you to everyone who has ever played a Halfbrick game.

From six people in a basement to a hundred men and women across various countries, Halfbrick's journey has been amazing, and we couldn't have done it without you: the players! Thank you for your support. We look forward to celebrating more anniversaries, more milestones, and more beautiful game art with you in the next ten years.

WE'D LIKE TO THANK ALL HALFBRICK ART STAFF PAST AND PRESENT FOR THEIR CONTRIBUTION...

Sierra Asher	Murry Lancashire
Motze Asher	Resa Liputra
Stefanie Belau	Shath Maguire
Zoe Bochmann	Toni Martin
Justin Bowen (Video)	Laura McCabe
Wren Brier	Danny McGillick
John Carr	Toby Meadows (Video)
Brendan Deboy	Adam Nichols
Sara Fonseca	James Quick
David Giron	Scheree Reeves
Joel Gordon	Gemma Refalo
Ellen Hansen	Brad Robinson
Gareth Heavon-Jones	CL Terry
Bob Jones	Hugh Walters
Matt Knights	Michelle Whitehead
Emma Koch	Rod Wong